GIRL IN A GREEN GOWN

GIRL IN A GREEN GOWN

The History and Mystery of the Arnolfini Portrait

CAROLA HICKS

Chatto & Windus
LONDON

Published by Chatto & Windus 2011

2 4 6 8 10 9 7 5 3 1

Copyright © Estate of Carola Hicks 2011

First published in Great Britain in 2011 by
Chatto & Windus
Random House, 20 Vauxhall Bridge Road,
London SW1V 2SA
www.rbooks.co.uk

Addresses for companies within The Random House Group Limited can be found at:
www.randomhouse.co.uk/offices.htm

The Random House Group Limited Reg. No. 954009

A CIP catalogue record for this book
is available from the British Library

ISBN 9780701183370

The Random House Group Limited supports The Forest Stewardship Council (FSC®),
the leading international forest certification organisation. Our books carrying the FSC label
are printed on FSC® certified paper. FSC is the only forest certification scheme endorsed
by the leading environmental organisations, including Greenpeace. Our paper procurement
policy can be found at www.randomhouse.co.uk/environment

Typeset in Centaur by Palimpsest Book Production Limited,
Falkirk, Stirlingshire
Printed and bound by
CPI Group (UK) Ltd, Croydon, CR0 4YY

'The subject of this picture has not been clearly ascertained.'

Trustees of the National Gallery, 1843

'The finest picture in the world.'

Edward Burne-Jones, 1897

'This picture seems too alien to grasp, and at the same time entirely straightforward.'

Art historian Margaret Kostner, 2003

Contents

List of Illustrations

Illustrations in the text

Acknowledgements

The National Gallery in London has been supportive and helpful throughout, and especially Alan Crookham, Nicholas Donaldson and Mercedes Ceron of the National Gallery Archive. The staff of the British Library, London Library, Cambridge University Library and The Nicolas and Elena Calas Archive in Athens have also kindly assisted.

Individuals who helped with advice and information included Maggie Burr, Katy Edgecombe, Ed Freeman, Norman Hammond, Elsa Hands, Toby Hicks, Colette Hicks, Vivien Perutz, Richard Purver, Dale Russell, Steve Russell, Jean Wilson, Tina Wilson.

The Marie of Hungary portrait is reproduced by kind permission of the Society of Antiquaries of London, the Habitat advertisement by kind permission of Habitat, the *Guardian* cartoon by kind permission of Martin Rowson and Oswin Baker, *Mum* by Benjamin Sullivan by kind permission of the artist, and the poem 'The Arnolfini Marriage' by kind permission of Paul Durcan.

Jenny Uglow of Chatto & Windus, Carola's editor and friend of many years, did a superb job of editing this posthumous publication, along with everyone at Chatto & Windus. Clare Alexander, Carola's agent and another friend, believed in the project from the start.

Gary Hicks

Foreword

Grayson Perry

My wife was married in green. In a larky wedding snap we pose hand in hand in front of our fireplace, on the mantelpiece a vase I made to celebrate our union. My right hand is raised as if in blessing, her left rests on her pregnant belly. What inspired our nuptial jape was of course a painting over 550 years old. I cannot remember the first time I saw a reproduction of the Arnolfini portrait — it must have been in a school art book — but it seems to have been in my mind forever. It is a civil ikon, the near symmetry of the composition, full-length depiction of the couple, the neat arrangement of significant objects are reminiscent of the much-kissed artworks of orthodox Christianity. To my modern eyes this painting is an early altar to human love. It is an archetype echoed through art history, by Gainsborough's *Mr and Mrs Andrews* and Hockney's *Mr and Mrs Clark and Percy*, and by those aspirational spreads in *Hello! Magazine* where we see the accoutrements of social climbing laid out as plainly as in that coolly lit room in Bruges in 1434.

I wonder if it is possible for a relationship with a painting to be akin to that with a marriage partner? The initial glimpse across a crowded room, the first meeting eye to eye, a delightful first date: my gaze roving over the surface, hungry for new joys. Then the marriage: a painting becomes my official favourite. I am often asked what sort of art I like and have a ready list to trot out. But I worry — what if I were to read a book solely about one painting, what if I were to know of its long string of past

relationships in messy detail? What if I were to be led chapter by chapter through every line, every image, every symbol on its lovely surface – would I tire of it? Would over-familiarity bring on the 'Mona Lisa curse' where the cultural baggage of an artwork overwhelms its beauty. Reading this fine book, such fears were soon laid to rest. Carola Hicks has reinvigorated my love for the Arnolfini portrait to the point where I want to make my own homage. I have sometimes been dismissive about the view that knowledge about and understanding of an artwork would enrich one's appreciation of it, but I am a convert. I now look at van Eyck's crystalline masterpiece with new wonder, not only at his illusionistic skill and formal rightness but also his social acuity.

Perhaps the most moving realisation has been how thin the thread is that has pulled this small glowing panel of wood through history. It has survived five and a half centuries of damp, parties, neglect, adulation and war, not to mention travel by sailing ship and baggage cart. Reading this book has turned every future visit to the National Gallery into a pilgrimage where I must each time if only for a few moments renew my acquaintance with the 'lank quakerish object' from Lucca and the girl in the green gown.

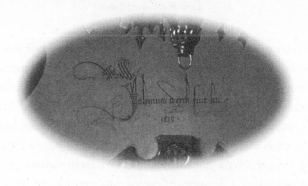

Preface: History and Mystery

One of the most loved works in the National Gallery in London is the Arnolfini portrait, painted by Jan van Eyck in 1434, a subtle and beautiful double portrait of a wealthy Bruges merchant and his wife. It shows the couple standing in a room, the man in a large-brimmed hat and dark robes, the woman in a green gown the rich fabric of which dominates the scene. Viewers comment on two things in particular: the woman must be pregnant because of the folds of material over her stomach, and the artist has included his own reflection in the mirror on the back wall of the chamber.

The painting ranks high in any compilation of famous artworks. In 2006, the *Guardian* included it among 'Twenty Works of Art to see before you die'. The year before, the nation voted it fourth in a radio poll for the best paintings in Britain. Another list put it among 'the world's 100 greatest pictures'. It is constantly cited in the canon of masterpieces of Western art, and features prominently in any discussion of the history of painting. It has influenced artists from Diego Velázquez to David Hockney, and its timeless status is proved by the way the man and the woman have been reinterpreted as Disney, Muppet and Star Wars figures, and even featured in advertisements as a pair of aspirant consumers.

This is intriguing, because the work is relatively modest in size (the painted surface measures just 82 x 60 centimetres) and apparently undemanding in subject matter. In addition, despite endless speculations, the identity of the characters and the true meaning of the scene are still uncertain. Scholars and public alike have puzzled over the meaning of this haunting gem of medieval art. The enigmatic couple seem to be conveying a message to us across the centuries, but what? Is the painting the celebration of a marriage or pregnancy, a memorial to a wife who died in childbirth, a fashion statement or a status symbol?

The first impression of the painting is that it is muted and modest. But on further inspection its contents seem to glow, each item in the room slowly comes to life and begins to contribute to the story. It is the first known portrayal of a couple who are neither royal nor aristocratic, and who are posed in a domestic setting rather than a church or a court. The man and woman are shown full length, holding hands, in an opulently furnished room. On the wall behind them, in the exact centre of the painting, is a convex mirror which reflects not just the whole room and the backs of the couple, but also two more people who are apparently entering by the door opposite. The artist has signed the work, placing his name not discreetly and conventionally at the bottom but prominently in the centre, above the mirror on the back wall. He has written *Johannes de Eyck fuit hic, Jan van Eyck has been here*, a cryptic comment. He has also considerately added the year, *1434*.

My book sets out to explore the painting and its history, and considers why it remains such an icon today. One reason may be that we live in a culture of celebrities and are fascinated by the lives of individuals. The people in the painting are not the gods and goddesses or Bible heroes and heroines who dominate so much of Western art, and they make no threatening demands on our imperfect recollection of mythology, history or literature. It is a secular image for a material age. van Eyck's meticulous depiction of the contents of the room and the couple's dress reveals a burgeoning consumer society revelling in vigorous

international trade and celebrating its access to new markets – a carpet from Turkey, damask from the East, silk from China – showing a love of fine things that finds striking modern parallels. The couple look real, inhabiting a tangible world brought to life by van Eyck's quite exceptional skills. As if in a *Hello!* spread, they are showing off the signs of success – expensive clothes and other status symbols. We are intrigued by their relationship and the circumstances behind their joined hands. It is the fifteenth-century equivalent of a photograph and we can make up our own stories about it.

Through different accidents of fate the portrait became a prized possession which passed through many hands and travelled from medieval Bruges via Habsburg Spain, through the ravages of the Napoleonic Wars to Victorian London. It survived through fires, battles, hazardous sea journeys. And uniquely, for a masterpiece this old, its provenance can be tracked through every single owner from the mysterious Mr Arnolfini via various monarchs to a hard-up Waterloo war hero, until it finally came to rest in 1842 as an early star of the National Gallery. These owners, too, have cameo parts in the enthralling story of how an artwork of genius can speak afresh to each new generation.

Its history – so full of colourful characters and dramatic events – also reveals the different assumptions and expectations that people have brought to it over the centuries. The various interpretations of the painting show how dangerous it is to take anything for granted. We still do not know exactly what it means. My own view is that van Eyck painted a well-off couple in their well-appointed room, and used a repertoire of familiar motifs that they would have appreciated. It was intended for private consumption, to be seen by members of the family and select guests as another prized item to add to the others in that calm room. It is a fascinating portrait of a mercantile couple, with hints of closeness as in a marriage portrait, and with intriguing differences between the sober, realistic portrayal of the man and the idealised depiction of the woman, but with an emphasis more on their possessions than their inner thoughts. Many others have put forward different

theories, as we will see. Yet the uncertainty does not spoil our enjoyment. Like all great works of art, the Arnolfini portrait retains an inner core of mystery. The work epitomises the whole history of art, and helps relate the past to the present.

1. *Court Painter to the Duke of Burgundy*

On 19 May 1425, an ambitious young artist secured his future career by becoming official painter and *varlet de chambre* to the glorious Duke of Burgundy. (The term *varlet* did not mean domestic servant in the sense of valet, but simply a member of the ducal household.) The Duke's new employee was Jan van Eyck, aged thirty. Born in the southern Netherlands, possibly in the town of Maaseik, and trained, like his brothers, as a painter, van Eyck's skills and industry had already won him a prestigious position as official painter to the cultured court of John, Duke of Bavaria, in The Hague, where he helped to decorate the palace. But Duke John – nicknamed 'the Pitiless' on account of his mass hangings of insurgents – died in January 1425, and civil war broke out between the rivals for the succession. Having lost his patron and his guaranteed source of income, van Eyck decided to take his chance in Flanders, where one brother of his may have already been working in Ghent. His growing reputation – and current availability – came to the attention of the most ambitious ruler in northern Europe, the Duke of Burgundy, who summoned him to Bruges.

Philip 'the Good' was the third Duke of Burgundy. The cognomen was not acquired until after his death, and it did not refer to his outstanding

moral virtues, which were conspicuously lacking, but to a general nostalgia for the good old days and the lost golden age created by this most lavish and long-ruling of dukes. His father was John 'the Fearless', and his grandfather Philip 'the Bold'. That first duke was a member of the French royal family, a younger son of King Jean II, who awarded him the Duchy of Burgundy, an ancient feudal territory in eastern France whose capital was Dijon. A judicious marriage to the heiress Margaret of Flanders brought the duke extensive lands in northern France and the southern Netherlands – the counties of Flanders, Brabant and Artois. The duchy therefore encompassed a group of disparate territories whose proud and independent citizens resisted the attempts by successive dukes to centralise power and weld them into a unified whole. Historians still debate whether the dukes of Burgundy saw themselves as princes of France or rulers of a genuinely autonomous state.

Fatal tensions were forged between duchy and kingdom in 1407 when Duke John the Fearless arranged the murder of the French king's heir in order to advance his own claim to the throne. The new heir, the Dauphin, took terrible revenge by ordering John's assassination during so-called peace talks between the two factions in 1419, bringing van Eyck's patron, Philip the Good, to power at the age of twenty-three. The elegant Philip vowed to wear black for the rest of his life in eternal mourning for his father (this made the colour chic at court), and he thereafter viewed the French king as an enemy rather than an overlord. Philip shifted his power base from Burgundy to Flanders and made it the core of his sprawling duchy, which he extended still further by his policy of aggressive expansion, seizing the states of Holland and Zeeland. His itinerant court moved between Bruges, Brussels, Lille and Hesdin, with rarer visits to distant Dijon in what was still a fiefdom of France. Combining the exquisite taste of the French court with the prosperity of the industrious Low Countries, the Duchy of Burgundy developed a unique style and culture that made it the most sophisticated state in fifteenth-century Europe. For an ambitious young artist, it was the best place in the world.

Van Eyck's new master was more of a monarch than a duke. According

to Georges Chastellain, the official court historian (a completely new post, pioneered by the duke in order to record his triumphs for posterity), Philip 'had a handsome figure, upright, strong in the arm and back and well-knit . . . he had the rather long face of his father and grandfather, brown and weather-beaten. The nose was long but not aquiline, his forehead was high and large . . . such looks and such a figure seemed more befitting an emperor or a king than an ordinary man.' Miniature painters confirmed this description, giving him an excessively long face and a haughty, refined expression. The duke was fit and healthy too, skilled at archery, tennis and hunting. His only apparent vice was the sociable one of staying up 'almost till dawn, turning night into day to watch dances, entertainments and other amusements' while his many bastards, cheerfully acknowledged and supported, simply proved his fertility. Ironically, however, the duke's three marriages only produced one legitimate son and heir.

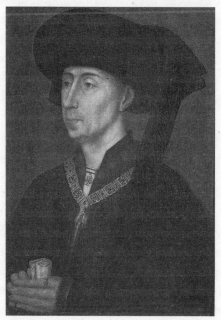

Rogier van der Weyden, *Philip the Good, Duke of Burgundy*

Recruiting a talented painter like van Eyck proved how seriously Duke Philip took his public image. The role of a court artist was to glorify his lord and impress distinguished visitors by tackling all tasks fitted to his training and skills. van Eyck was not the only official artist, for the duke had craftsmen on hand in all his residences. At the castle of Hesdin, in Artois, he employed as *varlet de chambre* the artist Colard le Voleur, whose job it was in 1433 to repaint the gallery and restore some ancient mechanical figures and cunning devices which squirted water, soot or flour at unsuspecting visitors: the highlight was a gadget which wetted the ladies from underneath. Other special effects included thunder, lighting and snow, and a walking talking hermit made of wood. Colard 'decorated the room in front of the hermit . . . in good quality oil colours of gold, azure, and so on . . . and he has done the whole ceiling and panelling of this room in azure strewn with large stars picked out in gold.'

In Lille, the duke's artist was Hue de Boulogne, one of whose projects was to create table decorations for a particularly ostentatious banquet in 1435. The two top tables sported artificial hawthorn trees painted with gold and silver flowers, bearing the arms of all the nobles present, while a further eighteen trees flaunted the ducal arms. Hue also painted these onto fifty-six wooden plates and constructed ten gilt lions to surround the live peacock that was carried in on a huge platter (for decoration rather than eating). To enliven another feast at Lille in 1454, Colard le Voleur travelled from Hesdin to help make a two-headed horse, a pair of elephants and a naked woman who squirted hippocras (spiced wine) from her breasts. In the same year, when the duke was planning a crusade against the Turks in revenge for their devastating sack of Constantinople, his artist Jehan de Boulogne (perhaps Hue's son) painted ducal emblems in gold onto damask standards and other military equipment.

Although the incomplete ducal accounts of the period do not list specific examples, these were the sort of tasks van Eyck might initially have been expected to undertake. He certainly accepted a decorative commission from the town councillors of Bruges to paint and gild eight

of the statues of biblical and historical characters that garnished the florid exterior of the Stadthuis in the Burg, the political and religious heart of the town. However, the duke was soon impressed by van Eyck's diplomatic as well as artistic skills, and dispatched him on a series of well-paid and evidently sensitive missions abroad; the accounts describe two of them as 'secret'. Philip operated an extensive network of spies and messengers all over Europe, and van Eyck may have contributed to the information gathering by drawing plans or recording fortifications and weaponry in potentially hostile states. He created a mappa mundi, 'a circular representation of the world . . . it is thought no work has been done more perfectly in our time; you may distinguish in it not only places and the lie of continents but also, by measurement, the distances between places', according to the Italian scholar Bartolomeo Fazio, who saw the original in 1456.

In his official role as court painter, van Eyck joined the huge embassy that set off in 1428 to seek the hand of the Infanta Isabel, daughter of King John of Portugal: the duke had already lost two wives but still lacked an heir. van Eyck's job was to make two portraits of the Infanta to be sent back to Flanders, one by land and one by sea in case the other got lost. It was unlikely that the marriage alliance depended on van Eyck's enticing image of the bride-to-be (unlike the unfortunate example of Henry VIII, seduced by Holbein's too flattering interpretation of Anne of Cleves). Isabel was a virgin of thirty-one, her rank as the daughter of a king outweighing her age. Commissioning her portrait was a mark of courtesy and a demonstration of the artistic resources of the duke's court rather than a test of her beauty.

While the king and the duke's men interminably negotiated terms and conditions, the extended stay in the Iberian peninsula enabled van Eyck to study landscapes and buildings that he could never have imagined in flat, foggy Flanders. The party visited Santiago de Compostela, Castile, Granada 'and several other lords, countries and places', travels which inspired, for example, the exotic, southern trees in the altarpiece van Eyck painted for St Bavo's Cathedral, Ghent. Being on a mission that lasted

for fourteen months also meant that the duke's artist lived in intimate contact with leading members of the Burgundian court, the duke's most trusted men. Among the distinguished ambassadors was Count Baudouin de Lannoy, old soldier and governor of Lille, whose craggy features van Eyck later immortalised.

Following a storm-tossed crossing of the Bay of Biscay and the English Channel which surely caused van Eyck to fear for his life and future career, the epic expedition culminated with the triumphal arrival of the bride in Flanders. The party reached Sluys, the seaport of Bruges, in December 1429, where they were greeted by celebrations designed to prove that the Burgundian court was the grandest in northern Europe. The orgy of ceremonies, processions and tournaments demonstrated how the duke had elevated his sturdy northern provinces to rival anything the Italian or French courts might offer. Growing prosperity had spawned luxury industries, while the ostentatious skills of the duke's artists and craftsmen were as brilliantly evident as the materials they transformed.

Patronising the arts was also seen as proof of moral virtue. Duke Philip promoted poets and writers by acquiring and commissioning books to fill his library, which contained more than a thousand manuscripts illuminated by the very best masters; this was how he first became aware of van Eyck, who probably began his career as a talented miniature painter. The duke naturally possessed hundreds of tapestries, the most expensive art form of all, looked after by a dedicated keeper, another *varlet de chambre*. He also owned literally thousands of jewels, so many, according to an awed foreign visitor, 'that the keeper of the jewels said he could not show them in three days. He told us his lord had so many jewels that he had not seen them all in many years and indeed did not know where they were.' The same tourist noted the duke's silver and gold plate, which outdid even the luxuries of Venice: 'it is said that nowhere in the world were such costly treasures, if only because of the hundred-thousand pound weight of beaten gold and silver gilt vessels which we saw in many cabinets'. The duke took most of these

prized possessions with him on his constant progresses from one palace to the next. A typical journey, when the court moved from Dijon to Lille in the spring of 1435, required seventy-two carts, each pulled by five or six sturdy horses. It took five carts to carry the duke's jewels, and another two for those of the duchess. The tapestries occupied a further six.

Being employed by such a patron meant that van Eyck was entirely at the duke's disposal, although he was permitted to undertake commissions for other clients. A major privilege was exemption from the niggling restrictions of guild regulations, and from local taxes. His annual salary was 100 livres, and he wore the duke's livery. On joining the court in 1425, he had to move from Bruges to Lille, the duchy's administrative centre, and the duke paid the costs of that move. For the next seven years, van Eyck lived in Lille (apart from the foreign trips and possible visits to Ghent to work on the massive altarpiece). Working for Philip was certainly profitable, although payment could be uncertain. In a bid to reduce household expenditure at the end of 1426, the duke cancelled several pensions and dismissed some servants, but unfortunately the Flanders receiver erroneously assumed the court painter's salary was also to be stopped and it took more than a year following his complaints before it was resumed by special edict and all arrears paid. Six years later there was another financial hiatus when the duke most generously replaced the 100 livres annual salary with a life pension worth 4,320 livres, partly financed by taxes on the export of Flanders woollen cloth. The accountants at Lille, concerned that no reason had been given for such an enormous increase, declined to pay. van Eyck threatened to leave, forcing the duke to explain to his recalcitrant officials that he was about to use this particular employee on 'certain great works', no other artist of his ability was available and they must pay the pension without further argument or delay, or face his wrath.

In 1432, van Eyck moved back to Bruges, where the duke was now spending much of his time. The court occupied the old Princenhof palace, lavishly refitted to host the wedding celebrations, but the duke also had

a second residence in Bruges, the hotel Vert, where he escaped from the formalities of court life. The newly enriched *varlet de chambre*, who did not have to live at court, acquired a property of his own, a combination of home and workshop, in the artisan heart of the vibrant city.

2. Bruges, Venice of the West

Bruges epitomised the golden age of Flanders. Its supremacy was based on international trade, and it was as much the wealth of merchants as of the court that helped the arts to flourish there. Art needs money and its innovations were ultimately underpinned by decent wages and stability in the cost of living following the duke's reform of the disparate currencies. The character and attractions of Bruges are brought vividly to life in the eyewitness account of a traveller from Castile, Pero Tafur, who toured Flanders in 1438 at the tail end of an epic journey from the Holy Land. Impressed first by Brussels where 'the multitude of people and their refinement and splendour can scarcely be described', Tafur was overwhelmed by Bruges:

> a large and very wealthy city, and one of the greatest markets in the world. It is said that two cities compete with each other for commercial supremacy, Bruges in the West and Venice in the East. It seems to me however, and many agree with my opinion, that there is much more commercial activity in Bruges.

He noted that this Venice of the West offered:

everything which the whole world produces. I saw there oranges and lemons from Castile, which seemed only just to have been gathered from the trees, fruits and wine from Greece, as abundant as in that country. I saw also confections and spices from Alexandria, and all the Levant, just as if one were there; furs from the Black Sea as if they had been produced in the district. Here was all Italy with its brocades, silks and armour, and everything which is made there; and indeed there is no part of the world whose products are not found here at their best.

He could almost have been describing the Arnolfini portrait, in which van Eyck depicted some of the luxury imports – oranges, furs and silks – that helped make his town rich. Tafur explained how this cornucopia flowed from 'all the nations of the world; they say that at times the number of ships sailing from the harbour at Bruges exceeds 700 a day'.

Rubbing shoulders in the cosmopolitan throng were Spaniards importing the merino wool that was overtaking the once-predominant sacks from Lincolnshire, Shropshire and Yorkshire; the adventurous Portuguese bringing back sugar, spices and sweet wines from Madeira and Africa; the German traders of the Hanseatic league, for Bruges (together with Novgorod, Bergen and London) was a Hanse centre where ships unloaded the products of the north – furs from Russia and Siberia, cereals, ores and timber from Sweden, iron and copper from Prussia, ales from Hamburg, woad from Thuringia, and the Danish herring and Norwegian cod preserved in salt from Portugal or western France. The scope and particular privileges made Hanse members unpopular in Bruges: in 1436, for example, there was an unfortunate incident at Sluys, when locals attacked and killed a group of German traders.

Sluys was a bustling seaport on the Zwyn estuary, some 6 miles from Bruges, and directly linked to the town by the river and a series of ingenious waterways. Tafur explored its harbour, which 'looks as if half the world had armed itself to attack the town, so great a fleet of ships is always at anchor here: carracks, sloops from Germany, galleys from Italy, barques, whalers, and many other kinds of vessels according to the different countries'. Most merchandise was carried up the river Zwyn as far as the

port of Damme, on the outskirts of Bruges, where it was transferred to flat-bottomed barges to travel along a canal recently extended into the very heart of the town. Here, the goods were unloaded at the Waterhalle, the great depot that framed the east side of the Market Square. Heavy items, such as barrels of wine, were winched up by the town crane, a huge apparatus operated by sturdy lads marching its two treadmill wheels.

Traders disposed of the goods they had brought, then refilled their holds with new produce, including local wares, the expertly woven woollens, linens and tapestries that helped make Flanders so prosperous. Foreign merchants had to obey the protective restrictions imposed by the town guilds: they could sell imported products in Bruges, but not newly purchased Flemish fabrics, which were for export only. Nor were they permitted to deal directly with local traders, but could only negotiate through a *makelaer*, or broker, who was a member of the Bruges guild of brokers. Such men conveniently combined their trade with running the hostels where foreigners lodged. Tafur attributed the strength of the local industries to 'the barrenness of the soil, since very little corn is grown, and no wine, nor is there any water fit for drinking, nor any fruit. On this account, the products of the whole world are brought here, so that they have everything in abundance, in exchange for the work of their hands.'

The need for locals and strangers to communicate inspired a Bruges schoolmaster to compile the first ever bilingual phrase book, the *Livre des Mestiers* (*Book of the Trades*) in the mid-fourteenth century. This took the form of a Flemish/French conversation manual which proved so popular that it was regularly updated. In 1483, William Caxton published a French/English version in Bruges which continued to stress the skills of local artisans like Gabriel the linen weaver, Elias the cloth dyer, Ferraunt the hosier, Vedaast the furrier, and Colard the goldsmith, all of whose works van Eyck celebrated in the outfits worn by the Arnolfini couple.

In the 1430s, the population of Bruges numbered around 40,000, and the city impressed visitors like Tafur with its civilised and prosperous atmosphere: 'the inhabitants are very wealthy. It is well peopled, with fine

houses and streets, which are all inhabited by work people, very beautiful churches and monasteries, and excellent inns . . . the people of this part of the world are exceedingly fastidious in their apparel, very extravagant in their food, and much given to all kinds of luxury.' But there was also a downside. 'Without doubt, the goddess of luxury has great power there, but it is not a place for poor men, who would be badly received.' And Tafur noted the presence of the many prostitutes who solicited trade around the market, and the proliferation of the notorious bathing houses, whose mixed-sex bathing, he suspected, was just an excuse for immorality.

In addition to his official work for the duke, van Eyck developed a profitable sideline painting the darker side of Bruges. In marked contrast to his demure Madonnas, he produced a range of saucy bathing scenes that featured naked ladies. (The originals have not survived, but there are later copies and contemporary references.) The town would remain famous for its forbidden delights. A generation after Tafur, an aristocratic Bohemian, Leo of Rozmital, visited Bruges as an essential stop on his tour of Europe. His travel diary duly recorded the notorious baths where men and women bathed together, and evoked an unsettling image of disguise and travesty during Carnival Week, when 'it is the custom for noblemen to go about masked, each striving to be more fantastically dressed than the others . . . the servants are similarly dressed'.

Bruges's ambiguous reputation was long established. In *The Canterbury Tales*, Geoffrey Chaucer, who had travelled in Flanders in the late fourteenth century, cited the town as the essence of permissive behaviour. The workaholic merchant in 'The Shipman's Tale' left his frustrated wife in Paris (where she cheerfully submitted to seduction by his hypocritical cousin, a monk) and went on business to Bruges, where he bought goods and arranged credit, but stubbornly refused to participate in two of the local attractions, gambling and dancing. Chaucer also used a Flanders setting for 'The Pardoner's Tale', a morality story about three corrupt companions who haunt brothels and taverns, dance, gamble, blaspheme, and eat and drink too much: the tale ends in treachery and murder.

Bruges's outward prosperity in the decade of the Arnolfini portrait barely masked the effects of recent political conflict. Tafur noted many high gallows around Bruges and Sluys displaying the heads of dead men. These were the remains of the unfortunates who had dared to oppose the duke in an unsuccessful uprising in 1437 when the burghers were attempting, as ever, to demonstrate their autonomy over the alien ruling dynasty which imposed unreasonable taxes and regarded the town as an inexhaustible money box to fund the court's luxuries: the high-spending duke seized one-seventh of Bruges's annual revenues. The mood of growing unrest climaxed in May, when the citizens virtually imprisoned the duke by closing the town's main gate after his ceremonial entry but before his troops could follow him. He escaped, but took his revenge by demolishing the offending gate and executing the ten leading rebels, whose heads he stuck on the other ten gates as a warning. Further reparations included a huge fine, which temporarily drove the town into poverty and famine. The honourable Tafur was shocked when a starving woman in Sluys offered him one of her daughters for money. He gave them 6 Venetian ducats and optimistically made them promise never to do it again.

While prostitutes prowled the arcades of the great trading Halls on Market Square, the real red-light district was the St Gilles area to the north-east, where van Eyck lived. Here the brothels and bathhouses flourished, together with all the hostels, taverns and gaming houses that catered for cosmopolitan gangs of sailors kicking their heels and bent on pleasure until their ships left port. van Eyck's house was in St Gilles Nieuwstraat, a teeming zone where hard-working artisans lived side by side with a transitory and often unruly population speaking unfamiliar tongues – English and Scots, Portuguese and Italian, Prussian, Scandinavian and Slav. This was just a few minutes' stroll from the respectable trading area colonised by foreign merchants, centred on Beurse Square (named after the family of innkeeping brokers who lived there, whose money-changing activities are thought to be the origin of the term 'Bourse').

Bruges's origin as a marketplace for north and south, east and west, began with the great fairs that punctuated the European year, magnets

bringing buyers and sellers together. Flanders hosted five annual fairs; the one in Bruges ran for six weeks in the spring, then the cavalcade moved on. However, the town's convenient location near a seaport meant that traders found it more profitable to establish permanent bases there to deal with the volume and variety of goods arriving. The different nationalities initially occupied hostels for temporary living and storage space, but by the fifteenth century they had established their own separate headquarters, and acquired the necessary accommodation. Such houses came to contain the necessary status symbols of tapestries, furniture – and paintings.

Among the foreign merchants living around Beurse Square were members of the Arnolfini clan from Lucca, one of the autonomous city states of the Italian peninsula which, together with Genoa, Venice, Florence and Milan, established permanent bases in Bruges. These Italians were vital members of the town's commercial community. Combining trade and finance, they became the first merchant bankers.

The intrepid seafaring Genoese were the first to sail to Bruges in the late thirteenth century in sturdy galleys purpose built to withstand the battering of the North Sea. The Venetians soon followed, adding a new northern base to their maritime empire in the south and east. The arrival of the Venetian galleys at Sluys each spring was a major event in the year. They brought silks and gold-woven fabrics from Byzantium and Islam, wonderful southern luxuries for the table (semi-tropical fruit, cane sugar, malmsey wine) as well as the 'spices' needed not just for garnishing food but also for manufacturing. The French term *épices* covered not merely condiments but also all sorts of products from Africa and the East, including the dyes and mordants essential for the cloth industry; the alum that set colours permanently was an essential element for Flemish and English cloth workers. The next wave from Italy, the Florentines and Lucchese combined their import–export businesses with the operation of innovative banking systems which enabled merchants to obtain short-term credit in the major European cities.

The Church defined as usurers those who profited from loans by

charging interest – they were sinners who would go to Hell. But theologians did not object to the use of bills of exchange for buying and selling foreign currencies, and this was how bankers really made their money: their loans managed to conceal substantial interest rates within the fluctuating exchange system. Those sophisticated accountants, the Florentines, who invented the revolutionary method of double-entry bookkeeping, were the first to exploit this principle, and they made Bruges the northern point of a financial network that linked the major centres of Paris, London, Montpellier and Barcelona. In 1439, the Medici bank opened a branch in Bruges.

Their banking rivals were the Lucchese, who also specialised in trading superb silks made in Lucca. The 'Community of Lucchese residing in Bruges' acquired new headquarters in 1394 in a house just off Beurse Square, the base for the consul and a three-man council, whose role was to support members and ensure they maintained the necessary standards. These premises were close to those of their compatriots, for the Florentines, Genoese and Venetians all had properties in the square itself, the latter having taken over the Beurse family hostel. (The enterprising Genoese would surely be delighted that their former headquarters now houses the world's first Museum of Chips, opened in May 2008.) Their young men came to Bruges to work in the family business for a year or two as one stage in a developing career, but some remained as permanent expatriates, well integrated into local society. These included the Arnolfini, Rapondi and Giudiccioni families, all from Lucca. Like the other Italian groups, the Lucchese retained a distinctive national identity, and worshipped in their own chapel, dedicated to the Volto Santo, Lucca's famous Crucifixion relic.

It was probably a source of pride for the Duke of Burgundy that such discriminating patrons sought the works of his own court painter. van Eyck received a number of commissions from the Italian community, and his reputation soon spread to Italy, generating further demand. Anselm Adorno, a prominent member of a Genoese family long established in Bruges (where he built a remarkable church that imitated the Holy

Sepulchre in Jerusalem), bought at least two works by van Eyck, showing scenes from the life of St Francis. Another Genoese merchant, from the Giustiniani family, commissioned a triptych of the Virgin and Child that included an image of the patron himself wearing elegant Flemish dress. And the Genoese Lomellini family also commissioned a triptych, so desirable that King Alfonso of Naples subsequently bought it. Lorenzo de Medici acquired St Jerome, probably commissioned via the Bruges branch of his family bank. Cardinal Ottaviano of Florence managed to get his hands on one of van Eyck's titillating bathing women, a piece originally commissioned by Federico da Montefeltro, Duke of Urbino, if Vasari's lives of the artists can be believed. And the painting known as the Lucca Madonna (because it was identified in that town in the nineteenth century) must have been commissioned by one of the Bruges Lucchese. This suggests that by the 1430s, the works of van Eyck, court painter to the magnificent Duke of Burgundy, were becoming major status symbols for Italian collectors and connoisseurs. So when a Bruges-based member of the Arnolfini family decided to commemorate himself and his wife, the only artist to approach was the duke's painter. van Eyck's double portrait represents the ultimate assimilation of the Italian merchant community, a man from Lucca and his wife in a setting and a style which were entirely Flemish. The work could only have been created in cosmopolitan Bruges.

Followers of Fashion

The precision and subtlety with which van Eyck has treated the faces of the couple in his portrait is extraordinary. He depicts the man with almost photographic accuracy – long, lean face, high cheekbones, deep-set greyish eyes which deliver a cold stare, prominent ridge of the nose and slightly cleft chin. The image appears to be truthful, for van Eyck painted the same recognisable features again in the half-length portrait of a man (now in Berlin), recreating the same character with a face that was hard to forget. (To modern eyes, it bears an uncanny resemblance to Vladimir Putin.)

Van Eyck gave the same detail to the woman's features. Tilting modestly downward, her face is a smooth oval whose peachy texture is enhanced by the delicate highlights cast by the reflection of her creamy linen headdress onto the underside of her plump jaw. The mouth is small, its curvaceous lower lip casting a shadow on the rounded chin, which has a tiny dimple at the tip. But there is something not quite right with the proportions of this face. Even making allowance for the fashionably over-plucked pencil-thin eyebrows, they are still unnaturally high above her eyes. Although van Eyck was capable of applying the same unflinching gaze to his female as well as his male sitters – exemplified by the

careworn expression of the donor's wife on the Ghent altarpiece, and the pursed lips and quizzical stare of his own wife in the portrait in Bruges – the Arnolfini woman seems to be an archetype, an image existing in his mind rather than before his eyes. For by now he has painted this face several times. The high eyebrows and puffy skin below them, the long straight nose and rosebud mouth already characterise his angels on the Ghent altarpiece, especially the angel of the Annunciation. And he repeats these formulaic features on other Annunciation angels (Washington, Madrid) and St Catherine (Dresden). The faces of his serene Madonnas also have these particular proportions. This all implies that, in contrast to his all too accurate treatment of her husband, van Eyck did not draw this woman from the life but chose to turn her into a vision of idealised holy beauty.

However truthful or idealised their faces, it is by their clothes that van Eyck locates them in the external world. They both wear the products that made Bruges the centre of a trading empire – fur, silk, wool, linen, leather, gold – and they personify the wealth of the city in its heyday. Dressed to impress, they are stating their position in society. For the colleagues, family and friends whom the painting was meant to impress, the code was perfectly clear. It spelled discreet ostentation, and celebrated the merchant class in all its permitted finery.

Those in control have always tried to regulate what other people wear. In the Middle Ages, morality and conservatism combined to create sumptuary legislation designed to preserve a strict social hierarchy. This reached a climax in the burgeoning urban consumer societies of the fifteenth century, driven by the shameless rise of nouveaux riches who could outspend the old feudal aristocracy. Kings and dukes felt they had a right and a duty to flaunt a lavish public persona, for extravagant dress and jewellery confirmed their dynastic status, glamorous court, and access to the wealth needed to support them. Their dress was also an opportunity to show off the skills of their craftsmen – tailors, embroiderers, furriers, goldsmiths and others – working to glorify their patron and inspire admiration and desire for their exquisite products.

For the lesser nobility, however, striking the correct note was more challenging, and it was a positive minefield for a merchant, no matter how wealthy. Evidence of contemporary anxiety about social transgression is given by a statute drawn up in 1430 by the Duke of Savoy, ally and neighbour of the Duke of Burgundy, which defined thirty-nine different social ranks, and specified the clothing and accessories appropriate to each.

Van Eyck applied the insights of a courtier who would have appreciated every nuance, and ensured that the Arnolfini couple got it just right. Her outfit demonstrates seemly prosperity, and his controlled opulence, a man with a finger on fashion's pulse. He wears the dark shades pioneered by Duke Philip, who made this fashion a political statement, including cutting-edge linings of brown marten fur. In contrast, her bulky green gown could have been worn at any time during the previous generation, and its fur lining is made from the more common and (relatively) cheaper squirrel. His dashing straw hat is a stylish import but she wears a provincial, domestic headdress of linen.

Although subsequent varnishing and cleaning have muted the original colours, Arnolfini wore fabrics that had been dyed rich plum and black, tones that not only copied court fashion but also announced his own gravitas and virtue. Jean Courtois, writing in the fifteenth century on the significance of colours in heraldry, declared that a merchant wearing black was indicating his '*loyauté*', his trustworthiness; obviously an essential quality to project.

Arnolfini's outer garment is a *heuque*, a long tabard, sleeveless and open at the sides. The shape originated as a form of Italian military dress that could be worn over armour, but it became fashionable as civilian wear in the early fifteenth century (like our modern-day use of camouflage patterns or combat trousers). The one in the painting seems to be made of silk velvet, and was thus a blatant advertisement for the luxury textiles imported to Bruges from Italy, and specifically Lucca, where the Arnolfinis came from, an important centre of velvet production. Making velvet required an enormous amount of the finest quality silk thread to achieve the closely

sheared, wondrously smooth surfaces that gave the fabric its special nature. Duke Philip wore the most luxurious type of all, *velours sur velours*, made from a complex weave of two different heights of pile. The dense folds of Arnolfini's tabard prove that it was made of many metres of costly material.

The deep plum tone was another statement of wealth, for dark shades required more laborious processes to achieve a permanent dye and were therefore more expensive to produce. Woad and madder were used to dye silk black, but violet shades also needed kermes, an even more expensive ingredient. Kermes (*kermes vermilio*) came from a wingless parasite living on the leaves and branches of the scarlet oak that grew around the southern and eastern Mediterranean, in the Levant and further east. Laboriously gathered in the spring and killed with vinegar or steam, the scaly insect bodies were crushed, dried and powdered to produce a powerful and permanent carmine dye that was one of the vital components of the spice trade. It was among the goods, for example, carried in 1432 by a caravan of 3,000 camels that swayed their way on a fifty-day journey from Damascus to the port of Bursa by the Sea of Marmara. Here, Florentine and Venetian merchants bought up much of the precious load and shipped it to northern Europe. That was how the dyers of Bruges got their hands on this powdered dye.

The quality of the dyes used was another useful way of demonstrating status. From the thirteenth century, the statutes of the Lucca dyers' guild warned that any member using an inferior red would be fined, or lose his right hand if he couldn't pay the fine. In the complex social hierarchies of fifteenth-century Venice, the colour of clothes was restricted to black for every day and red for festivals. Here the range of dyers' recipes for kermes red was far more extensive than for reds made from cheaper products, which were inevitably less intense and prone to fading. Madder root, dried and powdered, produced alizarin, effective as an ingredient in making black but when used on its own appeared terracotta rather than bright red. For this reason, it was banned as an additive to kermes, which cost three times as much. When the Venetians adopted the Burgundian

24

fashion for dark colours, dyers were, however, permitted to combine kermes with woad and madder to achieve the desirable strong black. Another red dye was Brazilwood (called *verzino*) which initially produced a vivid scarlet or crimson but tended to fade, so Venetian dyers were forbidden to mix *verzino* with kermes. To guarantee the purity of their product, they even had to colour-code the finished edges of woven cloths to indicate the constituent dyes.

Yet the ultimate refinement of the Arnolfini tabard is not its colour but the fur lining, visible at the neck, the long side openings and the hem. These are so exquisitely painted you can almost touch its gleaming softness. Fur linings and trimmings were a standard feature of high-status clothing, worn all year round as a form of portable central heating in an era of draughty rooms, glass-free windows, uncarpeted floors, and fireplaces that gave out more smoke than heat. Wearing fur was socially contentious and inevitably inspired many sumptuary restrictions. In late fourteenth-century England there were strict categories of use from top people's ermine down to commoners' cat or rabbit.

The most prestigious fur of all was sable, reserved for royalty and the top aristocracy. Almost black, wonderfully smooth and enormously expensive because it had to be imported from far distant Siberia, it appealed to the sombrely clad Duke Philip as a superb contrast in texture to the fine wools, brocades and damasks of his dark robes. Ducal accounts for 1432–33 record the purchase of several black velvet, sable-lined *heuques*. Arnolfini would not have dared to wear this princely fur. His tabard was lined with the next best thing, the lighter brown coat of the pine marten, which was not restricted to princes but was almost as prestigious. The English King Henry V wore both sable and marten and owned twenty furred gowns, ten fur linings and six furred cloaks, according to his will of 1422. The Duke of Savoy also possessed marten-lined *heuques*. And van Eyck's other portraits suggest that many wealthy Burgundians wore marten. He portrayed the duke's right-hand man, Chancellor Rolin, kneeling before the Virgin and Child in a brocaded gown the neckline, cuffs and hem of which reveal the same gleaming brown fur as Arnolfini's

tabard. Another devoutly kneeling client was Canon van der Paele, whom van Eyck depicted in the white surplice of his office, which however failed to conceal the marten collar peeping up from the robe beneath. Other subjects wearing marten linings include the knight Baudouin de Lannoy, and Jodocus Vidt, patron of *The Ghent Altarpiece*. When van Eyck painted his second portrait of Arnolfini, he showed him in marten again, lining a long-sleeved, high-necked brown robe. As a member of the court, van Eyck may well have worn marten himself: *Man with the Red Turban* (1433, National Gallery, London), assumed by many to be a self-portrait, wears an almost identical garment. van Eyck's use of sable, however, was restricted to the tips of his paintbrushes.

Arnolfini's costly lining followed fashion and at the same time advertised his own wares. Bruges was the hub of the fur trade, another luxury product which featured in many merchants' portfolios. Marten was almost as expensive as sable because it was trapped far away in the remote forests of Russia and northern Scandinavia, and the pelts passed through sundry middlemen before the furriers even got started on their own laborious manufacturing processes. Many skins were required to line a garment. A long gown made for the Duke of Touraine in 1391 required 170 skins, and his short gown seventy. A calf-length tabard like Arnolfini's required at least 100 skins.

Beneath the opulent outer layer, Arnolfini wears a black doublet – a high-necked, long-sleeved jacket in another costly silk-based fabric, probably satin, elaborately woven into leafy patterns. The sleeves are clasped at the wrist by elegant silver-braided cuffs, fastened with scarlet laces. His legs are clad in purple hose, the colour carefully selected to match that of the tabard. Hose were long stockings, joined to each other like modern tights, and normally attached by laces to the hem of the doublet. Woollen hose were a famous local product, mentioned by Chaucer, who had a professional eye for such details from his time working as a controller of imported cloths. In *The Canterbury Tales*, listing the wardrobe of the elegant Flemish knight Sir Thopas, he specified 'Of Brugges were his hosen broun'.

Over his hose, Arnolfini wears close-fitting ankle boots with a fashionably pointed toe. These were evidently made of the softest leather because they reveal the contours of his feet. Another luxury touch is that they are dyed purple to match his tabard. These boots were evidently so precious or delicate that when he was outside he protected them from the dirt of the street by wooden overshoes, or pattens. van Eyck implies that Arnolfini has only recently come into the house, because a pair of muddied pattens lies on the floor beside him as if he has just kicked them off. Even these functional overshoes are a fashion statement, carved into the excessively long pointed toes that bore little relation to the shape of actual feet and caused moralists to rail. Pattens were made of light and malleable woods such as alder or aspen, cut into rough sole forms when still green and properly shaped after the wood had dried and shrunk. Then the shoemaker nailed broad leather straps to the sole on each side of the instep, to be fastened by a buckle in the middle. van Eyck has included all these details, down to the slightly concave insole carved to accommodate the ball of the foot, and has meticulously put in every grain of the wood.

Perfect from toe to top, Arnolfini wears a hat that is, naturally, in the latest style. High crowned and wide brimmed, it is a clever reworking of the tall Flemish 'beaver' hat (so-named because it was made from the woven hairs of the rodent). But this is a superior model, far lighter on the head because it is made of straw woven into tiny plaits, then minutely coiled into the required shape. The light from the window picks out the detailing on the left side — van Eyck has revelled in recording the intricate construction as well as employing the dark halo of the brim as a striking counterpoise to the pallor of the man's face. The hat is another example of a luxury import, for Italian straw hats had been traded north from the beginning of the century. And Arnolfini's is even more of a status symbol because it is dyed black to match his doublet. Dyeing straw (whether as plaited strands or as a finished object) such a strong shade was just as complex as dyeing silk or wool, and required the same range of ingredients.

The contrast between the modish hat and the woman's head covering could not be more extreme, and suggests a whole range of deliberate oppositions — black/white, cosmopolitan/local, up-to-date/old-fashioned, dashing/demure. Her modest face is framed, indeed almost overwhelmed, by an elaborate linen veil made, as costume historian Margaret Scott has demonstrated, from one long strip of material which has been folded backwards and forwards into five separate layers, the edges shirred and fluted to give the effect of lacy trimming. Yet it is a relatively simple version. Such a cloth could be folded as many as twelve times to make a really elaborate headdress; van Eyck painted his own wife wearing a seven-fold variant in his 1439 portrait of her. Such headdresses were held together with the aid of strategically placed pins. Although van Eyck does not show any here, they can be spotted in contemporary Flemish portraits, like Robert Campin's *Young Woman* (*c.* 1435, National Gallery, London).

This head-wear may represent a distinctive Bruges variant of a wider Flemish fashion (as in Brittany, where the women from each district sported a distinctive lace coif, a medieval custom which survived into the early twentieth century). It also denoted the necessary restraint of a merchant's wife. An aristocratic woman would have worn something wider or higher, for this was an era of extreme head-wear, like the outrageous hennins, consisting of great horns of stiffened fabric on either side of the head, spanned by a veil. These were at their peak in the 1420s, and attracted the church's disapproval on the grounds that the Devil also wore horns. But van Eyck gave the woman in the portrait a head covering so discreet that it would have caused no concern. Her hair, fairish in colour, has been coiled into two conical buns on either side of her temples, held tightly in place by russet silk hairnets trimmed with a narrow plait. Great ladies, even married ones, were permitted to reveal more hair than can be seen in this austere version; van Eyck portrayed his own wife with wider and taller hair cones.

The high smooth forehead and extremely thin eyebrows suggest the moral ambiguities of a woman's image, with real life impacting on van

Eyck's idealised vision. For he makes it look as if the merchant's wife has succumbed to the morally reprehensible fashion for plucking the hairline and eyebrows. According to an etiquette manual which the Chevalier de la Tour Landry compiled for his daughters in the late fourteenth century, and still widely read in the fifteenth, facial depilation represented the sin of Vanity. In punishment for every hair plucked, the Devil thrust a red-hot needle into your skull.

Her green gown must be the most recognisable garment in the whole history of dress. It has astonishing dimensions, and although she is already holding up quantities of the fabric, a heavy train still trails on the ground. (The replica made in 1997 by students from the Wimbledon School of Art as part of their 'costume interpretation' course required 35 metres of material.) Such excess angered moralists at a time when the poor wore rags. Regulations compiled in Bologna in 1401 decreed that no robe should measure more than 10 *bracci* around the hem (a *braccio*, or arm-length, was approximately 60 centimetres). The hem of the green gown would have been far longer than this. Apart from its exceptional volume, however, the garment was a conventional example of the full-sleeved, high-waisted dress which had come into fashion in the late fourteenth century, replacing the tighter-fitting clothes of the previous generation. The garment was first known as a *houppelande*, but this term was now out of date, having been replaced by *robe*, in the French of the Burgundian court, or gown in English.

The green gown was undoubtedly made from the famous woollen cloth spun from quality Spanish or English fleece and woven by the renowned Flemish weavers who produced fabrics as fine as silk or as thick as felt. It is clearly of the most delicate texture. It must have been cut from a circular pattern, because the front is just as long as the back, with a hole in the centre for the neck, and slits in the side for the arms. The sleeves are separate, made of rectangular lengths of material, and attached kimono-style, at the shoulders. There is a belt just below the bust which creates a high-waisted effect and helps to give the impression of a protruding stomach. This is a desirable feature, both socially and

visually, and is enhanced by the stance that artists give women. Fertility is a vital quality in a wife and many are in a recurrent state of pregnancy. Those who are not are failures. So a posture which emphasises the stomach, stressed by a high waistline and the folds of a voluminous gown, is the height of elegance. Arnolfini's wife may or may not have been pregnant, but van Eyck gives other definitely non-pregnant women the same profile. In *The Ghent Altarpiece*, the stylish Cumaean Sibyl wears a similar, sap-green gown and, like Arnolfini's wife, places her hand on the swelling curve of her high waist; the naked Eve also has a very prominent belly. St Catherine in the Dresden triptych has the long loose hair that indicates virginity, yet her stomach is so protruding she rests her prayer book on it.

The sleeves are as voluminous as the rest of the gown. Cut in the wide, trailing style known as 'bag-sleeves', they practically touch the ground. (Bag-sleeves were regarded as so decadent, quite apart from impractical, that Scottish peasants were banned from wearing them in 1430.) And van Eyck has made them even more prominent through their rich appliquéd decoration. This consists of a further layer of fabric cut and shaped into a fancy trim sewn in overlapping layers around the lower half of the sleeves. Called 'dagging' because the edges are stamped into the characteristic 'dagged' or zigzag outline, and cut into little shapes resembling Maltese crosses, the edges are deftly trimmed with pinking shears to stop them from fraying. Such ornamention proved how much time as well as fabric had been invested.

Yet it is all slightly out of date. The dagging of sleeves, hems and hats was a decoration the popularity of which peaked in the late fourteenth century, a time when such modish lavishness was feared to carry grave spiritual risks. Chaucer's moralistic Parson railed against 'so much dagging of shears, with the superfluity in length of the said gowns trailing in the dung and in the mire, on horse and eke on foot, as well of man as of woman' because it manifested the sin of Pride. And he pointed out that this was 'a waste of cloth in vanity' that should have been given to the poor. Prior William of Stranton went even further in his 1409 vision of

Purgatory, wallowing pruriently in the punishments threatening men and women who wore dagging and long hems: 'I saw the jagges [dagging] that men were clothed in turn all to adders, to dragons and to toads, and many other horrible beasts sucking them and biting them and stinging them with all their might.' As for 'women with gowns trailing behind them a long space . . . I saw the side trails cut off by the fiends and burned on their head.' But Arnolfini's wife had no need to worry about the afterlife because by 1434 dagging offended no one, except perhaps followers of fashion: the sleeve decoration proved that she was dressed very conservatively indeed and, despite the cost, was making no claims to be a style setter.

Nearly as outmoded as the dagging is the colour of her gown. While Arnolfini boasted the new black, his wife seemed to be locked in the previous century when bright colours like red, blue and green were the preferred options. Although, of course, van Eyck may have chosen the colour to provide a contrast with her husband's black and purple. Green dye was made from a combination of woad and the herb weld (Dyer's Yellow) and was easier to brew than fashionable dark shades. Green clothes did of course remain in use in the fifteenth century. Rogier van der Weyden painted a contemplative Mary Magdalene, wearing a very similar full green gown (1445, National Gallery, London). A contemporary English wearer was Margaret Paston who, in 1441, instructed her husband to buy cloth for a new outfit, otherwise 'I have no gown to wear this winter but my black and my green *a lyere* [cloth from Lierre, Brabant] and that is so comerus [cumbersome] that I am weary to wear it.' Blaming the great weight of the old gown was a fine excuse for a new one. (She also demanded a new girdle as her advancing pregnancy meant that the old one no longer fitted.) Selling Flemish cloth to English customers like the Pastons may have represented another aspect of Arnolfini's portfolio, as advertised by van Eyck, as an exporter as well as an importer: Flemish-woven woollens were in demand all over Europe.

Van Eyck painted another feature of the green gown as lovingly as the

dagging. The fur lining helps explain its bulk and further confirms the wearer's status as the wife of a wealthy man. Creamy fur can clearly be seen at the neck, hem and generously bordering the prominent sleeve openings. The whole skirt seems to be lined, not just trimmed at the lower hem, because more fur is visible behind the portion of the skirt she holds up, while the concertina folds of the train trailing on the floor look far heavier than if they were just wool. It is impossible to imagine the weight and warmth of the whole garment.

As linings for womenswear needed more furs, they were much more expensive than those used for men's shorter robes. Perhaps this was why they were so often made of squirrel. According to the complex hierarchies of use, the white fur called ermine (which came from the stoat) was reserved for the aristocracy, while lesser ranks used the plump winter coat of the squirrel, turned white as camouflage against the harsh snows of the far north. In the early fifteenth century, squirrel was still an important product in the fur trade but prices were starting to go down because its widespread use made it less attractive to the marten-preferring elite. (van Eyck gave his green-gowned Cumaean Sibyl a marten lining as proof of her high status.)

There were different types of squirrel fur, graded by the furriers according to colour and quality: *gris* was the back, *vair* the alternating bands of grey and white from the softer belly, *minever* was white belly fur with a faint edge of grey, *pured minever* had all the grey trimmed away. The whole skin was divided into these separate sections, which the furriers then stitched with silk threads into conventional sizes and lengths. This was all done according to the high standards that the guilds set and monitored. In Bruges, for example, it was decreed that no *minever* hood should contain less than 30 skins.

The lining for a woman's gown required at least 600 skins, but a really full one, as in the painting, might use as many as 2,000. The flatter belly fur, *minever*, was the best. When Philippa of Lancaster, daughter of Henry IV, married the King of Denmark in 1406, her wedding robes were lined with 2,114 skins of *pured minever*, together

with thirteen of ermine to edge the sleeves. Her outfits included another five *minever*-lined gowns. The Duchess of Bedford (who was the Duke of Burgundy's sister) had a green woollen *houppelande* made in Paris in 1421 lined with 2,000 pieces of *minever*. The trousseau of the Duke of Savoy's daughter, on her marriage to the Duke of Milan in 1426, included twelve fur-lined gowns. Even her nightwear, a short-sleeved gown and a cloak, were cosily lined with *gris*. One way for the nobility to look expensive while secretly economising was to have the unseen part of the lining made in *gris*, reserving ermine only for the visible cuffs and neck. Fur linings aroused as much disapproval as dagging: Chaucer's Parson listed among the sins of Vanity 'the costly furring of their gowns', and clad his worldly Monk in 'sleeves rounded at the hand / With *gris*, and that the finest in the land.'

Beneath her green gown, the woman wears a long-sleeved underdress, another mode which reflects the styles of the previous century when close-fitting garments were the norm. This is bright blue, in some sort of textured fabric which might be crushed velvet or patterned damask; van Eyck has gone to some pains to suggest a rippling, slightly uneven surface. It too has fur at the hem, though surely cannot have been lined throughout. This fur trim is whiter than that on the gown, and might represent the *pured minever* that was paler than *gris*, or perhaps *lettice*, the winter coat of the weasel. These were both more expensive than *gris*, and therefore more suitable for hem-trimming than for the whole lining. The tight blue sleeves are clasped at the wrist by little braided cuffs decorated with interlacing patterns in pink and gold (echoing her husband's black and silver cuffs). Such braids were made of silk and gold threads imported from Italy, where the different cities all boasted distinctive techniques. Margaret Paston referred to 'gold of Venice' and 'gold of Genoa', when ordering quality thread for her embroidery. Lucca produced its own versions of luxury braid too, so this was probably another advertisement for Arnolfini's wares. The costume's final detail is the belt, essential to pull the green fabric into the desirable high-waisted effect. Clasped just below the bust, it is made of gold-embossed leather, geometrically

patterned with intersecting diamond shapes and borders decorated with little squares.

Her feet are hidden by folds of fabric so copious that she gives the impression of being unable to move. Yet there is a pair of sandals on the floor behind her, not neatly parallel but splayed out in a very natural way, as if she has just stepped out of them to pose for van Eyck. They are as beautifully made as the rest of her outfit, and are the one fashionable element of her ensemble, a relatively recent type of open sandal developed from the basic patten shape. Made of red leather delicately ornamented with three rows of tiny brass studs, they are fastened by broad leather straps across the instep attaching in the middle with brass buckles. Dyed leather was another luxury, and the shades worn by the couple – the purple of his boots and the scarlet of her sandals – were the hardest colours to achieve. The red was almost certainly made from Brazilwood, an imported dye from the redwood sappan tree that grew in India. Its heartwood or pods were chopped up and simmered to produce a strong, permanent red that dyed skins and hides. (Brazilwood gave its name to the richly forested Portuguese colony in South America rather then vice versa.) With the embellishment of the shiny brass studs, the sandals must have been very expensive, a status symbol as prized as Louboutins or Jimmy Choos today.

A merchant's wife was in a difficult position. The genteel French author Christine de Pisan wrote an etiquette manual for women in the early fifteenth century, bemoaning the increasing blurring of social boundaries and urging bourgeois wives not to go too far. She warned them against trying to dress like young noblewomen: wearing extravagant and ultra-fashionable clothes would damage their reputations by proving them vain and frivolous and, worst of all, by showing up their attempts to attract young men. (Social grounds argued a different case for restraint. In Florence, in 1433, there were calls to prevent women from threatening the very fabric of society by dressing too extravagantly because young men, reluctant to pay for such clothes, were refusing to marry.) However, she did concede that the expensive, showy clothes of women married to very

rich Italian merchants in Lucca, Venice or Avignon were more acceptable worn in those places than in France, because they were at least demonstrating their husbands' professional status.

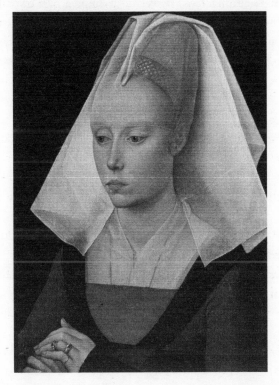

Rogier van der Weyden, *Portrait of a Lady, c.* 1460

As if to avoid potential criticism, the jewellery of husband and wife is restrained, though still undeniably costly. He wears one ring only, on the third finger of his right hand, which appears to have a raised bevel as if it contains an inset cameo or seal. She has two plain gold rings on her left hand, one placed near the tip of her fourth finger, and the second halfway down her little finger. This does not necessarily mean that the rings did not fit, and may just have been a custom. The lady in van der Weyden's *Portrait of a Lady* (*c.* 1460, National Gallery of Art, Washington)

wears a ring which sits just below the joint of her finger, while his other *Portrait of a Lady* (*c.* 1460–9, National Gallery, London) has two rings above her finger joints. Round the neck of Arnolfini's wife is a double-stranded slim gold chain crafted from droplets of filigree. van Eyck knew at least two men who might have created such a lovely object. One was Jan de Leeuw, a prominent member of the Bruges goldsmiths' guild, whose portrait he had painted; the other was John Peutin, the duke's own goldsmith.

3. Courtier, Ambassador, Spy:
Don Diego de Guevara

The first owner was the man who commissioned the painting from van Eyck. His aim was to make a statement about himself and his wife for the benefit of the select group privileged to see it. van Eyck's aims, in contrast, would have reconciled flattering his patron with demonstrating his own distinctive talents – not necessarily the same thing. Whether or not the patron's name was Arnolfini can never be known for sure but the circumstantial evidence is, at the very least, worth considering, and is generally accepted in this book. There are no problems, however, in identifying the painting's subsequent owners, for it has an excellent pedigree. Catalogued, or itemised, as it passed from one collection to another, the work was found sufficiently interesting and curious to attract the comments of those who saw it and even those who had merely heard of it by reputation. Yet there is a shift in the response to it over the generations: the portrait remained a prized possession, but was valued for differing reasons. Like the mirror at its heart, it reflected changing times and changing attitudes.

The first recorded owner was Don Diego de Guevara, a Spaniard by birth who spent most of his working life in Flanders serving the Habsburg

dynasty which succeeded the Dukes of Burgundy. In the late fifteenth century, the ruling houses of the Netherlands and Spain became inextricably linked because of a drastic shortage of male heirs. Although van Eyck's employer, Duke Philip the Good, produced many bastards, his only legitimate son, Charles, was killed in a battle in 1477. Like his father, Charles married three times but had only one heir, a girl, Marie. Her grandfather, Duke Philip, allegedly refused to attend the baptism of this first grandchild because she was female. Aged only nineteen at her father's death, the orphaned heiress hastily married the Archduke Maximilian, son of the Holy Roman Emperor Frederick of the Austrian Habsburg family. They had a son, Philip 'the Handsome', and a daughter, Marguerite. Maximilian succeeded his father as emperor, but Marie died at the age of twenty-three after a riding accident.

Sometime in the 1490s, Don Diego de Guevara entered the household of the young Archduke Philip, sole heir to the Burgundian and Habsburg dynasties, and he served the family for the rest of his life. His name is just a footnote in the history of the Arnolfini portrait but if he had not acquired it and then given it to the Regent of the Netherlands, it could have disappeared without trace.

The Guevaras of Santander in Castile were an aristocratic family with distant royal connections: Inigo de Guevara attracted the rare favour of van Eyck's patron Duke Philip the Good, who made him the first Spaniard to join the exclusive chivalric Order of the Golden Fleece, which Philip founded in 1429 as part of his wedding celebrations. His kinsman, Don Ladron de Guevara, and Ladron's sons Diego and Pedro, decided to carve out careers in the lucrative service of the wealthy Duchy of Burgundy rather than in bleak and barren Iberia. For ambitious young men, the restrictions and insecurities of isolated Spain offered far less opportunity than the urban Netherlands. (One example of the clash of cultures was that the proud, reserved Spaniards viewed the locals as easy-going drunks.) Ladron worked for Philip's son, Duke Charles, then served his widowed duchess, the English princess Margaret of York, before becoming chamberlain, councillor and ambassador to the Emperor

Maximilian. His sons found employment in the service of Maximilian's son Archduke Philip: in 1495, Pedro de Guevara was a member of the motley fleet that attempted to invade England under the pretender Perkin Warbeck, whose claim to be Duke of York and rightful English king was maliciously backed by Maximilian, Margaret and Philip in their campaign to destabilise the usurping Tudor, Henry VII. The Guevaras all profited from the royal marriage treaty of 1494, which for two years Ladron had worked to accomplish in Spain, and which linked the families of the Emperor Maximilian and of the Catholic monarchs Ferdinand and Isabella.

According to the archduke's household ordinances of 1496, Don Diego de Guevara was one of twenty-six *'écuyers tranchants'* or 'esquires of the carvery'. The household consisted of several hundred staff, all ranked according to the minutest nuances of Burgundian etiquette, from *maistres d'hostel* (chamberlains) down to the humblest scullions and stable boys. *Écuyers tranchants* were in the upper echelons, ranked after *pannetiers* (gentlemen of the pantry) but before *écuyers d'écurie* (esquires of the stable). Diego and his colleagues did not really sully their hands with food or straw because they were all *gentilhommes* and there were real servants to do the dirty work: their job titles were the fossilised record of the past functions of the Burgundian dukes' retinue. Their role now was to attend the archduke and accompany him on the elaborate 'Joyous Entries' that marked his progressions from city to city. There were plenty of *écuyers tranchants*, who were divided into two teams of thirteen, each attending Philip for six months. Diego was sufficiently senior for his name to head the January to June team. He had done well, because Spaniards were very rare at court, and regarded with suspicion.

These elaborate household ordinances were based upon the long-established traditions of the Burgundian court, preserving the exquisitely refined etiquette of an earlier generation that Aliénor de Poitiers also sought to protect in her strictures on bed hangings. As in the days of van Eyck, over fifty years earlier, everyone had their proper place, from *varlets de chambre* upwards; this provided an established career ladder for the

ambitious like Don Diego. Archduke Philip's mother, the late Marie of Burgundy, had gravely diminished her son's inheritance by yielding many of the duchy's powers to the French and to the sturdily independent Flemish towns. But his marriage to a Spanish princess, the Infanta Juana, third child of Ferdinand and Isabella, could elevate him from a duke to a king. This was the scheme of his wily father, the Emperor Maximilian. Furthermore, it was part of a dual deal in which Philip's sister Marguerite married Juana's brother, the heir to Spain, epitomising Maximilian's policy of extending Habsburg influence by weddings rather than wars. Don Diego, a native Spaniard now fluent in French, and a loyal Habsburg servant experienced in etiquette and in discretion, played a vital role as the intermediary between two very different cultures.

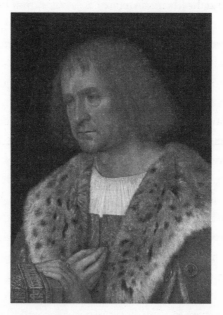

Michel Sittow, *Don Diego de Guevara*, c. 1515

The ever-impoverished Maximilian decreed that the fleet and huge train which escorted the Infanta Juana from Spain to Flanders for her wedding in the summer of 1496 should be reused to take Marguerite

and her entourage back to Spain that winter. Diego was appointed one of her escorts. Among his colleagues was Jean de Bourbon, who wrote an account of their eventful journey (and complained that he had to buy lengths of silk himself to provide a smart new wardrobe – presumably Diego had to do the same). They sailed from Flushing in January 1497, just the wrong time of year, and the weather was predictably so bad that the fleet had to shelter in Southampton harbour for three weeks. This generated unctuous letters from Henry VII to Marguerite, about to become his kinswoman because his elder son Arthur was betrothed to Ferdinand and Isabella's younger daughter Catherine. Spain, England, the Netherlands and the empire were being linked by a tight network of marriage alliances that surrounded and excluded France, their mutual enemy.

Marguerite and her armada reached Santander, Diego's family home, in March 1497. From there they travelled to Burgos where she was married to the Infante Juan with huge pomp and ceremony. Diego then returned to Flanders (with a gratuity of 200 ducats from Juan for his expenses), to rejoin Philip and Juana's household as Juana's *maistre d'hostel*. He was probably relieved to escape from the rigid formality of the Spanish court to the more relaxed ambience of Ghent or Bruges, unlike poor Marguerite banished to Spain, and warned she would have to modify her dangerously open behaviour to accord with her new surroundings. Yet Diego had to be a cultural chameleon, because the presence in Flanders of the devout Juana and her sombre retinue was starting to make Spaniards unpopular. Diego's burgeoning interest in Flemish art may have been one way of declaring his loyalty to the north, as well as demonstrating his prosperity. And he became involved with a girl in Brussels, who gave birth to their illegitimate son in 1500, naming him Felipe after the archduke. He also had a daughter by another local woman.

Don Diego witnessed a dramatic rise in his master's prospects of ruling Spain as the heirs of Ferdinand and Isabella died in quick succession: first Juana's brother, then her elder sister, then the latter's infant son. By 1500 Juana and Philip were next in line to the throne. To establish a presence in Spain, and comply with Ferdinand and Isabella's desire to make

their son-in-law seem more Spanish and less Netherlandish, the young couple set off in September 1501 on what was a royal progress from Brussels to Granada. Don Diego accompanied them. The latest edition of the household ordinances proved that he had climbed right up the greasy pole and achieved the highest position in the ducal household, *maistre d'hostel*, or chamberlain, to Archduke Philip. Four men shared this elite rank, the most senior being Philip, the Bastard of Burgundy (sired by Duke Philip the Good at the age of sixty-eight), and ranked next to him was Don Diego de Guevara, Seigneur de Jonvelle. (Jonvelle was an estate in Franche-Comte, a region to the east of Burgundy which had fallen into Habsburg hands; Diego inherited the title which Maximilian had awarded to his late father Ladron.)

The courtier Antoine de Lalaing compiled a wonderfully detailed account of their journey. They travelled by land, taking advantage of an unusual phase of reconciliation with France. The new king, Louis XII, not only offered safe conduct but provided a spectacular welcome to celebrate the new rapport between former enemies. This was not, of course, altruistic because it was meant to remind Philip of his subservient role as a vassal of France, while also securing the friendship of the future rulers of Spain. They reached Castile in February 1502 and stayed for over a year, a time of growing tension between Philip and his devious father-in-law Ferdinand who, now anticipating the death of his sick wife Isabella, threatened to remarry and produce new heirs to supersede the Burgundian–Habsburg line. Diego's services to all parties were invaluable. He attended a banquet that Philip held for Ferdinand in the summer of 1502, when he was presented with a generous sum of money for his services to Juana. Queen Isabella paid him 75,000 *maravedis* (an Iberian unit of coinage) in September, and in December Philip and Juana gave him 400,000 *maravedis*. Such rewards help to explain why men like Diego were so anxious to serve in royal households, and could afford to buy paintings.

After much ill will over the succession, Philip and his retinue returned to Flanders in July 1503, leaving the heavily pregnant Juana behind like a

hostage, to join him after the birth. Diego went with him, returning in the spring of 1504 to escort Juana back to Flanders, minus the new baby whom Ferdinand insisted on retaining as a hostage. Queen Isabella used Diego as a continuing discreet supporter of Castilian affairs, for she gave him more money and, a few months before her death in 1504, signed a mandate to pay him 200 ducats a year while he was in Flanders.

Keenly anticipating his expectations of the Spanish crown, Philip promoted Diego to become his own most senior *maistre d'hostel* and a trusted councillor. Philip and Juana set off from Flanders for Spain in January 1506 to claim Isabella's kingdoms before Ferdinand could persuade the Cortes to revoke their decision. Diego and his brother Pedro were crucial members of this entourage, undoubtedly among 'those around her brother who had turned his head' as Marguerite apologised to her father-in-law Ferdinand for Philip's arrogant behaviour. As the French alliance had already broken down, the party travelled by sea in an ostentatious fleet of over thirty vessels containing around 3,000 men. But winter storms battered them and many ships were lost. Diego's own ship went down, but he survived. (Philip was reported to have worn an early sort of life jacket, an inflatable leather garment labelled 'Philip, King of Castile', even though the title was not yet confirmed, for easy identification in case his body was washed up.) They limped into harbour at Plymouth, to be welcomed by Henry VII who, like a spider catching flies in its web, detained his increasingly desperate guests for almost three months until Philip had agreed a treaty of friendship including promising to marry his sister Marguerite to the ageing monarch.

When they finally reached Spain, Don Diego came into his own as Philip's ambassador and spy at Ferdinand's court. He was the ideal, and probably the only, man for the job. As a native Spaniard, he could communicate directly with Ferdinand and his advisers, who had little French; but he was also fluent in French, the language spoken by the Burgundian court. In his person, he epitomised the struggle between the Netherlands and Spain, between the land of his career and the land of his birth, and his loyalties must have been severely torn. His efforts

to mediate between two very difficult men – his employer, the ambitious, arrogant Habsburg archduke who was desperate for a crown, and his employer's crafty father-in-law, determined not to yield an inch of his own powers – were driven by a desire for peace, but also by the prospect of very great rewards.

During two tense weeks in June 1506, Don Diego had a series of meetings with Ferdinand, whose former supporters were increasingly deserting him for the Habsburg party, and reported back to Philip almost daily, giving measured and tactful advice in a precarious situation. Diego instructed the intransigent, greedy prince as firmly as he dared, warning Philip to think hard before declaring war on Ferdinand, and begging him to be more polite to his potential supporters, the touchy Castilian grandees: 'kind words cost nothing'. He also advised Philip to scotch the rumour that he was holding his wife Juana a prisoner (which he was) by immediately parading her in public.

Don Diego also won the trust of Philip's father-in-law and managed to negotiate a meeting between the two sides. One of his letters contained a PS: during their last encounter, when Ferdinand had received a message from his new wife, the French king's niece, 'he gave the greatest sigh in the world, cursing the hour he had even chosen her – he wishes she was in the middle of the sea'.

As the direct result of Don Diego's smooth negotiating, on 27 June 1506 Ferdinand and his 'very dear and most beloved son-in-law' Philip signed the Treaty of Villafranca, which handed over Isabella's kingdoms of Castile, Leon and Granada to Philip and completely bypassed the rightful heir, his wife Juana, on the grounds of her alleged madness. 'Considering her maladies, passions and other behaviour', she had supposedly declined the role, otherwise the 'total destruction and perdition of these kingdoms' would follow. So Don Diego had helped prevent civil war and won Philip's confirmation as king, although at the expense of Juana's status and apparent sanity; he backed the Habsburg, not the Spanish side. Reward followed soon. In August, Philip appointed him governor of the fortress of Carthagena, and gave him 400,000 *maravedis*. His brother,

Pedro de Guevara, recently released after being arrested by Ferdinand for spying, received similar prizes.

The Habsburg triumph ended prematurely. In September, Philip suddenly died – of a fever, it was reported, but there were inevitable rumours of poison (Ferdinand? Juana?) and suddenly the Netherlanders had no place in Spain. The majestic funeral ceremonies included a procession of Philip's *gentilshommes*, carrying items that belonged to the late prince: Don Diego bore his *'cotte d'armes'*, the garment he wore over his armour. Diego and other senior members of the household divided up Philip's valuables with unseemly haste – the jewellery, priceless tapestries, ostentatious silverware, all the status symbols that were meant to demonstrate his majesty in Spain – for safety and for keeping out of Spanish hands as they scrabbled to leave the country. The Cortes (representative assembly) appointed Ferdinand regent of Castile on behalf of his grandson Charles (Philip and Juana's eldest son). It was reported that Don Diego had unsuccessfully tried to retrieve Philip's younger son, whom Ferdinand was bringing up as a proper Spanish prince, from the castle at Simancas but the crowd turned upon him. The Flemish party had a dangerous return journey through Spain, dogged by illness and the absence of safe conducts. Diego was responsible for the safe custody of the silver casket that contained Philip's heart and brains extracted when his body was embalmed for burial in his native Flanders. This final mission succeeded, for the casket survives today in the church of Our Lady in Bruges, in the tomb of Philip's mother Marie of Burgundy.

Don Diego had lost one master but immediately gained another when Maximilan appointed him councillor and *maistre d'hostel* to Philip's eldest son and heir, Charles, then aged six (the same age as Diego's own son, Felipe). Despite the alleged mental instability which had resulted in her convenient incarceration in Spain, the Infanta Juana had performed well as the mother of Habsburg heirs. She and Philip produced six children. The two youngest remained in Spain, but Charles and his three sisters were brought up in Mechelen in Flanders by their childless aunt Marguerite,

whom Maximilian had summoned from mourning her late husband to become the children's guardian, and governor of the Netherlands in Philip's place.

Diego worked closely with Marguerite, who used him as a trusted diplomat in the most delicate negotiations. In September 1507, she and the Estates of Flanders sent him to England to seek Henry VII's support against the French king's threatened invasion. There was also gossip that he was there to negotiate the marriage between Henry and Marguerite which Philip had promised, though at the same time Henry was putting out feelers for the widowed Juana. De Puebla, the Spanish ambassador to England, reported to Ferdinand that Henry's response to Diego's request for help consisted only in evasive assurances of friendship.

It was fitting that such an important man, as he advanced from lowly esquire to senior diplomat and ambassador, should cultivate an interest in art. According to Felipe, Diego commissioned portraits of himself from 'Rugier' (Rogier van der Weyden), and 'Michiel' (Michel Sittow), artist to the courts of Europe. The Sittow portrait hangs today in the Washington National Gallery of Art. Its format, the devotional diptych, was a popular type in the Netherlands because it combined conventional piety with a modern, realistic image of the patron. It depicts an eminent man in middle age, the furrowed brow and deeply etched facial lines suggesting a long life of devotion to duty and the narrow, pursed lips hinting at an underlying ruthlessness. There is a touch of vanity in the way he has attempted to disguise his thinning hairline with a straggly fringe. Deliberately inserted is a reference to his membership of the ancient Castilian Order of Calatrava. Sittow has added its cruciform emblem, woven into the intricate pattern of his richly brocaded doublet, after starting work on the portrait. Over his doublet, Don Diego wears a robe whose magnificent striped and spotted fur collar is made from the Iberian lynx, perhaps a further reference to the land of his birth. Another luxury item is the oriental rug covering the sill before him, on which he rests a ringed hand.

The painting (the portrait is one panel of a diptych, whose other

subject is the Virgin Mary, the object of Diego's devotion) was also an acknowledgement of status because only the rulers and the rich had themselves portrayed praying to a saint or the Madonna in this way. Diego would have seen many suitable models in the court circles where he moved. The choice of artist was also significant, for Sittow had a prestigious reputation – he had trained in Bruges, was Queen Isabella's official painter in Spain, then worked consecutively for Philip the Handsome, Marguerite and Charles V.

As well as commissioning paintings, Diego collected them. Behind his image of prosperous piety lay a life of ambition, cunning and loyalties divided between his native country and his adopted country. Buying a work by the great Flemish painter Jan van Eyck, and later presenting it (possibly as a bribe or a reward) to a Habsburg ruler, was typical of how Don Diego had reached the top in his chosen career. At some time in the first decade of the sixteenth century, he acquired the Arnolfini portrait and had his family arms and motto – '*hors du conte*' – inscribed on the shutters which then protected the masterpiece. He may have bought it directly from a member of the Bruges-based Arnolfini clan, for the Lucchese merchants dealt on occasion in paintings and illuminated manuscripts in addition to luxury fabrics and other products. If the man and woman whom van Eyck portrayed had left no children, the heirs to their worldly goods might have felt less compunction about keeping the painting. Selling desirable commodities to those who wanted them was what merchants did. A work actually signed by the famous 'Johannes de Eyck' was of great value to a connoisseur like Diego who proved his interest in the Flemish master by acquiring a second piece by him, the *Portrait of a Portuguese Lady*. Possibly, this was the product of van Eyck's 1429 trip to Portugal to make the likeness of the Duke of Burgundy's bride-to-be, for it was uncharacteristically painted in tempera on cloth, more convenient for travelling than oil on boards.

Don Diego continued to serve on sensitive missions. When Charles reached his majority in 1515, he sent Diego to England on a goodwill

embassy to the next English king, Henry VIII, warning his ambassador to gloss over the embarrassing fact that his long-planned marriage to Henry's sister Mary had been broken off. But he was being watched. The English ambassador in Flanders warned Henry VIII of alarming rumours about Diego's anti-Tudor, pro-Yorkist stance. The ambassador also wrote to Henry's chief adviser, Cardinal Wolsey, to urge that the king 'observe his accustomed serenity and prudence towards Don Diego de Guevara. He is a subtle fellow.' And he passed on secret information that Diego intended to visit the Duke of Buckingham, one of Wolsey's enemies. The Spaniard was clearly seen as a force to be reckoned with. In 1517, when he accompanied Charles to Spain to claim his southern inheritance after Ferdinand's death, Charles appointed Diego as one of the receivers of royal revenues for Castile, at an annual salary of 300,000 *maravedis*, a post perceived as so lucrative that Diego sold it on for 5,625,000 *maravedis* two years later. This was one way for the shy, inarticulate young king, who understood barely a few words of Spanish, to acknowledge his gratitude to the Guevara family.

Diego did not remain in Spain with Charles, but after more than twenty years' service he was at last permitted to retire. He returned to the Netherlands in 1519 and died in Brussels in December 1520. His burial in the church of Notre-Dame de Sablon was as magnificent as that of a prince. The coffin of gilded copper was laid in the choir in front of the great altar. The church was a fitting choice for this loyal servant of the Habsburgs since it was illuminated by magnificent stained-glass windows showing Philip and his family, which the archduke had presented in 1503, and other windows commissioned earlier by Duke Philip the Good. The glass included portraits of leading figures of the day, so Diego hoped to spend posterity in the same distinguished company he had known in his lifetime. Charles even came to the aid of Diego's son Felipe, now himself a member of the royal household, by overturning Pedro's challenge to Diego's will that left everything to Felipe. There is no surviving catalogue of Diego's possessions, but the inventory of the art collection of Marguerite of Austria, ruler of the

Netherlands and the most powerful woman of her day, proves that by 1516 he had given her both the *Portrait of a Portuguese Lady* and the Arnolfini portrait.

The Beads and the Brush

Those who saw the painting might have thought two other items to be accessories of the woman rather than the man – the beads and the brush which hang on the back wall on either side of the mirror. Like everything else in the portrait, they have more than one meaning. The string of amber prayer beads is a paternoster (named after the opening words of the Lord's Prayer, 'Our Father which art in Heaven'). The Bruges guild of paternoster makers produced many sets, so van Eyck was perhaps taking the opportunity to celebrate another local industry, as well as advertising a different element of Arnolfini's import–export business, supplying a characteristically northern product to southern Europe. At the same time, the beads symbolised the woman's piety, and were an appropriate gift from husband to wife. In mid-fifteenth-century Lübeck a paternoster was the standard present from a bridegroom to his bride.

The beads in the painting are not joined in a circlet, like a necklace, but are one long strand. Loosely strung to aid the counting and sliding process of praying, they hang asymmetrically over a nail in the wall. Apart from their religious significance, they illustrate van Eyck's constant fascination with the brilliant effects of gemstones. He has painted the amber

so transparent that it reveals the green silk thread running through the centre, terminating in long soft tassels at either end. It is difficult to work out the number of beads because they seem to reflect each other, the light bouncing off the wall behind and creating the impression of a virtual third strand. These are not the work of van Eyck's imagination but further proof of the analytical power of his vision. There seem to be thirteen beads hanging to the right and sixteen to the left, suggesting a possible total of thirty, one of the standard figures for a set. Prayer beads were strung in familiar permutations which corresponded to Christianity's complex number symbolism – three for the Trinity, five for Christ's Wounds, seven or fifteen for the Joys of Mary, even 150 for the number of the Psalms. Few numbers lacked significance, but paternosters most frequently contained thirty or fifty beads.

They were an essential element of private worship. Reciting prayers compensated for not being able to read (a condition that affected many lay clergy as well as ordinary men and women), and the more times you repeated a prayer, the better it was for your soul. As it was hard to remember the number of repetitions, people kept count by sliding beads along the strand in their hands. In van Eyck's day, the term paternoster referred to all prayer beads, though in an age of the cult of the Virgin, the female alternative to the Lord's Prayer was to recite the Ave Maria. Later in the century the beads were called rosaries, the name derived from the image of the Virgin in an enclosed rose garden: the circle of beads echoed the perfect circle of the rose.

By 1420, the Bruges guild of amber-paternoster makers had seventy masters, and more than 300 apprentices and assistants, and the bilingual phrase book the *Livre des Mestiers* listed among typical local craftsmen Walter the paternoster maker, who sold beads of amber, crystal, glass and horn by the dozen. (In London, the street names Paternoster Row and Ave Maria Lane still commemorate the prolific medieval industry.) Although beads could be made from the humblest materials, such as fruit pips, wood or bone, most people preferred something more precious. Yet paternosters that were too ornate ran the risk of being perceived as a

fashion accessory rather than a devotional aid and, as such, attracted sumptuary legislation. Later in the century, Leipzig maidservants were banned from wearing rosaries made of coral while an earlier offender was Chaucer's vain Prioress who flaunted a pretty coral paternoster, from which hung a gold brooch bearing the ambiguous motto, 'Love Conquers All'. The Burgundian court naturally chose the luxury option. On his death in 1467, Duke Philip left his son no fewer than thirty-five paternosters of gold, jet, chalcedony, coral, crystal and amber. He might have inherited some of the latter from the first duke, Philip the Bold, who owned several amber sets. If amber was good enough for the ducal family, that made it more than acceptable for the Arnolfinis' reception room, whereas gold or chalcedony might have been a little ostentatious.

Amber was a magical hard stone (vegetable, not mineral) whose tones and transparency ranged from deep orange to an opaque, milky white. Beads were shaped from chunks gathered from the shores or fished from the icy waters of the Baltic and were a local product par excellence. The origins were a mystery. Guicciardini, an Antwerp-based Italian merchant writing in the late sixteenth century, tried to explain:

> *Amber is a juice not of a tree, but of a stone which groweth like Coral in a mountain in the North Sea clean covered with water . . . when any tempest ariseth in the North Sea especially in September and December, this liquor by violence of the sea is rent from the rock and cast into divers havens and upon divers sea coasts where the people gather it, to the great commodity of divers princes . . . Amber being taken out of the water hardeneth like to coral, neither is this amber found elsewhere but in those seas only.*

He was nearly right. Amber is the fossilised resin of ancient conifers embedded in the strata of the prehistoric forested land mass subsequently swamped by the Baltic and Arctic Seas. Storms, as Guicciardini noted, broke fragments off and washed them ashore, while some daring fishermen even took to the water with nets and pronged poles to prise it out from under the rocks. This was a very risky procedure in the fourteenth and

fifteenth centuries when amber was the monopoly of the Order of Teutonic Knights, who punished unlicensed gatherers by hanging them from gibbets placed prominently along the shoreline. The 'Amber Knights' sold their precious commodity to the merchants of the Hanseatic League, the trading alliance of Northern Europe, who shipped it to their main centres, especially the Bruges warehouse they established in 1411. This became the focal point of the whole amber trade, replacing the previously dominant centre of Lübeck. From Bruges, amber was shipped south, west and east, both as raw lumps and as finished products. By filing and smoothing, polishing with a paste of ash or chalk, then perforating with a sharp metal point, the craftsmen of the amber guilds transformed these mysterious stones into the sparkling, translucent miniature globes of the type that hang on the Arnolfinis' wall.

The beads were also there as a recurrent device for painters to indicate the virtue of their owners. Many contemporary works contain examples in amber and in other materials. In van Eyck's *Virgin of the Fountain* (1439, Antwerp), the infant Jesus holds a tasselled string of coral beads, while the posthumous *St Jerome in his Study* (1442, Detroit), attributed to van Eyck's workshop, shows an amber, green-tasselled paternoster hanging from a shelf. In fellow Fleming Robert Campin's *Merode Altarpiece* (1425, Cloisters, New York), the patron's wife holds a coral string, while his *St Barbara* (1438, Prado, Madrid) carries a string in some other material. Campin's pupil Rogier van der Weyden placed a tasselled string of dark amber beads in the background of his *Magdalene Reading* (1438, National Gallery, London); one of the figures in his *Adoration of the Magi* (1455, Munich) holds a coral set. So the paternoster seemed to be a device promoted by this pioneering group of Flemish realist painters to give a touch of authenticity that linked the everyday world to that of the Bible.

Also on the back wall, a Martha to the beads' Mary, hangs a brush suspended from a nail in the wall immediately beside the chair by the bed. Made from the softest of twigs bound together at the top by coarse pink thread to form the handle, its presence in the formal reception room was an artistic device rather than a depiction of reality. An almost identical

example hangs in the chamber of the Virgin in Campin's *Annunciation* (Brussels), painted in the 1420s, and a work van Eyck might well have seen in Campin's workshop in Tournai, a town he visited in 1427 and 1428. Campin was the first artist to paint the Virgin in a modern domestic setting, thus establishing a model for the Flemish tradition of showing biblical characters in contemporary settings and so imbuing ordinary furniture and accessories with new symbolic connotations. A brush, a basin and a towel represented the Virgin's industry and humility. (In *The Ghent Altarpiece*, van Eyck placed a brass basin and a towel in the background of the Annunciation Virgin.) Such a brush would have had the functional role of keeping clothes clean, but it also represented the virtue of Christ's Mother.

4. La Grande Mère de l'Europe:
Marguerite of Austria

D iego had known Marguerite, daughter of the Emperor Maximilian and sister of Philip the Handsome, since he accompanied her on her wedding trip to Spain in 1497. The catalogue of her collections, compiled in her presence in July 1516, named the Arnolfini portrait as the first entry in a long list: 'a large picture which is called Hernoul-le-fin with his wife within a room, which was given to Madame by don Diego, whose arms are on the cover of the picture. Made by the painter Johannes.' Safety must have been an issue when rulers travelled with all their precious possessions, for a note in the margin added that 'it was necessary to put on a lock to shut it; which Madame ordered to be made'.

Perhaps it was a present for favours received or in hope of good things to come in an age of bribes and sweeteners, when one of the perceived roles of a ruler was to award places and pensions to endless petitioners. There was just such an occasion in January 1513, when the Emperor Maximilian requested Marguerite to find a position in the service of the three young princesses, her wards and nieces, for the niece of 'our friend and loyal chevalier, the councilor and *maistre d'hostel* to

Archduke Charles, don Diego de Guevara'. Maximilian added that the girl was the daughter of Diego's brother and that she was aged thirteen or fourteen. Marguerite had little choice in the matter, because, as her father pointed out, he had already promised this to Don Diego, who naturally expected him to keep his pledge. (Another usefully connected young girl who joined Marguerite's household in 1513 was Anne, daughter of Sir Thomas Boleyn, the English envoy who had charmed Marguerite with his winning ways. Placing your daughter at this highly cultivated finishing school was an excellent way of of widening her horizons and improving her marital prospects.)

Keeping in the good books of Marguerite, Regent of the Netherlands, would certainly include making presents of artworks, for she was an avid collector with a keen eye who was turning her court in Mechelen into a centre of culture. For her, art was both a political statement and a source of pleasure. She combined the acquisition and display of works which referred to her distinguished family and its allegiances with genuine appreciation and taste. Her art inventories make constant value judgements – a fine painting, a very fine painting, very well made – undoubtedly expressing the opinions and sensibilities of a talented woman who herself painted and composed music and poetry, and who personally supervised the compilation of the catalogue. Collecting art was not just a leisure interest but a vital element of her persona as a leader. For her, van Eyck's significance was his status as the famous painter who had been in the service of her glorious great-grandfather Duke Philip the Good in the Burgundian Golden Age which she sought to recreate in far more turbulent times. The Arnolfini portrait was a fine product of that era. But the picture of a staid married couple may also have meant something more personal to a woman who by the age of twenty-four had been married three times, rejected by her first husband and widowed by the next two.

Marguerite of Austria was the ultimate princess pawn. She lost her mother, Marie of Burgundy, when she was still a baby, then her father Maximilian betrothed her to the son and heir of the French king, and sent her, aged three, to France to be trained and educated as befitted a

future queen. Here she was married to the twelve-year-old Dauphin, and did become Queen of France at the age of four when her husband, Charles VIII, succeeded his father. But seven years later he dissolved their union in order to marry a more strategic candidate. (Expedient dissolutions were not unusual, as long as the marriages remained unconsummated.) Marguerite then spent two humiliating years in France until Maximilian eventually let her return to the Netherlands. She was only thirteen.

Two years later, he brought her into play again as part of his new double alliance with Ferdinand and Isabella: by marrying their only son, Marguerite, former queen of France, would become the future Queen of Spain. But this marriage only lasted for six months, because her delicate husband, the Infante Juan, died suddenly in the autumn of 1497. Marguerite was already pregnant but lost the baby in the shock of her grief. Again, it was a long time before she could leave, because Ferdinand haggled over her dower settlement and Maximilian had no immediate need for her. In 1501, however, he married her off to a new candidate, his ally, Philibert, Duke of Savoy. The young couple seemed fond of each other but produced no children. This gave the energetic Marguerite the opportunity to become the true ruler of Savoy, for her husband preferred to hunt and play. This happy state only lasted three years, as Philibert died unexpectedly in 1504. Marguerite flung herself into widowhood, cut off her golden hair and vowed to devote herself to the pious rebuilding of the family church of Brou, where he was buried. She had her motto carved all over the church: *FORTUNE. INFORTUNE. FORT. UNE.* It implied that 'fate was very cruel to women'.

But it was also fate, in the form of her brother Philip's death in 1506, that brought her back into the wider world and made her such a dominant female leader, *La Grande Mère de l'Europe*, as she was called. Philip's son, the archduke Charles, was only six, so the States General of the Netherlands appointed his grandfather, Emperor Maximilian, as regent. Maximilian, who preferred to live in Austria, summoned Marguerite from her widow's seclusion to become his deputy, and official guardian of Philip's children. In March 1507, he installed her as Governor-general of the Netherlands,

and in 1509 appointed her Regent – the first woman to hold this position.

She established a base for herself and her household at Mechelen, in Brabant, and made it the first permanent capital of the Burgundian Netherlands. This was where she had lived sporadically when it was the home of her step-grandmother Margaret of York, the last Duchess of Burgundy. But Margaret's palace, the Kaiserhof, was too small for the new ruler and her family, so Maximilian bought the building across the road for her. Renaming it the Hotel du Savoie, Marguerite had it refurbished and extended over the years to provide a fitting space for her official duties and domestic responsibilities, as well as her growing art collection.

The 1516 inventory that mentioned the Arnolfini portrait was compiled at a difficult time in Marguerite's life, for her nephew Charles had come of age, assumed rule over the Netherlands and abruptly dismissed her from her post. (He became Charles V, Holy Roman Emperor in 1519.) Critics had accused her of embezzling money, exceeding her powers, and upsetting the pro-French faction, the latter possibly justified because she maintained a constant hostility towards the French after her childhood humiliation at their hands. But perhaps Charles just wanted to free himself from his dominating aunt and guardian.

She had certainly succeeded in her aim of keeping the Netherlands as peaceful and neutral as possible by attempting to defuse French hostility and maintain the English alliance, while employing all her wiles to reject Henry VII's persistent proposals of marriage. Despite Maximilian's pressure, she firmly refused to marry again (though she tactfully let Henry know that if ever she changed her mind, he would be her first choice). Maximilian claimed that Henry would let her remain Governess of the Netherlands and spend several months there each year, but these unlikely promises failed to tempt her, likewise the six horses and the greyhounds that Henry sent her, as the Spanish ambassador de Puebla reported to Ferdinand. Another reproachful letter from Maximilian recalled her bitter complaints over her first two marriages, her resentment that she had been

sent wandering away and abandoned like a forgotten orphan. Never again was she going to risk being in that position. She was a key participant in the talks establishing the 1508 treaty called the League of Cambrai, which temporarily allied most of Europe against the Venetians. An observer of the negotiations noted how 'this princess had a man's talent for managing business, in fact she was more capable than most men, for she added to her talents the fascination of her sex, brought up as she had been to hide her own feelings'.

Bereft at being dismissed from her job as regent after eight years of power, Marguerite had time on her hands to survey the possessions which she perhaps feared having to remove from the palace in Mechelen. The 1516 inventory proved her interest in earlier Flemish paintings, many of which she had inherited from the collection of Duke Philip the Good. As well as the Arnolfini portrait and that of the Portuguese lady presented by Don Diego, she also owned copies of van Eyck's *Madonna at the Fountain* and *Madonna in a Church*, the latter a diptych which had originally belonged to Duke Philip whom the other panel showed kneeling in prayer. Marguerite took this as a model for the diptych she commissioned of herself praying to the Virgin, in a room which imitated the architecture and furniture of an earlier Burgundian style rather than the modern renaissance features of her palace. The one up-to-date detail was the inclusion of her pet dog Bonté (Lucky). Other parallels with the Arnolfini portrait were the draped bed in the room, and fruit on a sideboard at the left. Her other earlier Flemish paintings included van der Weyden's *Descent from the Cross* and works by Memling, Bosch and Juan de Flandes. She had already proved her commitment to the family heritage in 1509 when she unsuccessfully requested from Maximilian the title of Countess of Burgundy rather than Marguerite d'Autriche or Madame de Savoie.

Listing her treasures prior to packing and moving out proved unnecessary, for the overstretched Charles soon reinstated her. After Ferdinand died in 1516, Charles invited his aunt to join the Regency Council before he set off for Spain. Realising how much he needed her support in the

Netherlands while he was so far away, he learned to trust her again and gradually increased her responsibilities. In 1519, after he succeeded Maximilian as Emperor (an election in which she campaigned vigorously to support him), he appointed her Regent and Governor of the Netherlands. Charles's domains were now so vast that he was unable to manage them without the most trusted deputies – the success of Maximilian's pan-European Habsburg network imposed a terrible burden on his grandson. As Marguerite resumed control, she became the most senior figure in a Europe dominated by three young rulers, Henry VIII of England, François I of France and her own nephew Charles V. She unsuccessfully backed Cardinal Wolsey in his efforts to be elected Pope in 1523, but triumphed in negotiating a rare peace treaty between the empire and France in 1528; this was known as '*la paix des dames*' because the two leading participants were Marguerite and her sister-in-law Louise of Savoy, queen-mother of France.

In Mechelen, Marguerite continued to expand her palace and gave the 'Court of Savoy' a new extension which consisted of a suite of eight rooms, and a loggia and graceful colonnades, the first example of renaissance architecture in the Netherlands. The regent filled the new space with her remarkable art collection and commissioned a second inventory, between July 1523 and April 1524, which was over 400 pages long and also noted which rooms her possessions were in. It is a remarkable record of one woman's personality and preoccupations.

On 9 July 1523, her catalogue described the Arnolfini portrait as 'a very fine picture [*fort exquis*, very rare praise indeed] with two shutters attached, where there is painted a man and a woman standing, with their hands touching; made by the hand of Johannes, the arms and motto of don Diego the person named on the two shutters Arnoult fin'. It was kept in 'the second chamber, with a fireplace'. The way Marguerite distributed her artworks throughout the palace emphasised the functions of each room, ranging from the public reception areas to her personal suite, showing how she attempted to distinguish her official from her private life. The room where she kept the Arnolfini portrait was separate from

the more formal areas, yet was hardly private because eight guards attended her there in rotation and it was where she received special visitors. In the room was an altar, chests, cupboards and a bed. Adjoining it was the 'small cabinet' which served as her study and held books, a table and writing equipment. The walls of both rooms were covered with green taffeta, material which was also used to curtain some of the paintings. The art displayed in these apartments was quite different from that in the *première chambre*, where she received ambassadors and other official visitors and was an impressive portrait gallery exhibiting some thirty images of members of the Burgundian dynasty and their allies, including the Tudors. The library, where she hung more family portraits, was also accessible to visitors.

The room where she kept the Arnolfini portrait, however, contained works that meant something to her spiritually and emotionally rather than politically. As well as the altar, there was the diptych of herself praying to the Virgin, another diptych of her grandfather Duke Charles the Bold and the Virgin ('rich and very exquisite' according to the catalogue), and thirty more religious paintings. More personal were wooden busts of herself and her late husband Philibert, carved by court sculptor Conrad Meit. (She displayed larger marble versions of these among the other family portraits in the *première chambre*.) In these images, which she commissioned after Philibert's death, she was portrayed, exceptionally, not wearing the widow's headdress of her official persona but touchingly with the loose hair of a bride. (Posthumous portraits were not unusual in an era of sudden and premature deaths. Maximilian continued to commission paintings of his wife Marie of Burgundy long after her fatal accident.)

It was within the poignant context of memorials to her own brief but happy third marriage that Marguerite chose to display the van Eyck that Don Diego had given her. Contemplating the serenity of the hand-holding couple, pet dog at their feet, may have provided some refuge and respite from the incessant burdens she shouldered on behalf of the family. One personal connotation in van Eyck's painting was the little figure carved on the chair beside the sumptuously hung bed, depicting her patron saint

and namesake St Margaret. In the adjacent portrait of her late husband, the same saint appeared on the badge he wore on his hat, an accessory he had deliberately chosen because of its reference to her name.

Among other clues to the very personal nature of this room was the paintbox, disguised as a book with a purple velvet cover bearing arms, which contained five silver-decorated brushes and a little silver bowl. For Marguerite's pastime was painting, a skill she had learned during her childhood in France. Continuing to practise art must have been another lifeline, and understanding the techniques may have given her greater appreciation as a collector. Also in the room was a painting of a little girl holding a dead parrot. This again held a special meaning, for among her menagerie of pets Marguerite had a favourite green parrot which had belonged to her mother Marie of Burgundy. When it died, Marguerite wrote a rhyming epitaph, and her court chronicler, Jean Lemaire de Belges, composed the bird's imagined response in his poem 'L'amant vert.'

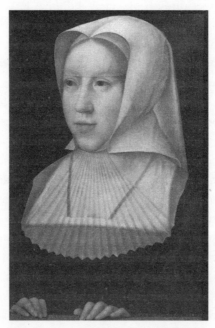

Bernard van Orley, *Marguerite of Austria*

In the tradition of the earlier Dukes of Burgundy, she attached artists to her court. One of her *varlets de chambre* was the painter and manuscript illuminator Gerard Horenbout (who later worked for the Tudors). She also retained Michel Sittow (who portrayed Don Diego), and the Venetian Jacopo de Barbari, donor of the paintbox, who had already worked in other European courts. After his death in 1518, Marguerite appointed Bernard van Orley, the 'Raphael of the North', as her court painter. He created and disseminated her public image (of which he painted at least nine examples) as a demure woman wearing the traditional white peaked hood and pleated ruff of Netherlandish widowhood; this made it clear that she was no longer on the marriage market but wedded to her country.

Marguerite's collections became renowned throughout Europe. She had inherited most of Philip the Good's vast store of tapestries and metalwork, manuscripts and paintings, prized possessions which included another example of van Eyck's work in the form of the mappa mundi which he made for the duke. By acquiring many more works, she pioneered in northern Europe the sort of 'Cabinet of Curiosities' of Italian renaissance patrons, blending art and science and evidence of distant cultures. The 1523–24 inventory included exotic things from the New World, brought back to Spain by stout Cortez and presented to Marguerite by Charles V – Moctezuma's feather cloak, Aztec mosaic masks, a stuffed bird of paradise. Together with corals, minerals and shells, and some daring renaissance nudes, these treasures were displayed in the purpose-built exhibition space of her 'garden cabinet', the large room which led from her study. She even employed a full-time curator, plus two assistants, to look after all her paintings and precious possessions.

This made the palace at Mechelen a vital destination on the itinerary of privileged tourists. One such was an Italian cardinal, Luis of Aragon, whose chaplain Antonio de Beatis kept a journal of their travels through Europe in the years 1517–18. In July 1517, they arrived at Middelburg, near Flushing, where Charles was waiting, accompanied by Don Diego, to embark for Spain, the expected long absence that had led to his aunt's

political resurrection. Here Luis met Marguerite, 'a person of about thirty-five, I would say, not ugly at all, and of a great and truly imperial presence; she has a certain most pleasing way of laughing'. She also spoke excellent Spanish. A few days later, the travellers reached Mechelen ('superior to all other towns of Brabant and Flanders') and found Marguerite's residence 'very fine and well appointed, though not particularly imposing'. But her library was magnificent, and they were particularly touched by Meit's marble busts of her handsome late husband and of herself. They were almost certainly admitted to the room where she kept the Arnolfini portrait, for de Beatis noted the 'fine panel paintings and other pictures by different artists, all of them good masters'. De Beatis was not familiar with van Eyck's name or reputation. When they visited Ghent a week later, they admired the famous altarpiece in St Bavo's Cathedral, 'the finest painting in Christendom' which, the cathedral canons told them, was painted 'a hundred years ago by a high German master named Robert'.

Another visitor was Albrecht Dürer, who toured the Netherlands in the summer of 1521. He already knew Marguerite's sculptor Conrad Meit, and her painter Bernard van Orley, and wanted to present her with his portrait of Maximilian, which she rather ungratefully rejected on the grounds that it was not a true enough likeness. (Or perhaps it was too Germanic, for the official portrait she displayed showed Maximilian as a proper Burgundian, wearing the Order of the Golden Fleece.) But Dürer's journey was not wasted: 'Lady Marguerite showed me all her beautiful things; amongst them I saw about 40 small oil pictures, the like of which for precision and excellence I have never beheld. There also I saw more good works by Jan.' Dürer admired van Eyck whose works in Bruges he had already inspected.

Marguerite remained in the service of her nephew and the Netherlands to the end of her life. Maximilian had arranged the marriages of his three granddaughters, her nieces, to spread the family web across Europe, and Marguerite took on domestic responsibilities for another young family when her niece Isabella died and her son and two daughters came to live at Mechelen. Although Marguerite longed to step down and resume a

private life, hoping to complete her late husband's memorial at Brou and enter the Convent of the Annunciation at Bruges, her sense of duty to Charles came first. Death intervened. In December 1530, at the age of fifty, Marguerite died from gangrene. Her will, made many years earlier, left everything to Charles V, but it was her niece Marie of Hungary who inherited the role of Regent of the Netherlands – and the Arnolfini portrait.

The Furniture

Ambiguity extends to all the furnishings in the room in this most complex of paintings. van Eyck has ensured that they are as informative and specific about the Arnolfinis' status as the clothes they wear, yet the particular ensemble he has selected places them simultaneously in a material world and a symbolic one. There are four pieces of furniture, together with their covers and hangings, and a rug on the floor. Each has its own significance. The man and the woman may not have possessed any of the items so lovingly shown, but van Eyck has chosen this particular setting because it is the most seemly and flattering way to depict his patron.

Like clothes and accessories, furniture was an aspect of self-display that was entirely controlled by status and rank. In the etiquette-obsessed courts of fifteenth-century Burgundy and France, there were protocols that were ignored at your peril. Visiting and receiving, dining and drinking, marrying, giving birth and dying were all modulated by the exact contents of the rooms where carefully choreographed social rituals took place. Bowing, kissing, knowing the correct salutations and making suitable conversation were all designed to maintain the rigid degrees of precedence that kept people in their correct ranks,

firmly reinforced by the appropriate accessories and furniture. The court which employed van Eyck was a role model for anyone connected with it, like an Italian merchant who supplied goods and services to the demanding duke.

Fascinating hints of what was permissible at court, and what had percolated down to the Arnolfini room, were supplied by Aliénor de Poitiers, daughter of one of the ladies who came to Flanders in 1429 in the train of Isabel of Portugal, the duke's third wife. As van Eyck had been on that expedition too, he would have been just as aware as Aliénor's mother of the contrasts between Burgundian and Portuguese etiquette. Brought up in the court of the new duchess, Aliénor was a stickler for the status quo and had a mission to preserve the protocols she feared the next generation was forgetting. She laid down the rules of conduct in her manual *Les Honneurs de la Cour*, written in the 1480s in the unhappy political vacuum that followed the death of Duke Philip's successor, Charles the Bold. Her tract harked back to the golden age of the old duke, and tried to preserve an idealised Burgundian court where there was perfect courtesy and everyone knew their place. Her specification of the differences between the bed hangings and covers permitted for queen, princess, duchess or mere countess suggested once rigid forms of precedence that were being dangerously eroded. 'These old rules have been changed in several instances,' she lamented, 'but that cannot degrade or abolish such ancient honours and estates, which were made and formed after much thought and for good reasons.'

Van Eyck shows Arnolfini and his wife apparently welcoming guests, the two tiny figures reflected in the mirror on the back wall, whose entry into the room seems to be acknowledged by the raised right hand of their host. This makes it a reception room. The furniture, including the bed, is what honoured guests would expect to see there: Aliénor's list of the contents of a grand receiving chamber included a bed, a chair and a carpet. These vital features are all present in the painting, together with a draped, cushioned settle beside the chair, and a chest

under the window. Aliénor does not mention the two latter items in her inventory of what was de rigueur for the nobility, but she does specify that there must be a low couch with hangings and fine cushions, and a buffet, or sideboard, on which to show off gold and silver plate. The number of shelves on the latter was a key indicator of rank. Aliénor referred disapprovingly to Marie of Burgundy, Duke Philip's grand-daughter, who breached all the rules by having five shelves to her buffet when, as a mere archduchess (despite being the greatest heiress in the land), she should have been content with four. Only queens were entitled to five shelves. The Arnolfinis' simple chest could have been van Eyck's way of not getting them entangled in the etiquette of buffets for fear of getting it wrong.

Chests were popular and versatile, for they combined the function of furniture and luggage and were an archetypal form whose French name *huche* (hutch) became the title of the guild of cabinetmakers, the *huchiers*. Chests were used for domestic storage, for transporting personal posses-sions, as seats, tabletops or sideboards, and they might be painted or decorated with carved panels or metalwork. They were a way of showing that you owned things, and that you expected other people to be aware of this: a 1405 inventory of the Duke of Burgundy's possessions listed ten chests that were kept in the public Great Hall. A chest might also represent the stability of marriage, and was therefore another conventional gift from a husband to his bride in which she stored the lovingly assembled clothes and linen of her dowry. van Eyck might have learned from his Italian clients that, on marriage, a prosperous Florentine was expected to furnish his *camera*, or reception room, with a pair of chests (*cassone*), together with a bed and a settle.

The chest is a standard type, probably made of oak (though walnut, which was easier to carve, was becoming increasingly popular during the fifteenth century). It stands off the ground, in order to protect the contents from damp, on the four legs created by the extended corner supports which frame the panelled sides. On surviving examples of the type, the sides were made of boards which slotted horizontally into

the uprights, and the bottom boards might be strengthened by iron nails. The legs and flat top of the Arnolfini chest suggest that it was not used for travelling, because those which served as luggage normally had a rounded lid and sat flat on the ground. The front panel is obscured by Arnolfini's tabard, otherwise van Eyck might have embellished it with carvings to match those on the settle and the chair. There is a chest of identical proportions and construction in the *Ince Hall Madonna* (1433, Melbourne), attributed to van Eyck's workshop if not his actual hand. The front of that is visible, displaying ornamental iron hinges and a keyhole. Perhaps the artist himself owned such a chest and used it as a model in these two separate contexts, making the Virgin seem accessibly human by placing her in a secular setting, while flattering the Arnolfinis by attributing to them an item also connected with Christ's Mother, like the other pieces in the room.

During the fourteenth century, craftsmen started to specialise in making different types of furniture. For the first time there was a distinction between general carpenters and the *huchiers* and *menuisiers*, the cabinetmakers and joiners who crafted and decorated the contents of domestic and religious interiors. However, their range remained limited. The basic form of seating was a bench, ultimately a plank on legs. Those who could afford it preferred something that had a back and arms as well, so the bench developed into a settle with wings the same height as the back, like a church pew. Benches and settles were generally placed against a wall in the summer, and moved closer to the fire in winter. To avoid too much disruption, the *huchiers* developed a superior type of settle known as a *banc à perche* with a cunningly designed back rail which pivoted towards or away from the fire so that people could sit on one side or the other without having to drag a heavy oak piece around. It is impossible to see whether the Arnolfinis' settle had a pivoting back but it certainly possessed another status indicator, the projecting footboard at the base. It was also embellished with a striking piece of decoration, a curious finial of two grotesque little figures seated back to back on the one visible arm. Squatter than a lion, though

both have manes, the creature facing the room has a malevolent, half-human face. The pair give a bizarre touch to the otherwise serene scene. Rather than making some kind of satirical statement, van Eyck was perhaps recalling or reproducing something that he had actually seen, one craftsman celebrating another's fantastical flourish; at the same time he was providing a humorous version of the more conventional lion finials, like the one on the adjacent chair.

What distinguishes the settle is its drapery, for it is entirely covered by a vivid red cloth, draped all the way from the back down to the footboard and beyond, so lavish that it spills onto the floor. With the additional refinement of two plump, red cushions on the seat, the settle looks as comfortable as possible in an era of unyielding wooden furniture. Being thus able to soften and embellish an otherwise standard item, while providing an opulent splash of colour to warm the room, was another form of display. Anyone seeing the painting would realise that Arnolfini could afford these extras. They might also have recognised the imagery associated with the Virgin. Again, Robert Campin had got there first. In his Brussels *Annunciation* (which probably predated *The Ghent Altarpiece* and the Arnolfini portrait) the Virgin's settle had very similar drapes and cushions, while his *Virgin and Child before a Firescreen* (*c.* 1440, National Gallery, London) also has a settle with carved figures and red cushions; the drape in this case is green.

Squeezed so close to the settle that the arms touch is another status symbol, a high-backed chair. Having a big chair was the privilege of the head of a household, and it represented his office, whether he was a duke, a merchant, a professor (they still occupy Chairs today) or a bishop (who still has a throne). Aliénor de Poitiers stressed that there must be a tall chair beside the bed in a reception chamber, on which a host might invite a distinguished visitor to sit as a mark of honour and respect. van Eyck is again relating the Arnolfinis to Burgundian etiquette.

Their chair is a very fine specimen, carved and partly upholstered – the one visible arm is padded and covered with red material to match that

on the settle. Contemporary sources refer to chairs upholstered with down or leather, so, although the seat is obscured by the woman's figure, it may have been quite comfortable. The chair was there to be admired. Its wooden back is decorated by neat carving like low-relief architectural ornament. On the very top is a row of spiky fleurs-de-lys like a battlement, below them is a band of circles with little sun-like flowers in the centre, then a cusped arch with a triquetra (the three-pointed knot that symbolised the Trinity) at the side, with two clusters of berries hanging from the cusps. This decoration provides a satisfying and subtle combination of naturalistic and geometrical patterns, worked in shallow yet sharply faceted carving whose angles van Eyck has exploited to the full to stress the contrasts between highlights and shadows. It looks like a layer of brown wooden lace draped over the back, to match the fluted edges of the woman's headdress.

Like the settle, the chair also bears three-dimensional sculpture. At the front of the arm is a proud little lion (and presumably a second, identical one on the concealed side). It has pricked ears, a well-defined face and a fine mane which flows in rows of curls halfway down its forelegs. On the very top of the chair back is the carved figure of a haloed woman, her hands clasped in prayer, apparently emerging from the body of a scaly-winged dragon whose paws clutch the wooden frame. This could be St Margaret of Antioch, one of the major saints, whose faith helped her escape from the belly of the Satanic monster who devoured her, thus turning her into the patron saint of women in childbirth. Another candidate, however, might be Martha, the patron saint of housewives, who famously overcame a dragon in Tarascon, Provence, where she was converting the pagan Gauls. Martha was symbolised in art by the brush she allegedly grasped while defeating her dragon; it is perhaps significant that the carved figure is immediately adjacent to the brush which hangs from a nail just beside the chair.

But did such a chair actually exist? van Eyck excelled in recreating in paint the detailed ornament of stonemasons and carpenters. His interiors abound with minutely carved capitals, arches, window openings and

niches which he must have copied from buildings that he knew, then added to the vast repertoire of motifs that he reworked as necessary. The main decorative features of the chair back are already present in *The Ghent Altarpiece*, together with images of wooden furniture adorned with statuettes of animals or people, and there are similar figures on the Virgin's chair in *Madonna with Canon van der Paele* (1436, Groeningemuseum, Bruges). The lions on the Arnolfini chair are identical to those on the splendidly canopied chair of *Madonna in an Interior* (1437–38, Stadel Museum, Frankfurt), which has four lions, two on the arms and two on the back, with the same alert ears, elaborate manes and sturdy stance. When associated with such images of the Virgin in a domestic setting, lions take on a definite Christian symbolism. According to the Book of Kings, Solomon's throne had lions on its handrests and others who guarded it all around. Robert Campin's settle in his Brussels *Annunciation* has four lions on the back and arms, while the panel between the legs has the architectural motif of cusped arch and bunches of berries, which van Eyck seems to have borrowed for the Arnolfini chair.

Immediately beside the chair is the chamber's focal point, the piece designed to impress the most. Chest, settle and chair contribute to the desired impact of the room, but all are outranked by the richly hung bed. This, however, did not prove that the room was used for sleeping. On the contrary, it implied that the master of the household was a person of sufficiently high status to exhibit such a possession as an adornment to his reception room. As part of the wedding ceremonies of the Duke of Burgundy and Isabel of Portugal in 1429, a bed of ostentatious dimensions was installed in the great hall of the ducal palace in Bruges; the same etiquette was observed in the placing of a bed in the state room at the marriage of Philip's son to Margaret of York in 1468. Displaying such a bed to select visitors rubbed in the superiority of the host, not only for owning one, but especially for being able to afford the hangings. According to Aliénor of Poitiers, the fabric and colour of the textiles rather than the bed's size or

construction (which remained fairly standard) showed off the social position of the owner. She refers quite specifically to the rich curtains, canopy and coverlet of the bed that was not intended for sleep but had to be present in an elite reception room.

5. The Amazon Queen: Marie of Hungary

Marie was the third daughter of Philip the Handsome and Juana the Mad, but she knew neither parent. In 1506, when she was four months old, they left her in the Netherlands and set off to seize the crown of Castile. They never returned. Philip died in Spain and Juana was confined in the fortress of Tordesillas for the rest of her life. So Marguerite raised Marie at Mechelen, understanding that the latest Habsburg princess was destined from the moment of her birth to play her part in Maximilian's plan of controlling Europe through marriage. There were many sad parallels in the destinies of Marguerite and Marie: both were the marital tools of Maximilian until a beloved husband was carried off by death, both had to assume their brothers' roles as Regents of the Netherlands. Despite very different personalities, each prized the Arnolfini portrait, though not necessarily for the same reasons. For Maximilian, each new grandchild was a fresh asset, girls as welcome as boys. He made all six of them kings or queens, even though Burgundy, their heritage, had only been a duchy. He promised Marie, at the age of six months, to an as yet unborn Hungarian prince (Louis). This was part of another double deal in which Maximilian betrothed his grandson and granddaughter to the infant siblings of the

74

King of Hungary and Bohemia (Austria's troublesome neighbour). Having linked the Habsburgs to south-west Europe, he intended that the new marriages would ensure the domination of central and eastern Europe.

Like her aunt Marguerite, Marie devoted her life to the service of the Habsburgs. The pattern was dreadfully familiar. In 1514, Marguerite, herself sent to France to be married when a very small child, had the duty of organising Marie's departure at the age of eight, with an enormous retinue of tapestries, furniture and gold and silver plate. Marie went first to Vienna to live under Maximilian's supervision until she was old enough to participate in the long-planned grand double wedding in St Stephen's Cathedral, when she was nine. During her time in Austria, she mastered the German language and fashions: Marguerite displayed portraits of her niece in the family gallery, dressed like the little queen that she was, in a robe of cloth of gold draped with black velvet, wearing a necklace, a ring and the wide-brimmed bejewelled flat cap of Germanic style.

Despite the great wedding Marie did not see her husband again for several years, during which time Louis succeeded his father but found his crown challenged by rival claimants. It was only after Maximilian's death in 1519 and her brother Charles's election as emperor that Marie was allowed to join Louis, when the warring factions in Hungary became temporarily reconciled under the threat of invasion by the Turks. If Hungary fell, then the whole empire was at risk. Marie was at last dispatched from Austria, and sailed down the Danube to join Louis at Buda. They were both sixteen.

For a girl brought up in the refined ambience of Marguerite's Mechelen, Marie had to expand her horizons drastically. If Austria had seemed alien, Hungary was a far greater shock, for it was an impoverished, primitive country with an impenetrable language and cliques of fractious nobles more interested in fighting each other than combining against the Turks. Magyars bore a traditional hatred towards Germans, so the alliance of their king to the emperor's sister was not well received,

nor was it ameliorated by Marie's Habsburgian hauteur and energetic domination over her charming, powerless, penniless husband. This was like Marguerite's relationship with the amiable Philibert of Savoy, and proved excellent training for a regent. While the Turks massed on their borders, the young couple indulged their passion for hunting, parties and tournaments, but it was Marie who received the blame for their extravagance and frivolity.

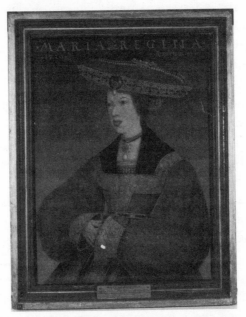

Hans Maler, *Marie of Hungary*

In 1526, the troops of Suleiman the Magnificent massacred the Hungarian army at the Battle of Mohacs. King Louis died, not gallantly in the field but drowning while trying to escape. It took weeks for his body to be recognised. Without even knowing whether he was still alive, Marie fled to Vienna and sought the protection of her brother Ferdinand, whom Charles had put in charge of his Austrian domains. It was the first time the siblings had met. Ferdinand reported the terrible news to Marguerite: 'as to the queen my sister, she is about

ten miles from Vienna, very unhappy and desolate as you may imagine'. Marguerite responded: 'if that you should send or write to her, I beg you to recommend me to her, and console her for her misfortune as much as possible, and comfort her and forward a letter which I have written to her'.

For the next three years, Marie had no role in life. Single, childless, with no responsibilities or duties, always short of money, she flung herself into travelling, hunting and religion. She refused to marry the King of Scotland (which upset Charles and Marguerite's strategy of linking the Scots to the Netherlanders rather than the French) and she refused to return to Mechelen when Marguerite invited her in 1530. But this was her last act of defiance. Marguerite's unexpected death at the end of 1530 left a vacancy for the regency of the Netherlands, for which Marie, born in Ghent, was the obvious, and indeed only candidate. She accepted Charles's summons and came back to her native land in March 1531.

As regent, Marguerite had always been dominated by her father Maximilian, and not entirely trusted by her nephew Charles. He placed far more confidence in Marie, the little sister with whom he had shared his earliest childhood yet had not seen for fifteen years, and allowed her greater power than he had ever granted Marguerite. Charles and Marie corresponded frequently, and she learned how to get her own way by the occasional threat of resignation. For him, the Netherlands were a source of finance for his complex European policies and wars, and he expected Marie to increase taxes on the reluctant provinces when necessary, while keeping the rival noble families under control. Being regent entailed being in charge of seventeen separate provinces, each with its own laws, customs and institutions. She ruled through the three councils that Charles had established, a more effective structure than Marguerite ever had. In fact, Marie claimed that her late aunt had not left matters in a very good state because she was too old and had been serving for too long. There may have been some truth in this, but it failed to recognise their different positions. Marie was able

to take decisions in her own right, and Charles respected her skills and local understanding.

Compared to Marguerite, Marie has attracted less interest from historians. A recent biographer, Etienne Piret, depicted an enigmatic character and stressed the strong contradiction between the image she projected of herself in her letters – a submissive, weak person constantly driven by self-doubt – and the way her contemporaries saw her, as a tough, unpopular woman who scared those who had to work with her. For nineteenth-century historians, a woman who led the Netherlands through three wars and rode like an Amazon lacked the feminine qualities that made Marguerite a more sympathetic figure. In fact both women were attempting to do what was perceived as a man's job in their distinctive ways. The role of regent was problematic enough, because a delegated ruler inevitably lacked the authority of the true heir. It was additionally hard for a woman, who had to protect her reputation yet reveal no feminine weakness. Marie once commented bitterly that it was impossible for a woman, especially a widow, to rule in peace or war, no matter how excellent her ability, because she would never be as feared or respected as a man.

One way of acquiring respect was the creation of an official image, and Marie's artists (like Marguerite's) responded to this. The Queen of Hungary was no longer shown as a fashionable figure in a jaunty feathered hat, but a widow in a stark black and white gown which draped her tiny frame. Her long thin face, with its prominent undershot Habsburg jaw had a grave, even grim expression. Yet this vision of piety and rectitude was only half the story, and there was a real contrast between Marie's official image and her personal life. Hunting was her obsession. The English scholar Roger Ascham (former tutor to Princess Elizabeth Tudor) had the opportunity to observe Marie when he was serving as secretary to the British ambassador to Charles V. He was awed: 'she is a virago; she is never so well as when she leaps on a horse and hunts all day long'. She was even said to select her ladies-in-waiting according to how well they rode. She kept three pet hounds in the

house, as well as maintaining various packs, and had many fine horses and falcons. She was even appointed Brabant's Master of the Hunt. Ascham's jibe of 'virago' was probably incurred because she controversially rode astride like a man (unheard of in an age when women went side-saddle) in order to be able to jump better. This also meant dressing like a man, which is how she is depicted in the set of hunting tapestries now in the Louvre.

Marie was more concerned to demonstrate the grandeur of the Habsburgs than Marguerite had been. She moved her headquarters from the relatively modest Hotel Savoy in Mechelen to the Coudenberg palace in Brussels, a sprawling Gothic building which Marguerite had seldom used. Marie turned it into the largest palace in Europe, extending and refurbishing it as befitted her official residence. One reason for this was its magnificent game park, where she continued to indulge her passion for hunting, but she was also aware that Brussels was the crossroads of Europe, and that there were always important visitors to impress. She knocked down one old wing in order to add a massive new galleried extension, and built a new chapel in renaissance style. In the grounds, where there was already a vineyard and a menagerie with bears, lions, ostriches, camels, leopards, and turkeys from the New World, she added lawns and flower gardens, lakes and fountains.

At first, she retained the Savoy Hotel at Mechelen and kept on Marguerite's former staff, including Etienne Lullier, who looked after the library and the cabinets of curiosities. But when the building suffered serious damage after a storm in 1546, she moved its contents and the art collections, including the Arnolfini portrait, to her other properties. These were tokens of Charles V's gratitude for her indomitable service. In 1546, he granted her the rights, revenues and estates of Turnhout to the north-east of Antwerp, a prosperous settlement that also offered excellent hunting, and of Binche near the French border in Hainault. This was a traditional dower of Burgundian princesses, a lucrative domain of nearly fifty villages, over whom Marie acquired seigneurial rights and the power to levy taxes, fees and fines.

In both places she started major building schemes. At Turnhout, where she occasionally held hunting parties, she converted the old castle into a modern renaissance-style building. At Binche, she started from scratch, using the well-travelled architect Jacques Dubroeucq to create a fairy-tale palace to rival that of the French kings at Fontainebleau. Marie was well aware of French taste and style through her sister Eleanor, now widow of François I of France (a singularly unhappy marriage), who returned to the Netherlands to live with Marie after being widowed in 1547.

The palace at Binche was the wonder of the world. It was where Marie held the legendary festivities (rivalling the chivalrous *fêtes* of her great-great-grandfather, van Eyck's Duke Philip the Good) to celebrate her nephew Philip's arrival in the Netherlands as Charles's designated successor in 1540. At dinner in the 'enchanted chamber', food arrived on a mechanical ascending and descending table while planets and stars circled in the artificial heavens above. There were tournaments and quests involving dragon-ships, islands, special effects of thunder and rain, and a magic sword that could only be withdrawn from its jasper rock by a masked knight who eventually revealed himself to be Philip.

Marie surrounded Binche with gardens full of exotic plants, fountains and statuary that copied the antique sculptures in the Pope's collection. Beyond was an extensive game park, in which she built a small and luxurious hunting lodge called Mariemont. To decorate her palace, she employed hundreds of specialist craftsmen, and commissioned stained glass, frescoes, statues, tapestries, carvings, stucco and paintings. The finest architectural feature was the grand gallery, with a coffered ceiling like the Pantheon, at one end of which were Marie's apartments and at the other end Eleanor's. Marie's bedroom contained nine tapestries woven with silver thread, and even her wardrobe next door had a tapestry of David and Goliath. There were silver candlesticks, fashionable French chairs carved with Roman heads and lions' paws, and the bed hangings were made of black cloth of gold. The epic scale and decoration of the gallery

reflected Marie's taste for modern art, for she commissioned four huge mythological canvases, inspired by Ovid's *Metamorphoses*, from the renowned Venetian painter Titian, whom Charles V had employed to define his dignity and gravitas as emperor. Marie admired his work enormously and followed this commission with orders for twenty family portraits, most of which she hung at Binche.

She also supported the top Netherlandish artists. These included the versatile Pieter Coecke, who had written about Vitruvius, stage-managed Philip's spectacular entry into Antwerp, and designed many of her tapestries; Michiel Coxcie, an admirer of Michelangelo, who painted portraits and designed tapestries; and the portrait painter, Antonio Mor. She also retained Marguerite's court artists Meit and Bernard van Orley, and the latter often copied family portraits as gifts. Marie appreciated the work of earlier Flemings. In the chapel at Binche, she installed Rogier van der Weyden's *Descent from the Cross*, which she had ruthlessly removed from a guild chapel in the church of Our Lady, Louvain (replacing it with a copy by Coxcie) and she tried to get hold of van Eyck's *Madonna with Canon van der Paele* from St Donatian in Bruges, but the church bravely refused to give it up. It must have been some consolation to own another signed van Eyck, the little portrait of a couple holding hands in a room.

If she kept this at Binche, it would not have sat well amongst the grandiose Italian canvases of the great gallery. Nor was it a suitable subject for the chapel. Yet the fact that it was associated with her aunt and was by Philip the Good's most famous artist may have earned it a place in a more intimate space in the palace, somewhere within her suite of rooms, as Marguerite had displayed it. However, Marie moved much of Marguerite's collection directly from Mechelen to the Coudenberg palace in Brussels, and seemed to prefer commissioning new works for Binche. Binche suffered a terrible fate before the palace was even finished, being totally destroyed by the French after the new French king, Henry II, renewed war with the emperor in 1551. But luckily Marie had wisely evacuated her collections, including all artworks

and 250 tapestries, in advance of the anticipated French attack. She also moved all the preserved game from the hunting park so that it would not provide dinner for the enemy soldiers. The resourceful Marie was now responsible for defending the vulnerable Netherlands against invasion, campaigning on horseback, touring the frontiers and encouraging the troops. In the summer of 1554, Henry retaliated for her army's destruction of the French border fortress of Folembray by advancing on Binche, which was on the direct line of march to Brussels, and burning down the palace and hunting lodge. The French king was reported to have cut down some of her trees himself to fan the flames of the burning building. Then he stuck up a vengeful placard: '*Mad queen, remember Folembray!*'

The logical destination for Marie's precious collection in this time of war was her palace at Turnhout, which lay safely to the north-east of Brussels. She may already have planned to move her favourite works there, because Charles, crippled by gout, piles, poor digestion and depression, and worn out by the difficulties of controlling his vast territories, the endless travelling, the campaigning, and the inability to trust anyone except his closest family, had decided to abdicate and live in retirement and seclusion in Spain. His loyal sisters Marie and Eleanor decided to go with him. Planning what to take and what to leave behind for her successor and heir Philip II preoccupied Marie for months. The Arnolfini portrait was certainly at Turnhout immediately prior to the move, according to a later inventory of the possessions and pictures she decided to take to Spain. 'Let there be also packed for her a large picture with two shutters by which it is closed; in it there are a man and a woman who have taken each other by the hand; also a mirror in which the aforesaid man and woman are reflected. On the shutters are the arms of Don Diego; done by Jan van Eyck in 1434.' It was one of only forty-two paintings that Marie took with her, leaving hundreds behind in the Netherlands for Philip. Including it was a mark of great approval, for Marie's own taste in art was Italianate and modern (she took twenty-four Titians to Spain, plus others by the 'northern

Raphael', court painter van Orley). Keeping the van Eyck demonstrated official Habsburg admiration for Flemish painting. It provided a link with the country she had come to regard as home, and it was a memento of the aunt who had taken the place of her mother. And perhaps this image of a sedate married couple represented a state to which a widowed pawn could never aspire.

At Charles's abdication in October 1555, he handed over everything to his son Philip II, in the setting of the huge hall of the Coudenberg palace. There were no established precedents or protocols for such an event, and Marie had to devise and choreograph it all herself. The ceremony also included her own resignation as regent, to be succeeded by the cold nephew whom she rightly feared would not understand the Netherlanders as well as she had done. Their actual departure was delayed for nearly a year while Charles struggled to settle his outstanding debts: he was so hard up that he even had to postpone a memorial service for his mother Juana, who had died in Spain in April 1555, until he could afford appropriate hangings for the church. Then they had to wait for the winter storms to pass, then for a visit by his daughter and her husband. Marie spent these months moving between Brussels and Turnhout, making final decisions about what to do with her collections. She intended to live in some style in Spain, while Charles craved simplicity. However, it still took a huge fleet of Spanish galleons (those which had previously accompanied Philip on his triumphal voyage north to marry Mary Tudor) and a Netherlandish convoy to take the three Habsburgs, their staff and their possessions to Spain.

They set sail from Flushing on 17 September 1556. Charles and his entourage travelled on the *Holy Spirit*, while his sisters went on the *Falcon*. Avoiding their company even on the voyage, Charles immediately began practising the detachment he sought in Spain. The van Eyck must have been carried in one of the many baggage vessels, stowed for weeks before the long-delayed departure, enduring the hazards of temperature and atmospheric change, let alone the risk of theft. The weather was kinder than it had been for the voyages of Marguerite and of Philip and Juana,

no baggage ships were lost, and they reached Laredo on the north coast of Spain in just eleven days.

Charles made it clear that he did not intend to live with Marie and Eleanor. He had been planning this escape for a long time, and was having a house built beside the monastery of Yuste, in a remote valley in the heart of the bleak Castilian plains. After they landed, he set off in haste, while his sisters took their time and enjoyed the official welcomes he had managed to bypass. Those in the party reported how happy 'the two queens', as they were known, appeared, and how Marie suddenly looked years younger; typically, she travelled on horseback while Eleanor was carried in a litter. The sisters spent the winter in Valladolid, to see if they wanted to settle there permanently. The paintings were unpacked and hung, to add distinction to the new residence. In addition to her favourite works, Marie had brought a real artist in her retinue, Catherine van Hemessen, and her husband, a fashionable Antwerp organist. Marie loved music as much as she loved art, and bringing the couple with her ensured she would not lack culture in her new home, wherever it was to be. The two queens decided that rather than Valladolid they preferred the climate of Guadalajara, to the east of Madrid, where there was good hunting too. Before moving there, they visited Charles, then travelled to the Portuguese border to meet Eleanor's daughter, the Queen of Portugal, who had not seen her mother for years. The emotional strain of the brief reunion, combined with Eleanor's already fragile health, was fatal: she died on the return journey, ten days after taking leave of her daughter. Marie was at her side.

Losing her beloved sister made Marie's life in Spain seem pointless. She longed for something to do, but was rebuffed when she offered to act as an adviser to Charles's daughter, who was serving as Regent of Spain as long as Philip remained in the Netherlands. She had still not found a permanent home, having decided that Guadalajara was too expensive without Eleanor's contribution, but she spent several months in 1558 at Cigales, near Valladolid, where she would again have unpacked

her paintings and tapestries. As she was alarmingly short of money to maintain the lifestyle she desired, she requested help and a pension from Philip. Her nephew's haughty ways had made him deeply unpopular in the Netherlands, which was now on the verge of civil war as well as war with France, and he longed to return to Spain. Seeing Marie as his salvation, he used the influence of the dying Charles, whom she could never resist, to propose that she might save the Netherlands for the Habsburgs by returning as regent again. Swayed by Charles's persuasive arguments that this was for the sake of the family, in the autumn of 1558 she reluctantly agreed, though she insisted that it must only be on a temporary basis. Content with this news, Charles died on 21 September. In the first two weeks of October, Marie moved between Valladolid and Cigales to organise her departure, while the fleet to transport her and retrieve Philip assembled at Laredo. But it was too late. Her health did not equal her willpower. Having complained of palpitations for years, she suffered a series of heart attacks and died on 18 October, at the age of fifty. Her will left everything, including the art collection that contained the van Eyck portrait, to her nephew Philip II, a man whom she disliked intensely.

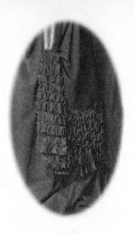

The Fabrics

The painting's layout means that only part of the bed can be seen and the perspective gives it a distorted shape. Like beds in other contemporary images, it stands on a low platform, and its canopy is quite separate, being hung on cords from the ceiling. This was an independent mark of estate: a canopy (*celour*) was frequently suspended over the chairs of kings or dukes, and also of van Eyck's Madonnas. Another, separate length of cloth, the tester (*dossier*), hung behind the seat. A canopied bed had the further refinement of curtains around the other three sides as well. At least one of these side curtains was kept looped up on social occasions, so that the covers and pillows could be properly appreciated, as van Eyck shows in the painting. Inventories and wills of the early fifteenth century described hangings in some detail, because they were precious possessions frequently transported by peripatetic rulers like the Dukes of Burgundy to provide instant luxury and a reminder of rank wherever they were. Hangings masked the basic wooden structures beneath, which did not travel but remained in the various residences.

In addition to canopy and tester, sets of bed accessories included three running curtains, valance, feather mattress (straw for humbler

people), blanket, coverlet and pillows. These could be made of extremely expensive materials, like the ensemble of cloth of gold hangings and ermine coverlet that King Richard II presented to an earlier Duke of Burgundy in 1396. Gold, green or red were the colours favoured by the nobility and these fabrics might also be embroidered or woven with patterns and images. Aliénor of Poitiers goes into great detail about appropriate hangings in her account of the arrangements for the birth of the Duke and Duchess of Burgundy's first grandchild in 1456. She distinguished 'the bed that was not for sleeping', in the outer, or state chamber (whose walls were hung with red silk) with its embroidered canopy and matching satin curtains and coverlet, from the beds 'arranged for sleeping' in Madame's inner chamber. This room contained a pair of beds which shared the same green damask canopy with a silk-fringed pelmet. Both beds had green satin running curtains hung from movable rings attached to the canopy, one of which was kept permanently looped up. These beds had bolsters, and were covered with ermine and a fine violet cloth, both of which 'reached fully to the ground and trailed along it for a yard and a half'. There was also the ultimate refinement of a 'fine gauzy sheet' under the covers which ostentatiously extended onto the floor to show how grand it was. Between the two beds was a high-backed chair with a cushion, covered with cloth of gold, and on the floor was a carpet.

The Arnolfini bed possesses all the features of these high-society beds – fringed canopy, tester, curtains, coverlet, bolster. The tester is over-shadowed by the canopy but appears to have a band of decoration at the top, possibly an embroidered inscription. The bedspread is as extensive as that of Madame, being much longer than the height of the bed requires, and the change of direction in the folds proves that the bed stands on a dais which the excess of fabric covers completely. The neat corner tucks of the bedspread suggest that it may have been sewn into the shape of a fitted valance. At the head of the bed lies a bolster covered in the same red fabric as the coverlet. The canopy, evidently suspended from the ceiling, runs parallel to the beams, a clever device that enhances the lines of

perspective. It is edged by a thick, fluffy fringe which seems to be of a different fabric and texture.

The curtain by the head of the bed is concealed by the woman but it presumably hangs straight down. That at the other end is looped up in the manner described by Aliénor and often depicted in contemporary images such as the lively illustrations to Netherlandish printed bibles of the first half of the fifteenth century. Intended for the private devotion of the literate, such texts were brought to life by the use of familiar imagery showing biblical characters living in modern domestic settings. These helped make the stories accessible, relevant and up to date and were the ultimate foundation of the realistic tradition of Netherlandish art. They also provide invaluable insights into how furniture was perceived and used. Hung beds (and high-backed chairs with finials) are common, and the looped curtain features, for example, in scenes of the birth of Samson, and of Solomon's meeting with the Queen of Sheba; this is evidently a bed 'not for sleeping' but a status symbol, for the couple and the bed are in a reception chamber which also contains a plate-laden buffet. However, David suggestively begins his seduction of Bathsheba beside a hung bed that does not have its curtain looped up, proof that privacy will be required.

More elaborate beds, whose hangings are invariably red, appear in contemporary manuscript illuminations and paintings of the life of the Virgin. Her chamber may contain a bed on a platform, as shown by van Eyck's close contemporary Rogier van der Weyden. In his first *Annunciation* (Prado, Madrid), a work that may predate the Arnolfini portrait, the Virgin's bed has one curtain looped up, and a high-backed chair with a red cushion close beside. In a later *Annunciation* (Louvre, Paris), the curtains all hang straight down, and the room also contains a settle with lion finials, red cushions and the sides carved with the standard cusped arch and berries. So it seems that Campin, van Eyck and van der Weyden were all drawing on the same repertoire at much the same time, not necessarily copying each other but recording what they felt was appropriate for the particular setting. van Eyck was paying the Arnolfinis a great compliment

by surrounding them with the furniture artistically associated with Christ's mother.

An even greater compliment was his reference to their wealth, for the vivid red textiles in the room proved they could afford to surround themselves with the most expensive materials of the day. Textile historian J. J. Munro has calculated that in 1440 one Flemish scarlet cloth, or *scarlatto*, cost the equivalent of the wages of a master mason for two years and two months; or 6,000 pounds of Flemish cheese; or 1,100 litres of fine Rhine wine; or 780 metres of coarse linen. The fabrics in the Arnolfinis' room – on the settle, cushions, chair arm, bed curtains and cover – would have required several of these fabulously expensive cloths.

The term 'scarlet' did not originally describe a specific colour but a superior type of woven wool, made silky-smooth by the long and complex procedures of fulling, teasing, clipping and shearing, only available in Flanders, with Bruges a major centre of production. As red was an expensive dye, the cost of the colour became associated with the cost of the fabric, and *scarlatto* came to mean red cloth only. The costliest red dye, kermes, produced a range of hues called vermeil, violet, rose, sanguine and cramoisy. The word 'kermes' ('red worm' in Arabic) gave rise to 'crimson', but cramoisy referred only to silks dyed with kermes, while *scarlatto* was restricted to wool. Whether the Arnolfini textiles ever existed in the real world or whether van Eyck selected them from the visual storehouse of his imagination, those who saw the painting would have known they were *scarlatto*, yet another quality product that an Italian merchant would export from Bruges. Once again van Eyck refers to his patron's trade as the source of his wealth and social status. Yet at the same time, he offsets any material vanity by relating these worldly goods to the images and symbols of Christian art.

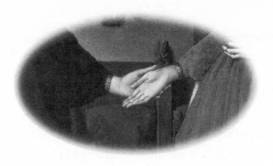

6. *Art Lover: Philip II*

Philip II was as much a pawn to Habsburg destiny as his aunt and great-aunt. Inheritor of the vast territories that had ultimately destroyed his father, his role was to produce male heirs to secure an infinite succession. Yet despite four marriages, Habsburg inbreeding took its toll. Philip's first wife was his first cousin twice over, while his fourth wife was his niece. Only one son survived into healthy adulthood. Determined to honour and obey the father who had trained him from birth for this role, Philip was reluctant to follow Charles's peripatetic existence, living in one kingdom after another with no permanent base. He made Spain the heart of his empire, and it was here that he indulged his passion for art and for building.

For Philip, Netherlandish painting was a key part of Spanish culture, and the early Flemish masters represented the proud Burgundian strand of the multiple Habsburg empire. Any work by van Eyck was therefore of merit, although the image of a married couple in a modest domestic setting (by Philip's standards anyway) might have meant less to him than to his great-aunt Marguerite. He inherited her whole collection in the Coudenberg palace, as well as the paintings Marie had left behind at Turnhout and those she had taken to Spain, and

acquired further works that proved his interest in his northern inheritance.

Philip concentrated on devotional painting, moved by the distinctive combination of religious intensity and contemporary precision of the Netherlandish style. van Eyck's *The Ghent Altarpiece* made such an impression that he commissioned Michiel Coxcie (Marie's former court painter, now director of the royal tapestry works in Brussels) to copy the whole masterpiece for the chapel of the Alcazar palace in Madrid. Its subject, the adoration of the mystic Lamb as a symbol of the Eucharist, was appropriate for the Habsburgs, who had a long-standing devotion to this rite. He had additional copies made of some of the individual figures from the altarpiece, and also commissioned replicas of two of van Eyck's Madonna paintings, and a St Francis. Further proof of Philip's taste for northern art was his unsuccessful attempt to acquire Metsys's *Lamentation* from the Antwerp furniture makers' guild; he did manage to buy van der Weyden's *Calvary* from the Charterhouse of Brussels. He already owned Coxcie's copy of the Louvain *Descent from the Cross*, which Marie had commissioned for him because she had bought the original herself. He also acquired Campin's *Annunciation*, and works by Gerard David, Jan Gossart, Michel Sittow, Juan de Flandes and Antonio Moro.

Antonio Moro, *Philip II of Spain*

Philip's favourite Netherlandish painter was Hieronymus Bosch of Brabant. The artist's combination of grotesquerie with medieval Christian symbolism, his way of blending sensuality with pain, and the surreal conjunction of fantastic and microscopically accurate landscapes epitomised the distinctive Spanish character and the fanatic power of Spanish religion. Philip's imposition of the Inquisition had contributed to the unrest in the Netherlands and the Council of Trent promulgated strict Catholic reforms to counter the dangerous spread of Protestantism. Philip inherited several works by Bosch from Marguerite's collection, and bought many more, including six from the estate of another avid collector, Felipe, son of Don Diego de Guevara.

Being a de Guevara supplied useful connections for life. Felipe transferred from Charles's household to that of Philip, and returned to Spain for good in 1543. He inherited his father's enthusiasm for art as well as his painting collection. On the basis of this expertise, in 1560 he wrote a pioneering history of art, the *Comentarios de la Pintura*. Its introduction declared that art had slept for centuries until it was awakened by Michelangelo and Raphael in Italy, and by van Eyck and van der Weyden in Flanders. Felipe made a bold attempt to define the differences in national styles, making a positive acknowledgement of Flemish art in an era of Italianate influence. This can only have arisen from Felipe's early exposure to Diego's collection, which included works by Bosch as well as the two van Eycks presented to Marguerite. Felipe dedicated the *Comentarios* to Philip, and boldly urged him to make his galleries accessible to art lovers because painting and sculpture only flourished if they were shared and not concealed – a daring exhortation to a Habsburg. Felipe died in Madrid in 1563.

The inventory of royal possessions and collections compiled after Philip's death in 1598 included 337 paintings. While it did not specify the van Eyck double portrait, it was by no means complete. Though listing the contents of various royal residences, the inventory excluded everything in the Escorial, the gigantic complex of palace, basilica, monastery and royal mausoleum Philip founded some 45 kilometres

north-west of Madrid to commemorate Habsburg power. Here he transferred the bodies of his father and mother, as well as Marie's. The more public areas contained suitably epic works by modern Italian masters, and imposing family portraits which were hung in a purpose-built gallery. However, Philip kept the paintings that meant most to him in his private apartments, including his works by Bosch. But there was no report of a van Eyck here.

In the earlier part of his reign, Philip's court had no fixed base, and the king travelled with his household, possessions and pictures (including his beloved Titians) to spend long periods of time in the largest castles of his court. The size of his entourage and the swelling bureaucracy of the court made a permanent home essential, so in 1561 he decided to settle in Madrid and resume the work Charles V had begun on modernising the Alcazar palace, a former Moorish fortress on a hill overlooking the city. When the luxurious renovations were completed in 1565, Philip installed many of the paintings he had inherited from Marie. This was the most likely location for the van Eyck, though another possible home was the palace of El Pardo, just outside Madrid, also begun by Charles V and finished by Philip as a country retreat in 1578. There were many works of art here but much of the building burned down in 1604, and the few paintings that survived were transferred to the Alcazar or the Escorial. Yet another palace was Aranjuez, which he began in 1565. So there was no lack of places to display the van Eyck, which may well have moved from time to time, as Philip expanded and reordered his collections.

In Philip's day the name of van Eyck, the '*Johannes de Eyck*' inscribed on the portrait, signified an artist whose works graced any collection and proved the taste and discrimination of the owner. During his reign the painting's fame spread beyond the restricted viewing circle of the king and his court. Sixteenth-century writers believed that van Eyck was not merely the master of realism but the inventor of oil painting, and they expanded his life with stories which grew in the telling, as one author embellished the works of another (done in the spirit of research rather than plagiarism). Like Fazio a century earlier, the Tuscan painter Giorgio

Vasari wrote about illustrious artists, in his *Lives of the Most Excellent Architects, Painters and Sculptors.* He aimed to demonstrate the superiority of modern Florentine art and show how it had developed through the ages, a theme which also conveniently flattered the enlightened Medici ruling family, his patrons. However, Vasari also sought to recognise the relative merits and contributions of artists from other regions and centuries. The first edition of his *Lives*, published in 1550, referred briefly to 'Giovanni of Bruges', the inventor of oil painting, who had passed on the secrets of his technique to Antonello da Messina. For his revised and expanded second edition of 1568, Vasari incorporated the eyewitness evidence of Lodovico Guicciardini, the Antwerp-based Italian merchant who had actually seen examples of van Eyck's work and who described *The Ghent Altarpiece* in a section on Flemish artists in his 1567 *Account of a Tour of the Netherlands.* Guicciardini had already drawn upon Vasari's first edition to repeat the claim that van Eyck invented oil painting, and Vasari returned the compliment in his second edition, which now included a proper account of Flemish painting based on Guicciardini's account. Guicciardini may also have come across Lucas de Heere, a Ghent poet and portrait painter, who affirmed van Eyck's connection with the altarpiece in St Bavo's (and that of his brother Hubert) in an ode in praise of the altarpiece in 1565. The ode included the absolutely unsubstantiable claim that the brothers included their own self-portraits amongst the crowd of riders in one of the panels, an alleged biographical detail that many subsequent writers accepted.

The first reference to the double portrait came from another Ghent author, the chronicler Marcus van Vaernewyck in his book *The Mirror of Netherlandish Antiquity (Dem Spieghel der Nederlandscher Audtheyt).* This was published in 1568, just too late for Vasari to have consulted it for his second edition. Van Vaernewyck attempted to define the nature of Flemish art and culture in a time of political unrest, when Netherlanders were rebelling against Spanish rule. The section on the van Eycks mentioned a small painting owned by the Queen of Hungary of a man and a woman holding each other by the hand as though united by faith. It is extremely

unlikely that van Vaernewyck had ever seen the original, which had been taken to Spain over ten years earlier. But it must have lodged in someone's memory, or he might have been describing a local copy of the work: at least two later replicas ended up in Spain and in Portugal. However, his account of how it came into Marie's possession was wildly inaccurate, for he claimed that she acquired it from a local barber, whom she rewarded with a place in her household worth 100 gulden. This story made no acknowledgement of the extensive collection Marie inherited from Marguerite, but it just might refer back to Don Diego's working in Marguerite's service. Elsewhere, he actually conflated the two female regents. Another example of his imaginative writing was an elaborated version of van Eyck's biography, inventing a sister, Margaret, who was herself a talented and prolific artist. This probably reflected genuine confusion with van Eyck's wife Margaret.

The next link in the written history of the portrait was Karel van Mander, poet and painter, and former pupil of Lucas de Heere in Ghent. Van Mander took Vasari's work as his model for the *Lives of the Illustrious Netherlandish and German Painters* (1604), arranged in a sequence of artistic development which began with the van Eycks, the founders of Flemish painting: 'it is astonishing that they appeared so perfect and brilliant at such an early date'. He drew on Vasari and de Heere to explain Jan's innovative rapid-drying oil-varnishing techniques, the secret ingredient being a combination of linseed and nut oil. He knew that Philip II owned Coxcie's copy of *The Ghent Altarpiece*, and repeated the text of de Heere's ode, which now hung in the Vydt chapel opposite the altarpiece; however, the latter was not normally visible because its shutters were kept closed. After listing van Eyck's better-known paintings like those in Florence and Naples (the information presumably taken from Fazio), van Mander referred to his 'many portraits, each one painted with great diligence and patience', and added that 'the same Jan also made one little painting in oils, two portraits of a man and a woman who offered each other their right hand as though they were embarking on matrimony and they were married by Fides, who bound them together'. This was a clear

misunderstanding of van Vaernewyck's account, because it assumed that the reference to 'faith' implied the presence of a third character who carried out the ceremony. Van Mander then repeated the story of Marie, 'this art-loving, noble princess', and the barber of Bruges.

The Rug

The rug by the bed has a dual function, with precedents both in art and in etiquette. A rug is often associated with images of the Virgin, and in secular terms Aliénor de Poitiers specified that there must be a carpet beside the bed in a reception or a birthing chamber. The rug in the Arnolfinis' room appears to be anchored under the feet of the settle and chair, and it stops behind the figure of the woman, who is not actually standing on it. The design of its central portion is concealed behind the bulk of her gown but the borders are visible, their patterns depicted with van Eyck's usual precision. It has three zones of decoration. The outermost is very narrow, consisting of a row of tiny, five-petalled rosettes in alternating light green, red and blue against a dark ground. The next border has larger motifs, geometric forms in light green or blue, alternating with a six-petalled rosette in white, all with red centres, and set against a dark blue ground, while the innermost band repeats this sequence, but moves it along one unit for the sake of variety. Without being able to see the centre of the rug, it is hard to say whether van Eyck was copying an actual model or simply creating from his prodigious memory something that looked right. He regularly featured rugs in other works to demonstrate his expertise in painting textures and textiles, like

all the surfaces he tackled. He enhanced the majesty of three of his seated Madonnas with a rug covering the steps of her throne to balance the rich brocades of the canopy and tester. The one in the *Madonna with Canon van der Paele* has the same six-petalled border rosettes as the Arnolfini example (both works were painted in the same year), while that in the *Lucca Madonna* has very similar rosettes in its central zone and an enlarged version of one of the geometric forms. However, van Eyck (or his workshop) employed the same pattern as a design for floor tiles, for example, in the posthumous *Madonna of Jan Vos* (c. 1450, Berlin). So he must have selected a range of standard motifs to create another luxury item of the kind he saw in the palaces of his patron, the Duke of Burgundy, without necessarily having to draw it from life.

Rugs were a rare commodity in fifteenth-century northern Europe, and they were meant for display rather than for standing on: Venetian painters showed them hung like flags from walls or windowsills to celebrate the city's festivities and processions. Even in the eighteenth century, artists were still showing rugs as table or sideboard covers rather than on the floor, because they were too valuable to be worn out by the passage of feet. Like so many other goods that reached van Eyck's Bruges, they were imported from the Islamic world by the wide-ranging Venetian traders, stockpiled in Constantinople, then taken from Venice in the annual galleys to Bruges, or carried by mule train over the Alps. Examples in fifteenth-century art are based on types made in Western Anatolia woven in the geometric style favoured by the Ottoman Turks and prized for their glowing colours and smooth pile-knotted surfaces, which contributed elegance and luxury to any setting. Desire for their distinctive products outweighed contemporary hatred of the Turks or suspicions of Islam, nor did the fact that many rugs were specifically designed for praying to Allah arouse anxiety. Displaying such an item was further proof of the Arnolfinis' gentility and wealth: only rich people had rugs, and in court circles displayed them beside beds. At the same time, it paid homage to the wife's piety by visually associating her with yet another artistic attribute of the Virgin.

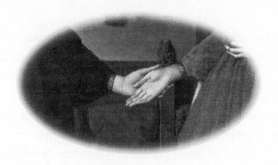

7. Spanish Palaces: From Philip to Napoleon

W hile the double portrait was establishing its reputation in the canons of Netherlandish art-history writing, its presence in Madrid meant that privileged visitors could see it. Wherever Philip II had originally hung it, it was definitely in the Alcazar by 1599 and was noted by a young German traveller. Jakob Quelviz from Leipzig spent most of that year touring Spain with a companion and wrote up his travels in the form of a journal, accompanied by illustrations. This was an enthralling text which covered the geography, customs and monuments of a mysterious and alien country.* Describing his tour of the Alcazar, Quelviz noted in the Salle Chiqua 'an image where a young man and woman are joining hands as if they are promising future marriage' and added, 'There is much writing'. This was not just van Eyck's inscription or the motto of the de Guevaras on the shutters (as mentioned in Marguerite's catalogue), but additionally two lines of Latin verse which he helpfully copied out (though slightly mistranscribed). It was a

* This has never been published but the original manuscript survives in the British Library. It was not until 1994 that Spanish art historian Fernando Checa, who consulted this document when preparing an exhibition on the history of the Alcazar, realised that Quelviz had described the Arnolfini portrait.

quotation from Ovid's satire *The Art of Love* (*Ars Amatoria*), translated as: 'See that you promise: what harm is there in promises? In promises, anyone can be rich.' This was part of the poet's advice to impoverished young men on how to get a girl – lie through your teeth – a text that gave the apparently innocuous portrait a surprisingly cynical interpretation.

Marguerite was unlikely to have had the verse added, because her cataloguer still knew of the Arnolfini connection. But Marie and Philip II both demonstrated a fashionable appreciation of Ovid by commissioning Titian to paint scenes from the *Metamorphoses*; for Marie he created the four huge canvases of *The Damned* for Binche that she took to Spain, and for Philip, six *Mythologies*, which eventually hung in the Alcazar. This demonstrated the later sixteenth-century fascination over the classical mythology underlying Christian philosophy, which made Ovid a topical subject. Adding his lines to the small portrait that had long belonged to the family gave it a meaning (although a totally misleading interpretation of the well-dressed Arnolfini as a poor man making a false promise) and brought it up to date. It is significant that the verses were of more interest to Quelviz than the name of the artist, which he did not note or perhaps even recognise.

The next recorded sighting was a century later. The painting was not included among the list of royal goods compiled after the death of Philip IV in 1665, but was listed as still being in the Alcazar in the 1700 inventory of the late Carlos II. This entry confirmed Quelviz's mention of the Ovid quotations, and located them on the gilded frame. And it described another ornamental feature, the fact that the wooden shutters had been painted to imitate marble. As to the meaning, the inventory announced that the scene represented a pregnant German woman, dressed in green, giving her hand to a youth; they were getting married at night, but the verses declared that they would deceive each other. The compiler must have been in too much of a hurry to look at the painting properly, otherwise he might have noticed the sunshine outside the window, and the fact that the man was much older than the woman. He valued the work at 16 doubloons.

Carlos II was the last Habsburg king of Spain. He had no direct heir, and, following the inevitable succession conflict, was succeeded by Philip V, grandson of Louis XIV and a member of the house of Bourbon. For this new dynasty, the Austrian–Netherlandish elements in the royal art collection would have meant very little. In 1734, a fierce fire destroyed the Alcazar and many of the paintings in it. Miraculously, the van Eyck survived and was next seen in the new palace, the Palacio Real, constructed on the old site during the 1750s. The new building was ostentatiously decorated by modern artists, and became the home for most of the royal artworks.

The superintendent of the collection did not bother to include the van Eyck in the catalogue that he compiled in 1787 for Richard Cumberland. An unsuccessful English playwright who briefly lived in Spain, Cumberland decided to revive his career by writing a Vasari-style *Anecdotes of Eminent Painters of Spain*, and supplemented the second edition with an extra volume based on the superintendent's work. This provided a fascinating insight into how the royal family displayed their masterpieces. There were forty Titians in the most public rooms of the Palacio Real, together with works by Velázquez and Bassano. Netherlandish artists, however, were no longer prominent (except for Rubens, a figure of international renown), confirming how tastes had changed from the sixteenth to the late eighteenth centuries. There was a handful of Bruegels, and, in the private space of the King's Closet, a series of small paintings by Teniers and a landscape by Wouvermans; in the Second Closet there was a Dürer. Cumberland criticised the poor hanging throughout the palace, but stated that matters were even worse in the Escorial, where the gloom made it impossible to see anything properly. He described rather summarily some paintings kept in the Buen Retiro palace, where he noted some Flemish works in a passage and other possibly valuable items in dark corners. The contents of that neglected palace alone, he said, were enough to fill a superb new gallery.

Cumberland aimed his book at connoisseurs such as the exquisite William Beckford of Fonthill, who visited Madrid in December 1787,

and whose travel diary recorded his pleasure at strolling in the Prado complex, although he found the ambience not particularly Spanish. In the Museum and Academy of Arts, he was impressed by the Persian vases and antique casts, but hated 'several fierce, obtrusive daubings by modern Spanish artists' – presumably including Goya. Much better was the Palacio Real, where he 'enjoyed the entire liberty of wandering about unrestrained and unmolested. I remained in total solitude, surrounded by the pure unsullied works of the great Italian, Spanish and Flemish painters.' His favourite was a Raphael Madonna. He even penetrated the king's bedchamber, where he noted caged songbirds and mechanical chiming clocks.

The reason Cumberland and Beckford failed to see the van Eyck in the Palacio Real was its location. According to the inventory compiled in February 1794, after the death of Carlos III, it was kept in a *retrete* – the modern translation is 'lavatory' – in the royal family's private quarters. Keeping favourite paintings in such a very intimate space appears to have been customary then. That catalogue entry simply described the painting as 'a man and a woman holding hands' by Jan van Eyck, the inventor of oil painting. There was no mention of marbled shutters or lines from Ovid. Perhaps it had been reframed. The compiler recorded the dimensions (which correspond approximately to those of the work now in the National Gallery), and estimated the value at 6,000 *reals*.

The French shared Cumberland's implied view that modern Spain neglected its artistic heritage. They regarded the country, its official ally against England, as backward, insular, uncivilised even, because it had ignored the Enlightenment. 'Greek slaves in Constantinople have more freedom than labourers in Madrid,' sneered Voltaire. Extracting masterpieces from Spain, whether by national or by foreign artists, was already accepted practice because art collectors claimed moral justification in acquiring their neighbours' goods. In 1779, for example, the Comte d'Angivillier, responsible for the French king's arts and buildings, wrote to their ambassador in Madrid: 'I know that there are old master paintings lost and forgotten in attics in Spain. I know that dealers have not

yet got there . . . please let me know if you foresee being able to find some paintings or other curiosities in the storage rooms of private houses'. It was this sort of approach that had inspired Carlos III – a sort of benevolent despot attempting to drag his country, however belatedly, into the eighteenth century – to impose an art export ban in that same year. Its lack of success can be measured by the lament uttered by the artist Manuel Acevedo five years later that 'paintings of the most famous [Spanish] painters as well as foreign have been acquired at great cost . . . it has become sensitive and painful to such a degree to see the best works not only being taken out of the kingdom, as happens every day but also the wretched prices at which they were disposed and sold.'

Carlos III died in 1788; the posthumous inventory that mentioned the van Eyck was not compiled until 1794, an example of traditional Spanish delaying tactics that so infuriated visitors from other European countries. He was succeeded by his son, the lacklustre Carlos IV, who, with his formidable wife (inevitably his first cousin) Maria Luisa and their children were painted by court artist Francisco Goya, in a memorable official portrait which its plain, proud subjects evidently liked but which many modern viewers interpret as cruel caricature. The court moved regularly between the various royal residences, for the king and queen did not like living permanently in the capital city, which they described as 'the centre of gossip and scoundrels, that Babylon of Madrid'. One cause of gossip was the rise of the royal favourite Manuel Godoy, the king's chief minister and the queen's former lover, who lived for a while in the art-stuffed Buen Retiro palace in Madrid.

The Revolution and the subsequent European wars enhanced French greed for art from Spain. Seventeenth-century and eighteenth-century connoisseurs may have ignored van Eyck, but Napoleon's restructuring of Europe – 'Roll up the map!' said Prime Minister William Pitt – made Netherlandish art desirable again. As Bonaparte moved into the Netherlands, the early Flemish masters were claimed as part of a wider French culture and targeted for display in the Louvre. Spain, with its Burgundian–Habsburg legacy of art, was a covetable source.

Late in 1800 General Napoleon Bonaparte appointed his troublesome younger brother Lucien the new ambassador to Spain, recalling him a year later. Lucien left Madrid with a collection of around 300 paintings. During his short time in the capital, he had become intimate with the controversial royal favourite Manuel Godoy, and it was noted that some of Lucien's loot came from the collections in the Buen Retiro palace, which Godoy then occupied. This was all too familiar. One disgruntled Spaniard remarked in 1801: 'So many and so alike are the foreigners who, on their own or through subalterns, continue today to take the steps and do the research in order to acquire paintings in and outside of the court, penetrating into all places and homes.' So brazen was Lucien's theft that Carlos IV swiftly, on 14 October 1801, reaffirmed his father's export ban but it was just as ineffective; Napoleon knew that his brother, protected by diplomatic immunity, had been stealing national treasures but he did not care. Napoleonic plundering of old Spanish masters would be far worse seven years later, following his invasion of Spain.

Among Lucien's haul was a work thought to be by van Eyck. It was in fact a Memling but this was a common enough mistake at the time, when one early Flemish hand looked much like another to eyes more accustomed to renaissance and baroque styles. Connoisseurs, however, were becoming increasingly appreciative of the northern tradition and of van Eyck's seminal position within it. This was due in part to the artist and author Jean-Baptiste Descamps whose *Lives of the Flemish, German and Dutch Painters* (1756–63) drew heavily on the now forgotten van Mander's *Lives* to explain the obscure early Netherlandish tradition to a modern French audience. In his section on van Eyck Descamps simply echoed van Mander on the double portrait; it showed two young people about to get married, and had been bought by Marie of Hungary from a barber. This helped to revive the name of Jan van Eyck, 'inventor of oil-painting', and provided further grounds for France's official policy of art reclamation.

Despite the depradations of greedy foreigners, the magnificent art collections of Madrid remained a magnet for cultivated tourists, the sort of people for whom Richard Cumberland had intended his guidebook.

One inexhaustible visitor was Elizabeth, Lady Holland, who arrived in Spain in 1802 and spent nearly three years there in search of a healthier climate for her sickly young son. Her journals give a vivid picture of the attractions of an insecure country clinging to old rituals in a time of change: she refers scathingly to Napoleon Bonaparte as 'the Corsican chieftain' although he was already First Consul for life and formulating plans to invade England despite the current Peace Treaty of Amiens.

In July 1803, Lady Holland visited the Escorial: 'the pictures in the sacristy are very fine, but we had no light to distinguish them as a heavy storm was approaching'. On a subsequent visit she admired the library, with its beautiful manuscripts and full-length portraits of the 'Austrian kings' from Charles V to Philip IV and learned that two monks still prayed incessantly for the soul of Philip II, as they had been doing in six-hour shifts ever since his death. In August, the party cheerfully endured the scorching heat of Madrid (which the royal family always abandoned for Aranjuez in summer) for its cultural treats. She reported Carlos IV's attitude to art on a visit to the Academy where 'by favour we were admitted into the forbidden apartment into which the pious monarch has banished all naked pictures; indeed an order was given for their destruction, but upon a promise being made that the eyes of the public should not be shocked by such sights, they were spared . . . they are merely a beautiful Venus, Danae and others of that sort, by Titian, Albano and other celebrated masters: some are exquisite and might compare with those formerly at Naples and Florence.'

In the royal palace she noted works by Velázquez and Titian and in the now empty Buen Retiro 'a few excellent pictures alone remain', including portraits by Titian and Velázquez, but also some Flemish paintings – 'admirable pieces' – recorded by Richard Cumberland. The Casa del Campo, the king's hunting lodge just outside town, provided a clue as to the royal family's opinion of the Netherlandish paintings collected by Marguerite of Austria and Philip II: 'The house is small and insignificant . . . There are some pictures mouldering on the chamber walls, chiefly bad portraits of the Austrian family. Some inexplicable allegories on

human life by Jerome Bosch.' The van Eyck was presumably still in the royal lavatory in the palace and not on the tourist trail.

Napoleon's conquests encouraged the removal of allegedly neglected art from Spain. He argued that the way to save works from destruction or decay in their homeland was to bring them to Paris, new cultural capital of the civilised world. It was also an effective way of rubbing in the triumph of the French. Before his revolutionary army occupied the southern Netherlands in the late summer of 1794, the recently founded Arts Commission had drawn up a list of works to be confiscated, in accordance with the new official policy. It distributed the list to the army, and sent out art specialists to supervise the handling, packing and shipping of these acquisitions to Paris. With Flanders now designated a province of France, it was open season on the works of van Eyck, thanks to Descamps' book. The French army accordingly seized the central panels of the Ghent altarpiece. (Ingres's 1806 portrait of Napoleon as emperor was inspired by the figure of God in the altarpiece, which was then on view in the Louvre.) Soldiers also removed the *Virgin with Canon van der Paele* from St Donatian's in Bruges before demolishing the ancient building altogether. They took many other paintings, including over forty by Rubens, for the seventeenth century was still more popular than the fifteenth. In September 1794, the Louvre put on a temporary exhibition of looted Netherlandish art to glorify French victories.

The Netherlands campaign served as a model for stealing art in Napoleon's later wars. When he marched into the Italian peninsula in 1796, he made the surrender of works of art one of the conditions of peace treaties with the surrendering states. As a result statues, paintings and bronzes poured into the Louvre (soon to be renamed the Musée Napoléon) in a stream which almost overwhelmed Dominique Vivant Denon, Napoleon's Director-General of Museums. Denon was aware that looting by the army was not the best way to acquire good-quality art, quite apart from the protests such confiscations engendered. So he became more selective, travelling in person to the defeated country in order to choose the very best works for Paris. He also appreciated that these had to be

properly registered and well looked after, especially because one excuse for removing them was to rescue them from local neglect.

Denon reorganised the Musée Napoléon to emphasise the sequence of development of the great masters under the inspiration of a recent French translation of Vasari. Since van Eyck held a canonical role as the inventor of oil painting, this justified the acquisition and display of further works by him. Denon's so-called 'van Eycks' included Memling's *Last Judgement* and Gerard David's *Marriage at Cana*. However, he also obtained authentic examples, such as *The Virgin with Chancellor Rolin* from Autun, and the *Portrait of Jan de Leeuw* from Vienna. Napoleon's invasion of north Germany in 1806 'released' around a thousand new paintings for Denon to incorporate into his ambitious displays. Two years later the emperor turned his attention to Spain.

The Oranges

More evidence of money, and perhaps of virtue too, are the oranges in the painting, three on the chest under the window and a fourth on the windowsill. Visually, they contribute lively patches of colour which draw the eye to the otherwise dark, lower left side of the room, and offer yet another opportunity for van Eyck to demonstrate his virtuoso techniques. The orange on the sill looks almost three-dimensional because it casts a shadow and is simultaneously reflected on the window frame behind it, a stunningly effective piece of observation and illusionism. The three on the chest are beautifully modelled too, made tangible by the curves of the delicately indented, crinkly skin and soft highlights on top where the light falls from the window. They are a tour de force of still life in miniature at least a century before any other painter was working like this.

But van Eyck was not painting fruit just to show off his skills. In Bruges, oranges were a treat and a rare delicacy imported from the far south for the few who could afford them. The Spanish traveller Pero Tafur noted amongst the goods being unloaded at Sluys in 1438 'oranges and lemons from Castile, which seemed only just to have been gathered from the trees'. Citrus fruits originally came to the West from India in

the wake of Alexander the Great's conquests. They could not grow in the north but were abundant around the Mediterranean. The Romans cultivated them in Palestine, southern Italy and Sicily, and the Moslems spread them to Spain and Portugal, with the aid of pioneering irrigation schemes. By the fifteenth century, Andalucia was the main source of the oranges and lemons exported to Flanders.

In the north, oranges were mainly prized for their cooking properties. Seville's bitter oranges, still the best for marmalade, were the basis for sharp-flavoured sauces that livened up dull Flemish winter fare by giving more flavour to meat or fish, and the pungent oily peel was just as important as the juice. The high cost of oranges and lemons meant that they were a preserve of the elite. At a dinner for clerics in Paris in 1412, for dessert the guests were each served one apple but only half an orange, for oranges cost six times as much as apples. The price was not such a concern for rulers. The King of France was served with fried oranges as garnish for a hare pie in 1457, and the Duke of Burgundy had lemons squeezed over his roast fowl. Citrus fruits were also appreciated for their medicinal properties: doctors recommended carrying and smelling them in order to stave off the plague.

Van Eyck probably saw them actually growing during his travels in the Iberian peninsula, for he included orange trees among the exotic vegetation he painted in *The Ghent Altarpiece* of cypresses, palms and olives. In the portrait, however, he was not only implying that the Arnolfinis' cook could afford to make bitter orange sauce, but employing an artistic device that connected his innovative domestic setting with the established context of religious painting, and again referred specifically to the Virgin. Images of Eve giving in to the serpent's temptation and seizing the forbidden fruit were frequent in manuscript, sculpture and stained glass, and often occurred in direct association with the scene of Mary with the Annunciation angel, contrasting one woman's disregard of God's word with the submission of the other. But the exact identity of Eve's fruit was unclear, both theologically and artistically, and this was further confused by misleading terminology which described oranges as 'apples'

or sometimes 'golden apples'. When van Eyck painted his naked Eve for *The Ghent Altarpiece*, he placed in her hand not an apple or an orange, but a citron, knobbly-skinned cousin of the lemon, a fruit so pithy that it was consumed for medicinal rather than gastronomic qualities. Confusingly, the citron was known as 'Adam's apple', in Latin *poma citrina*.

Another association with the Virgin was the legend that she picked oranges on the Flight into Egypt in order to quench her Son's thirst. van Eyck referred to this incident by including the fruit in two of his Madonna paintings. In the *Lucca Madonna*, he placed two oranges on the windowsill of her chamber, a motif he (or his workshop) repeated in the *Ince Hall Madonna*. However, the purely religious connotations were subverted by the single orange on the sill in the undeniably secular context of his naked *Woman at her Toilette*. The fruit and its blossom could also symbolise love and the marriage ceremony, so the Arnolfinis' oranges might have been a subtle reference to their relationship as well, perhaps even specified by the client as a distinctively Eyckian motif.

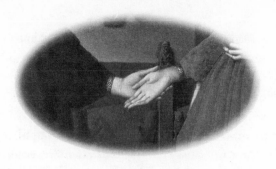

8. The Uninvited King of Spain: Joseph Bonaparte

Napoleon said of his brothers, 'They are nothing without me; they are great men only because I have made them great.' No one would have regarded his brother Joseph as a great man. He was well-meaning, considerate and cultivated (he collected art and wrote a novel, *Moina, the Peasant Girl of Mont Cenis*), but he was not up to the daunting responsibilities Napoleon imposed upon him of becoming King of Spain, running the country and commanding the army of occupation. This was deliberate. Though Napoleon despised his greedy, pliant family, he knew he could command their self-interested loyalty and therefore dominate them more than any ambitious outsider.

Joseph was the eldest, Napoleon's senior by nineteen months. They were said to be close during childhood, but the younger, tiny, driven man envied his big brother's charm and confidence and in the end controlled him like a puppet. After Napoleon made him French ambassador to Rome, Joseph began his career as a collector by allegedly looting artworks from the Pope. These were all lost at sea. After conquering Italy, Napoleon appointed Joseph King of Naples, where he ruled happily for two years, becoming a keen patron of the arts and presiding over a languid and luxurious court. But after Napoleon sent his troops into the country of his ally, Spain,

purportedly to tackle the threat from their mutual enemies, Portugal and England, his intervention in the succession crisis between Carlos IV and his son Ferdinand resulted in the king's abdication in 1808 and the heir's flight into exile that year. So Napoleon filled the vacancy with the reluctant Joseph, who as new King of Spain became the owner of the royal art collections in Madrid and elsewhere, including the van Eyck double portrait.

Imposed as the ruler of a country under military occupation, Joseph was in an impossible situation. The Spaniards called him *il re intruso*, the uninvited king. More coarsely, they nicknamed him 'Pepe Bottles' because of his drinking habits. (Lady Holland, on a second visit in 1809, also referred to him disrespectfully as 'King Pepe'.) He depended for such powers as he possessed on the presence of some 200,000 French soldiers and the backing of Napoleon's generals, who despised Joseph because, although nominally head of the army of occupation, he was only an amateur soldier. Yet he wished his reluctant subjects well, and was genuinely torn between defending French or Spanish interests.

Robert Lefevre, *Joseph Bonaparte, King of Spain*

Joseph's dilemma was epitomised by his attempts to protect Spain's artistic heritage from the official acquisitions policy of Napoleon and Denon, and other more established predators. An 1810 memorandum compiled by the Spanish Academy of Madrid complained of how the French surpassed even the English in the illegal export of artworks. One of the greediest was Marshal Soult, Joseph's own chief of staff and governor of Andalucia, who formed a magnificent art collection as a result of his service in the Peninsula. English dealers also took advantage of the opportunities for snapping up neglected masterpieces there. The most persistent and successful was William Buchanan, who sent out an agent in 1807 'with a view to acquiring some of those works of art which war and revolution invariably cause to change masters'. He learned not only that the French 'generals made little scruple in selecting from the convents many of the finest works of the great masters' but that 'many fine things are in the possession of the old noble families and are very little regarded'.

Joseph tried to retaliate by reinforcing the art export ban. The most serious threat, however, was the arrival of Denon himself in November 1808, on an official mission to acquire paintings from the Flemish and Spanish schools for the Musée Napoléon; he had already lamented to Napoleon that the museum had so few Spanish artists. Murillo was the most sought-after name, but Velázquez was also starting to be appreciated.

Napoleon himself came in January 1809, when he reminded Joseph of their requirements:

> *I wrote to advise you to make your entry into Madrid on the 14th. Denon is anxious for some pictures. I wish you to seize all that you can find in the confiscated houses and suppressed convents, and to make me a present of 50 masterpieces which I want for the Museum in Paris. At some future time I will give you others in their places. Consult Denon for this purpose. He may make proposals to you. You are aware that I want only what is good, and it is supposed that you are richly provided.*

More ominously, Napoleon commanded his brother to place cannons and mortars in the Buen Retiro palace, still home to some royal art: 'This measure will make the inhabitants manageable and docile, which will be an incalculable advantage to everybody.'

So successfully did Joseph drag his feet over presenting these fifty 'masterpieces' that not one reached Paris for four years. He managed to stand up to his brother without actually disobeying him, and was determined to protect his new subjects' heritage from French greed. Spanish *mañana* may also have played a role. Denon's correspondence reveals growing exasperation at the time lost and the burgeoning costs. In July 1813 he referred to the imminent arrival in Paris of the fifty paintings and the expenses for packing and transporting six crates of art from Madrid to Bayonne – insurance, feeding horses for twenty days, plus the unexpected cost of compensation for a horse shot dead by insurgents. And when the works arrived, he decided they were not good enough to display and complained that Joseph had been deceived. Joseph was deceiving him.

To prevent his brother from demanding any more works, Joseph issued a decree in December 1809 that announced his intention to establish a national art gallery in the elegant Prado building begun by Carlos III. It would be called the Museo Josefino, and would be Spain's version of the Musée Napoléon. This was a clever way of complying with Napoleon's policy of establishing centres of art throughout the whole empire, while also commemorating himself as a great benefactor. So he began to gather suitable works of art from the royal palaces, the dissolved monasteries, and anywhere that he chose: he even seized some Murillos from the city of Seville when it refused to make him a loan. As the Prado was still being used as a cavalry headquarters, Joseph's acquisitions were stored in conditions which the Madrid Academy later deplored: 'three years in a humid location where there is danger that the objects will deteriorate and be destroyed . . . many valuable pictures are without stretchers . . . detached canvases piled up one on top of another in which state they are exposed to harm'.

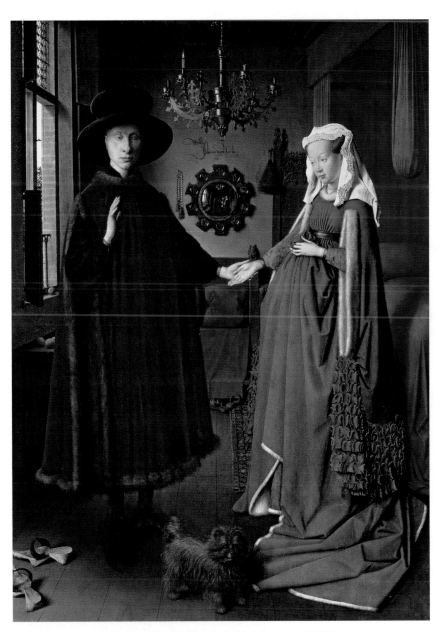

Jan van Eyck, *The Arnolfini Portrait*, 1434

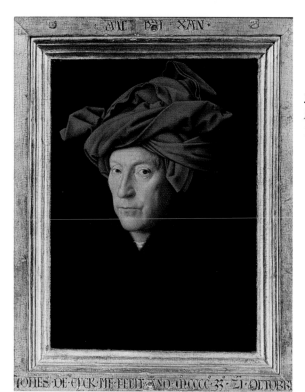

Jan van Eyck,
Man with Red Turban,
1433

Jan van Eyck,
Margaret van Eyck,
1439

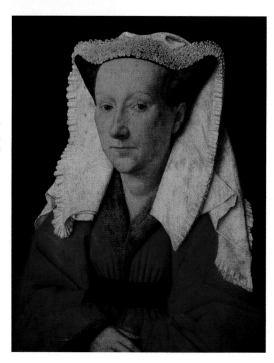

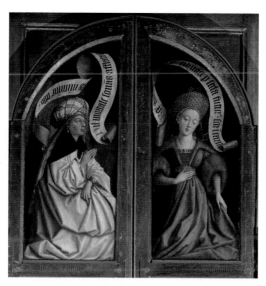

Jan van Eyck, the Erythrean and Cumaean Sibyls,
on the outer shutters of *The Ghent Altarpiece*, 1432

Jan van Eyck, *The Ghent Altarpiece*, 1432

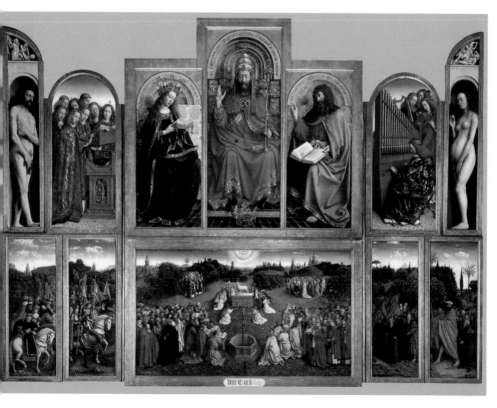

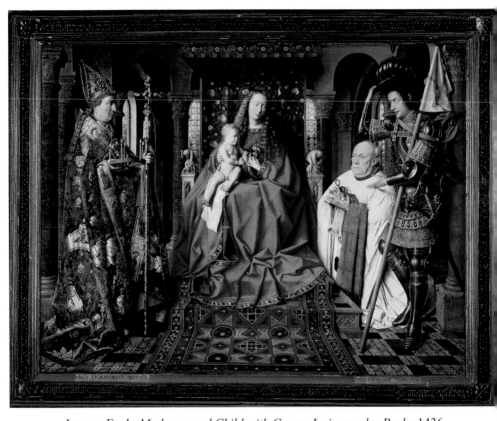

Jan van Eyck, *Madonna and Child with Canon Joris van der Paele*, 1436

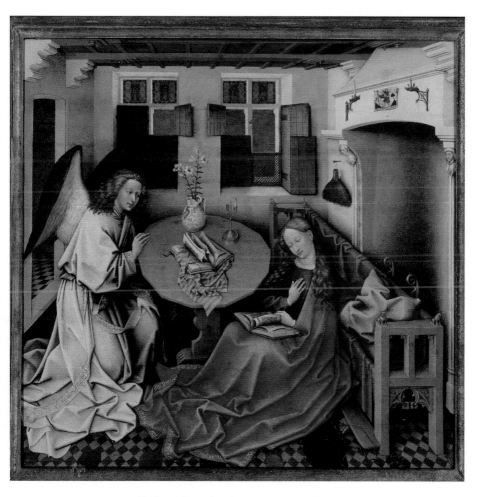

Robert Campin, *Annunciation*, 1420s

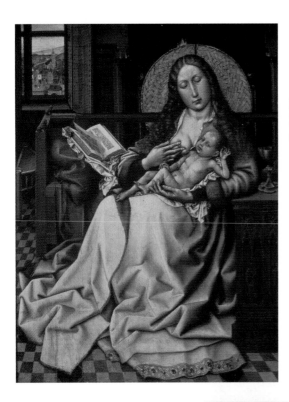

Robert Campin,
*Virgin and Child before
a Firescreen*, *c*. 1440

Rogier van der Weyden,
The Magdalene Reading, 1438

Rogier van der Weyden, *Annunciation*, 1430s

William Holman Hunt, *The Lost Child*, 1861

Ford Madox Brown, *'Take your son, Sir'*, 1851–2

Edward Burne-Jones, *Portrait of Katie Lewis*, 1886

William Orpen, *The Mirror*, 1900

Benjamin Sullivan, *Mum*, 2009

Martin Rowson,
'Bill Clinton and Tony Blair –
the Special Relationship',
Guardian, 1996

Anthony Browne,
from *Willy's Pictures*, 2001

Van Eyck had a firm place in this grandiose scheme. The 1794 inventory of the royal art collection served as a basis for Joseph and his advisers. With the renewed interest in Flemish art, a van Eyck in Madrid was again a status symbol, as were the other Netherlandish paintings that Marie of Hungary brought to Spain and Philip II purchased. Joseph probably had the double portrait removed from the palace's domestic quarters and added in some storeroom to the growing pile of exhibits intended to grace the walls of his future Museo Josefino. For this purpose, he emptied the Escorial. A visitor there in 1812 noted that 'the splendid gallery containing the noblest specimens of the Italian and Spanish schools, all had vanished. The Madonnas of Rafaelle, the Sebastian del Piombo, the Venus of Velázquez no longer graced its walls. The mausoleum of the royal family alone remained perfect [despite] the wantonness of French spoliation.'

Joseph's grand ambitions came to nothing because the English, Portuguese and Spanish armies gradually forced the French to retreat. Wellington's forces temporarily occupied Madrid in the summer of 1812, and Joseph fled, only returning after Marshal Soult retook it for the French in December. Napoleon's retreat from Moscow that winter made him recall many troops from Spain in order to boost the gravely depleted grand army. Among those he summoned was Soult, who returned to Paris in March 1813, 'taking with him a large number of valuables which he had brought from Andalucia', according to Count Miot de Melito, head of Joseph's household, and an eyewitness to the disintegration of French rule. These valuables included an impressive collection of paintings by Murillo and Velázquez, which Soult had seized from churches or private houses in Seville in compensation for civilian attacks on his men. Others who demonstrated the ineffectiveness of Joseph's art export ban included General Sebastiani and Monsieur de Crochant, paymaster-general to the French army in Spain: the magnificent art collections they amassed were later sold by the London dealer Buchanan, who had also built up a fine stock of his own.

It was obvious that French days in Spain were numbered. In January 1813, Napoleon ordered Joseph to evacuate Madrid and establish new headquarters in Valladolid, with the aim of controlling northern Spain only. The uninvited king decided to evacuate much of the royal art collection as well and annoyed his brother by delaying his departure until the middle of March. No doubt he was slowed down by the need to organise the removal of his treasures, as well as of his staff and all their possessions. It was only now that he took the final steps for sending the fifty masterpieces he had promised Denon in 1809, ultimate proof of his delaying tactics. He followed this, however, with an even larger batch of artworks for the Musée Napoléon, twenty-three chests containing at least 250 paintings, many of which came from the royal palaces and hunting lodges. These did not reach Paris until September, when Denon complained that their transport had cost almost 25,000 francs, but that only six were good enough to hang in the museum. The reason for their relatively poor quality was that Joseph had kept the best for himself. When he abandoned Madrid, on 17 March 1813, the royal baggage train carried a stack of canvases by Raphael, Titian and Velázquez which Joseph intended for his chateau in France. He also took the van Eyck.

Although he was meant to be in charge of the three French armies in Spain, their commanders refused to liaise with him, nor would Napoleon communicate with him directly any longer. The emperor blamed his brother for the retreat, believing, he said, that 'all the blunders in Spain stem from my ill-advised kindness to the King who, besides not knowing how to command an army, is in addition incapable of judging his own abilities accurately, and of leaving the command to a soldier'. Couriers took two to three weeks to travel between Paris and Valladolid, if their messages ever got through at all, so Napoleon's stream of instructions and Joseph's defensive replies were seldom relevant. As Wellington neared Madrid, Napoleon ordered the total evacuation of the area, and all remaining troops and a huge column of refugees departed north. These included French civilians and Spanish collaborators; the old aristocracy

had removed themselves but Joseph's glitzy court had attracted a new crowd of arrivistes and hangers-on. Joseph waited for the convoy to reach Valladolid in early June, before setting off for the French border, his soldiers almost outnumbered by some 20,000 refugees travelling with 3,000 wagons of possessions.

Among the Madrid evacuees was Andrew Leith-Hay, a young British soldier whom the French had captured earlier in the year and imprisoned in the Buen Retiro palace after interrogation by Marshal Soult, a man of 'neither a gentlemanlike nor soldierly appearance . . . a parvenu of the vulgarest and lowest description,' according to Leith-Hay. On 27 May, the hostage joined a convoy of 'persons of rank, quantities of carriages, cars, wagons or laden mules . . . Accompanying the Army of the South, numerous ladies, dressed en militaire and on horseback, having forsaken the plains of Andalucia, followed the fortunes of their Gallic lovers . . . the assemblage was motley in the extreme, nor could it be doubted that habits of luxury . . . had to a great degree encumbered the French armies.'

On the evening of 19 June 1813, they reached the town of Vitoria, set in an undulating plain between the river Zadorra and the foothills of the Pyrenees; this was an important junction bisected by the main road to Bayonne, the nearest town over the French border. Despite dreadful overcrowding, Joseph intended to stay there for some time while he awaited the cavalry reinforcements he believed, mistakenly, to be approaching. There was a strange atmosphere of festivity: Leith-Hay noted that 'at night, Vitoria was illuminated in honour of the soi-disant king'. However, Joseph and his commander-in-chief General Jourdan had underestimated the proximity and the size of Wellington's forces, which included a large component of flexible cavalry. Joseph had never planned to stand and fight at Vitoria and all troop movements were severely hampered by the chaos of the accompanying refugees who blocked all the roads. They even immobilised some of the guns by commandeering artillery horses to drag their luggage carts. Heavy rain fell on 19 June, causing appalling conditions underfoot.

The following day, a day of light showers, Joseph learned that it was too late for flight because the English, Portuguese and Spanish troops, whom he had assumed would only attack from the west, had nearly encircled the town. The only escape route was north-east, the high road to France, but time was running out. At 2 a.m. on 21 June, Joseph dispatched a large convoy of baggage towards the frontier. This contained some of the stolen works of art and other treasures from Madrid, and was escorted by an infantry division which he could hardly spare. (This convoy did reach France, bringing the paintings that so disappointed Denon.)

Joseph and General Jourdan prepared to face the enemy, who started their advance at 8 a.m. Ironically, the weather had improved. 'The nature of the ground and the fine day gave it truly the appearance of one of those pictures of a battle drawn from fancy,' as one British cavalry officer reminisced. The cavalry won the day. The French, outflanked and outnumbered, realised by the middle of the afternoon that they had lost and that the allies were almost upon them. This caused panic among the refugee train. As William Napier, general and historian of the Peninsular War, described it, 'beyond the city, thousands of carriages and animals and non-combatants, men, women and children were crowding together in all the madness of terror. And as the English shot went booming overhead, the vast crowd started and swerved with a convulsive movement, while a dull and horrid sound of distress arose . . . it was the wreck of a nation.'

Joseph gave orders to retreat. The 10th Hussars charged his fleeing party and nearly captured him but were fought off by his own light horse guards. Joseph leapt from his carriage and escaped on horseback over the fields. The desperate French – both soldiers and terrified civilians (one French officer described the camp followers as a mobile brothel) – headed for the only way of escape, a narrow road to the east which at once became a solid traffic jam. Count Miot de Melito, accompanying Joseph, reported how they left the battlefield but 'both the road and the plain that it crosses were obstructed by the great park of artillery

– men were spiking the guns – by a train of wagons and treasure chests, containing several millions in coinage which had been left open for all, by the king's carriages ready for starting, by those belonging to the generals and heads of the military administration and by quantities of luggage of all kinds'.

The baggage train saved the French, for many British troops got distracted from pursuit by plundering the convoy: 'The fortunes amassed by generals, officers and civilians during five years of warfare, plunder and extortion were all abandoned and became the prize of the conqueror . . . the ardour of the enemy to seize on the splendid booty within their reach saved the French army from destruction.' Somewhere among the chaos, in one of the abandoned carriages of the king's train, was the van Eyck portrait.

The previous day the hostage Leith-Hay had been exchanged for a French captive, having promised in a gentlemanly way not to fight in the imminent battle. He now contemplated the aftermath:

Such a scene as the town presented has been seldom seen . . . Its inhabitants and others *had commenced, diligently commenced, the work of pillage . . . To the accumulated plunder of Andalucia were added the collections made by other armies, the personal luggage of the king, fourgons [carriages] having inscribed upon them in large characters 'Property of His Majesty the Emperor', wagons of every description and a military chest containing a large sum recently received from France for payment of the troops, but which had not yet been distributed; jewels, pictures, embroidery, silks, everything that was costly and portable . . . Removed from their frames and rolled up, some of the finest Italian pictures from the royal collection were found in the Imperials [roof compartments] of Joseph Bonaparte's carriage.*

The van Eyck was painted on wood, not canvas, so of course it could not have been rolled up. But its dimensions were relatively small: taken out of its frame, it measured only 82 x 60 centimetres and would easily have fitted in a crate.

The triumphant allied troops indulged in an orgy of looting. The chest from Joseph's carriage had contained 5 million francs sent by Napoleon to pay the army, but the money melted like snow. Wellington, according to one officer's account, only managed to retrieve a fraction of the money after he set a squad of hussars to guard Joseph's abandoned possessions.

> *The moment that our brave fellows got possession of the enemy's baggage, all was riot — the army chest was forced and the men began to load themselves with bullion. To stop them was impossible. Some of the officers reported to the General that the men were plundering and carrying off the money. 'Let them,' was his answer, 'they have fought well and deserve all they can find, were it ten times more.'*

Wellington posted soldiers to prevent the looting of Vitoria itself, but anything abandoned by the enemy on the field of battle was fair game. Soldiers stuffed their pockets and haversacks with handfuls of dollars (Spanish silver coins used universally) and doubloons, and seized clothes, lace, jewellery, watches and every kind of personal luxury from the luggage of the French.

Joseph's abandoned possessions were the main target, although the looters missed some of the artworks. Wellington wrote to his brother: 'The baggage of King Joseph after the battle of Vitoria fell into my hands, after having been plundered by the soldiers; and I found among it an Imperial containing prints, drawings and pictures.' Another old soldier described how 'soldiers were stripping the carriage even of its lining in search of something portable . . . [including] great bundles of papers, charts, pictures of great value . . .' Even Joseph's travelling chamber pot – pure silver, and a gift from Napoleon – became a trophy of war for the 14th Light Dragoons, giving rise to their nickname, 'the Emperor's Chambermaids'. It is still used to serve champagne in their mess on special occasions. The looters were delighted by the king's finest linen 'unmentionables' and his

white silk stockings, embroidered with a scarlet 'J' surmounted by a crown.

That evening, the soldiers were intoxicated with relief and with the wine and brandy they had liberated from the well-stocked French – they even consumed tins of fowl in aspic from Joseph's catering wagon. Having advanced 400 miles in forty days, they had not eaten bread for days, and had fought the battle on almost empty stomachs. Now they were replete. This led to orgiastic scenes where British soldiers dressed up in French officers' uniforms, while others 'attired themselves in female dresses richly embroidered in gold and silver', according to Private Wheeler of the 51st Foot. The camp became an exotic bazaar where the looted goods were piled on wagons and sold to the highest bidder. In theory, officers and men were not meant to plunder (obviously they did) because anything seized from the enemy was supposed to be sold and the profits distributed fairly amongst each troop. That was what had happened, though on a much smaller scale, after the battles of Badajoz and Ciudad Rodrigo.

Another veteran recalled, 'It was not generally a night of repose. There was a grand auction on the camp of every brigade . . . the great variety of articles was far beyond anything ever heard of . . . plunder accumulated for years, torn with rapacious and unsparing hands from almost every province in Spain . . . silks, jewellery, plate and embroidery, mingled in strange disorder'. Wheeler also remembered the events of the jubilant night: 'When I left no fires had been lit, now the place was all in a blaze. I know of nothing to compare it to but an Arab camp after a successful attack on some rich caravan. Now the camp represented a great fair and the money and goods soon became more equally distributed. "Who will give fifty dollars [Spanish silver coins] for this pipe? Here is a portrait of Napoleon for 100 dollars."'

Amongst those auctioned watches and hats, parrots and monkeys, trinkets, ornaments and pictures, a small painting that had come from the baggage of 'King Joe' (as the British soldiers called him) might

have caught the eye of an exhausted but exhilarated cavalry officer, who snapped it up as the souvenir of an extraordinary day which heralded the liberation of Spain and the beginning of the end of Napoleon.

The Window

The fixtures and fittings of the room also confirm the Arnolfinis' wealth. The window has glass in it, yet another luxury when most people made do with shutters to keep out the cold, the wind and the rain.* The upper third of the window is glazed with square panels filled with glass roundels held together in a frame of lead, an elegant and sophisticated feature emulating the most ostentatious buildings of early fifteenth-century Venice, home of glass technology. The embellishments of the Ca d'Oro, the 'golden house' built for the Contarini family in the 1420s, included external walls painted in gold and aquamarine, and windows filled with glass roundels imitating those recently installed to illuminate the vast council room in the newly built extension to the Doge's Palace. Any Bruges-based Italian patron of van Eyck would have known such models.

This fashionable form of glazing used circular pieces of glass called 'bull's eyes' or 'crown glass', made by spinning a dollop of molten glass on a rod so rapidly that the centrifugal force turned it into a hardened

* In 1486, George Cely, an English merchant visiting Bruges, paid a 3-shilling supplement for the indulgence of a glass window in his room in the inn of the Sheep's Hoof. (Hanham, 219)

disc with an indented centre where the glass had touched the rod. The density and texture of crown glass made it an ornamental and highly effective window filler, for it let in the light but also modified its transparency and controlled the sun's dazzle (more of a problem in Venice than in Bruges) by blurring but not obscuring the outside world.

These qualities fascinated van Eyck. He painted crown glass windows again and again, inserting them in all his paintings of the Madonna in an interior, whether for church or secular setting. At the same time, glass had undoubted Christian symbolism. While stained glass in churches represented the Light of God and the gemstones of the Heavenly City of Jerusalem, clear glass was a specific metaphor for the Immaculate Conception of Mary and for her virginity. Twelfth-century theologian St Bernard of Clairvaux pointed out how a sunbeam could penetrate glass while leaving it perfectly intact, and St Fulgentius compared the Virgin to a window through which the spirit of God passed to earth. van Eyck's Madonna windows consisted of panels of roundels arranged in a standard pattern which, like the furniture and the rug, he also used for the Arnolfinis' room. Their window contains six panels (three on each side), and each holds nine roundels, interspersed with four-lobed leafy shapes in light green glass in the awkwardly shaped spaces between them. The panels are surrounded by an outer frame composed of alternating strips of red, blue and geometrically painted glass, which would cast luminous patterns on the floorboards when the sun shone; there was also a narrow strip of yellowish glass between the window and the wall. The very specific details of the frame might suggest that van Eyck had an actual window in mind, perhaps from one of the Duke of Burgundy's comfortable residences (there were identical coloured strips around the windows in *St Jerome in his Study*). The whole window looks thoroughly convincing even though it may never have cast light on that particular set of furniture.

The window has wooden shutters, divided into three tiers for greater control of the light, and held in place, when closed, by a latch in the central mullion. Such shutters were typical of a domestic interior, as if

to stress, for once, the purely secular context. There are no shutters in any of van Eyck's Madonna paintings, but he painted an identical pair in the *Woman at her Toilette*, whose room echoes that of the Arnolfinis down to the orange on the sill and the storage chest below the window.

9. *Hero of Waterloo: Colonel James Hay*

There is no proof that the auctioning of looted goods is how the van Eyck portrait came into the hands of Lieutenant-Colonel James Hay of the 16th Light Dragoons (no relation to Leith-Hay). But the circumstantial evidence is very strong. The baggage that Joseph Bonaparte abandoned at Vitoria contained paintings from the royal palace in Madrid, where the van Eyck was last recorded; before Wellington had time to put a guard on it, British soldiers plundered much of the baggage and distributed its contents amongst themselves; James Hay, the next recorded owner of the painting, fought at the battle of Vitoria.

Hay was a Scot, from Braco, Banffshire, the son of an officer of the Cameron Highlanders, and a soldier all his life. When the Peninsular campaign began, he was a captain in the 16th Light Dragoons. The 16th was one of the finest of the light cavalry regiments, an elite troop of dashing young men who aimed to spend as much time hunting and dancing as serving in the field – Wellington complained that his cavalry pursued the enemy as recklessly as if they were chasing the fox. (In his novel *Brigadier Gerard*, Arthur Conan Doyle created a typical gambling, aristocratic member of the 16th Light Dragoons.) Promotion through the ranks often depended on family wealth, and Hay's commission probably resulted from money and

contacts as much as military dedication. However, the Peninsular wars honed many latent skills, and the recollections of cavalry officers and foot soldiers alike reveal exceptional courage combined with the stoical endurance of constant hardship.

Hay fought bravely. He was mentioned in dispatches following operations at El Bodon in September 1811, when he captured a French colonel and took seventy-nine prisoners. In January the following year he was promoted major, and in February 1813 lieutenant-colonel. At Vitoria, the 16th Light Dragoons made a significant contribution to the allied victory by approaching from the north-east as part of the pincer movement that undid the French. Hay was awarded a Gold Medal for his conduct that day. So he would have been more than justified in participating with his men in the wild celebrations of the evening. For a lieutenant-colonel, buying a painting in the jubilant auction of the enemy's goods was more seemly than dressing up in a Frenchwoman's gown.

In the months after the battle, the allies slowly pushed the French out of Spain in the 'battles of the Pyrenees', then crossed the border themselves. The 16th Light Dragoons fought in the winter battles of Nivelle and the Nive, where Hay was awarded a second Gold and a third Silver Medal. He had reached Toulouse in April 1814 when news came of Napoleon's abdication and the end of the war.

If Hay had acquired the van Eyck at Vitoria, he would have had to look after it until his regiment returned to England almost a year later, in July 1814. It could have remained in his baggage, in the care of his servants, being marched through mountain passes, across rivers, and enduring the rain, ice and snow of that awful winter. Wellington's divisions were supported by huge baggage trains, a provision which he protested was overgenerous, and he complained that officers even commandeered army horses to transport their lavish personal possessions. But it was clear that this perfectly adequate allowance was being disgracefully exceeded. Hay and his fellow officers took huge amounts of kit. They travelled with fishing rods, hunting guns and even hounds in order to maintain the traditional leisure pursuits of their class in the breaks from campaigning.

It was more likely that Hay shipped the painting, and other homeward-bound goods, to England in the care of a colleague sent back to recover from wounds or to join the home staff. There were frequent movements of this kind from the north-east Spanish ports. His own Major-General Anson sailed for England after Vitoria in July 1813, and his colleague, the gallant spy Captain Tomkinson, left for Spithead that September.

After they returned from Spain, the 16th Light Dragoons were in quarters at Hounslow and Hampton Court during the autumn of 1814. Here they resumed conventional peacetime duties, being posted in late March 1815 to 'the neighbourhood of Westminster Bridge for the purpose of being in readiness for the riots occasioned by the passing of the Corn Laws', as Tomkinson put it. That role became redundant in the face of a much greater threat: 'During our stay there Napoleon entered France from Elba and placed himself again on the throne. Immediately on this

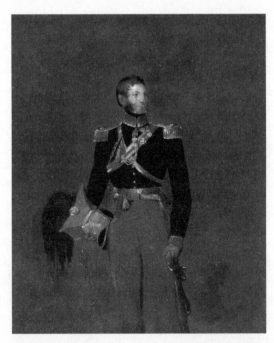

William Salter, *Colonel James Hay*

account arriving in London, all disturbances about the Corn Laws ceased and the 16th returned to Hounslow to prepare for embarkation to the Netherlands' under Lieutenant-Colonel Hay.

At first, it was almost like a holiday. Hay and his fellow officers visited museums and churches (suggesting an interest in Flemish art and architecture), and he took his men to inspect the historic site of Marlborough's victory at Oudenarde, where he quizzed his adjutant John Luard about the cavalry's function in that battle. They gratefully compared their relatively luxurious conditions, with decent accommodation, good food and cheap wine, to the severity of the Peninsular campaign. But Napoleon moved faster than the allies had believed possible, and by mid-June was threatening Brussels. News of this reached the camp at Enghien, where the 16th were waiting. At 5.00 a.m. in the morning of 16 June, Hay commanded his adjutant to assemble the regiment, breakfasted on bacon and eggs, then summoned his senior officers (some of whom had been up all night at the Duchess of Richmond's ball) to march to Quatre Bras, where Napoleon had just defeated the Prussian allies. Wellington moved to confront Napoleon by the village of Waterloo, 10 miles south of Brussels, on the evening of 17 June 1815. After a wet, cold night, when the 16th had to sleep on the ground rolled up in their soaking cloaks, battle commenced.

The 16th were posted on the allied left, and were sent in to rescue another cavalry brigade which had charged too far in pursuit of retreating French infantry, had become scattered and were being attacked by enemy cavalry. According to Tomkinson's account of the battle: 'On moving to support them, we had to cross a deep lane, which broke us and occasioned some confusion; we however got forward as quickly as possible, charged and repulsed a body of Lancers in pursuit of a party of the Scottish Greys. Lieutenant-Colonel Hay was shot through the body. The shot entered his back coming out in front. It was, at the time, supposed he could not live.' Tomkinson realised that Hay probably 'was shot by our own infantry firing to check the enemy, and not perceiving our advance to charge'. Hay's adjutant, Lieutenant John Luard, describing the horrors of the battle, said, 'Colonel Hay fell desperately and dangerously wounded

... the fire now became tremendous, particularly of musketry. I had at this moment my horse shot in the head by a musket ball and Lt Phillips had his head shot off by a cannon ball.'

Assumed mortally wounded, Hay was carried off the field, and removed with all the other gravely injured officers to farmhouses and cottages next to the battlefield on whose doors were chalked the names of the wounded. Here, on the point of death, he was visited a few days later by a young Scottish relative, Captain William Hay of the 12th Light Dragoons, who was checking up on his unit's wounded men and horses at Waterloo and Brussels. 'At the extreme end of the village of Waterloo I still found the wounded in hundreds, without any covering from the strong sun, lying on every spare space of ground.' Officers however were in 'little wretched cottages' at the end of the village. Having visited his own injured colonel:

> *I next went to see, at a house opposite, Colonel Hay of the 16th, who was also very badly wounded. His medical man immediately told me there was not the slightest hope of his recovery, that he was free from pain, and I might go in and see him. I found him propped up with pillows in his bed, quite light-hearted, happy and truly like a soldier, perfectly prepared to die. He conversed on the subject of the action as coolly as a man untouched and said he was quite aware the nature of his wounds was such as to deprive him of any chance of life; asked about all his friends, and how his regiment had conducted itself after he fell; and lastly, that he was particularly glad to see me . . . and then took, as he considered, his last kind and affectionate leave of me. But, I am truly happy to say, both he and his doctor were far out in their calculations, as, instead of dying, he recovered rapidly.*

The *Supplement to the London Gazette* for 3 July 1815 published Wellington's dispatch of the returns of those killed and wounded at Waterloo, and listed Hay as 'severely wounded'. But, having confounded his doctor, he was moved after eight days to Brussels where, according to his kinsman William Hay, 'almost every private house had been converted into a receptacle for the wounded soldiers – and, to their everlasting credit, I

found not only the whole of the rooms in the houses of the best families occupied by the men of the British Army, but the ladies of the houses attending and dressing their wounds and nursing them like their own children . . . too great praise cannot be bestowed on the citizens of Brussels, for their great attention and kindness on that occasion.'

The subsequent story was that during his stay in one of these hospitable residences, James Hay spotted the van Eyck portrait hanging in his room. 'During his long convalescence, it attracted his attention several times: he admired it so much that in the end, he acquired it from the owner.' This was the version that Belgian art dealer Chrétien-Jean Nieuwenhuys published nearly twenty years later at a time when he was busy marketing the increasingly fashionable Flemish 'primitives', whose greatest star was van Eyck. Yet it is very hard to explain how the painting had been moved from Madrid, where it was in 1799, to Brussels. And there is, too, the fact that, after Waterloo, Hay was a war hero who could get away with anything, including perhaps not telling the truth.

One reason why Nieuwenhuys claimed that Hay acquired the painting in Brussels rather than at Vitoria two years earlier was that after Napoleon's abdication in 1814, Louis XVIII pledged that all works of art seized by the French should be restored to the countries from which they had been removed. So the van Eyck should logically have been returned to its rightful owner, Ferdinand VII, the reinstated King of Spain. To complicate matters further, a grateful Spanish nation subsequently presented to Wellington the paintings that he had rescued from Joseph Bonaparte's baggage. So if Hay had admitted obtaining the van Eyck at Vitoria, he would have been depriving not only the King of Spain but his own commander the great duke, the most popular man in Britain.

Restoring stolen artworks was easier in theory than in practice. Some French provincial museums managed to retain their illegal acquisitions because the works were simply too large or fragile to be moved again, quite apart from the question of who would accept liability for the costs. However, Spain successfully reclaimed the collection that Joseph had sent to Paris, and although many were in very poor condition, they formed

the core of the Prado art gallery that Ferdinand opened in Madrid in 1819, thus ultimately fulfilling Joseph's intention. Many French people retained their contemptuous attitudes to Spaniards for a long time: as late as 1830, the art critic and inspector of ancient monuments Prosper Mérimée was still bemoaning the works that had got away: 'I find instead that the French were wrong to leave behind [in Spain] so many artistic treasures that are often not appreciated for their real value by their legitimate owners.' And he illogically criticised the British for hiding Spanish works of art: 'How many masterpieces went to enrich the collections, more or less inaccessible, of the happy few, lords or nabobs of Great Britain!'

Denon, still running the Louvre even after Napoleon's abdication, attempted to justify their acquisitions when he organised an exhibition in 1814 that included some of Joseph's paintings selected from the reserve collections. In July 1815, he staged an extremely popular show in the Salon Carré of 123 early Flemish and German works. Wellington was determined to stop this. Writing from Paris to Lord Castlereagh in September that year, he stressed 'the claim of the Allies to their pictures, because they were removed by military concessions, of which they are the trophies . . . the property should be returned to their rightful owners.' It would also be an excellent 'opportunity of giving the people of France a great moral lesson'.

The ambiguity of Wellington's own position might have inspired Hay's caution over the provenance of his van Eyck. After Wellington rescued the artworks from Joseph's baggage at Vitoria, he sent them back to England for protection (just as Hay might have sent back the van Eyck) in the charge of his brother, Lord Maryborough. The latter employed the restorer and dealer William Seguier to catalogue the more significant paintings. These turned out to be far more interesting than Wellington had realised, worth, Seguier calculated, over £40,000 (at least £2 million in today's money). Wellington initially tried to do the honourable thing and hand them back to Spain. In March 1814, he wrote to his other brother Sir Henry Wellesley, then British ambassador in Madrid,

concerning the 'prints, drawings and pictures' rescued at Vitoria: 'I sent them to England . . . and have found that there are among them much finer pictures than I conceived there were; and as, if the King's palaces have been robbed of pictures, it is not improbable that some of his may be among them, I am desirous of returning them to His Majesty.' In the meantime, he was having them 'put to rights' and cleaned as necessary. The Spanish court made no response until Wellington brought the matter up again two years later, in September 1816. This time the Spanish ambassador in London replied, 'His Majesty, touched by your delicacy, does not wish to deprive you of that which has come into your possession by means as just as they are honourable.' They were a handsome addition to the collection which the Spanish had earlier presented Wellington of works from the royal family's summer palace of La Granja in reward for the victory at Salamanca (where Hay had received a broken arm). Seguier's catalogue gave some sense of Joseph's taste: the earliest work he had taken was by Juan de Flandes, a painting originally owned by Queen Isabella, and he had included other Flemish works, by Bruegel and Teniers, which had survived the 1734 fire at the Alcazar. The haul included examples looted from other royal palaces as well as the Madrid Palacio Real.

While Hay gradually recovered in Brussels, his regiment chased Napoleon back to Paris, then spent a pleasant autumn hunting and attending balls in Normandy. They returned to England in December 1815 and were feted as the only cavalry regiment to have served right through the Peninsular campaign and then fought at Waterloo. Hay was made a Companion of the Bath in acknowledgement of his gallantry in battle. But despite his miraculous recovery, it was many months before he was fit enough to be considered for service again. As a convalescent officer on half pay, Hay began a new campaign – to sell his van Eyck.

The Mirror

Beyond the window, in the sunny world outside, we can just make out a cherry tree in fruit, which suggests it is early summer. The artist has squeezed details of the tree into a space barely 5 millimetres wide, in the narrow angle between the central mullion and the brick outer frame of the window, turning them into a lively pattern of leaves and fruit, made sharp and clear by dozens of tiny brushstrokes. Placing something in the distance, beyond the neatly confined interior, was van Eyck's way of challenging the beholder's eye, making it refocus and master a different perspective.

He repeats this trick in a more dazzling way with the mirror on the back wall, a feature that has fascinated viewers down the ages. 'Almost nothing is more wonderful than the mirror painted in the picture, in which you see whatever is represented as in a real mirror,' wrote the Italian Bartolomeo Fazio, who eulogised van Eyck's work within a generation of the master's death. However, he was not referring to the mirror in the Arnolfini room but to a different example, in one of those titillating bathing scenes that were in such demand. This suggests that a mirror was one of van Eyck's hallmarks, just the kind of classy touch a discriminating patron like Arnolfini would want included. Five hundred years after Fazio

The Times asked, 'The most notable mirrors in the wide wide world? The answer is easy enough . . . First the mirror in which are reflected the calm features of Velázquez's Venus, and second – even more marvellous – the mirror hanging on the wall in the van Eyck Arnolfini portrait.'

The mirror is like a great eye in the centre of the work. It reflects the reverse of the painted images – the backs of the man and the woman – but supplies a new subject, the frontal view of two more people entering the room through a door in the opposite wall. This creates the most confusing sense of three-dimensionality, further compounded by the fact that the glass reveals more of the room than the 'real' painting does. It is truly a looking-glass world. The mirror is like a picture within a picture, and the ultimate stroke of van Eyck's trickery is the introduction of two characters who only exist in their painted reflection, as if excluded from the 'actual' room they are apparently entering. By inviting the painting's viewers to question the scope of their own vision, van Eyck was proving effortlessly that he was the master painter of the day.

The mirror carries even more meanings than the other aspects of the room. It was, of course, another status symbol, as rare a domestic item as window glass. Mirrors were uncommon, expensive and reserved for the elite: the Duke and Duchess of Burgundy had a mirror in their palace at Hesdin, while the duchess kept another in her chamber. Those few privileged owners were able to see their own faces – whereas ordinary people never could – and realise the impact of headdress or hairstyle, jewellery and clothes. In a world that measured status by external display, being able to see yourself gave a rare insight.

The circular, slightly convex surface was the only shape then available for mirrors made of glass. Highly polished metal like bronze or copper provided a flat reflective surface but the best and the lightest images came from glass backed by molten lead, tin or pewter. The profile was necessarily convex because this type of mirror could only be manufactured from a blown globe of glass and a cast sphere of metal. In the fifteenth century, Venice was the most celebrated source of spectacularly beautiful glass vessels, but the north held its own for technical expertise. The centre

of mirror making was Nuremberg, a town which excelled in precision metalwork for scientific instruments, locks and clocks, armour and weapons, made for export throughout Europe. 'Nuremberg mirrors' were the town's most famous product, and mirror makers were regarded as alchemists.

Convex glass provided an intriguingly distorting vision which simultaneously reduced and expanded the image reflected. Magically, the wide-angle lens showed to the beholder more than his own eye could take in at one glance: this was a facility that artists welcomed, so a convex mirror was a standard item of workshop equipment. (The early seventeenth-century theorist Roger de Piles insisted that artists must use convex mirrors in order to achieve harmony and unity.) van Eyck's Italian contemporaries were also aware of the mirror's power. Brunelleschi, the ingenious Florentine architect and designer of the cathedral dome, was possibly the first to use one in order to draw the correct relationship of buildings in a townscape. Such a mirror would have aided van Eyck's recurrent exploration of the potentials of reflection. His works show how concerned he was to recapture the effects of light through the potentially perfect illusionism of oil paint. Some of the jewels in *The Ghent Altarpiece* were exquisite two-dimensional recreations of multifaceted gems which seemed to reflect the exact angle of the light cast from the windows in the side chapel that was its ultimate destination. In the Dresden *Madonna*, the helmet of the attendant St Michael reflects the figures of the Madonna and Child, as if they were present in some real space beyond the painted surface. In the *Madonna with Canon van der Paele*, St George's gleaming shield reflects not only the adjacent pillar and details of the saint's armour, but a minuscule figure whom we may assume to be the artist himself – a man wearing a red hat, dark blue gown and red hose, whose arm is raised as if he is holding up a brush or estimating the proportions. The larger figure of the two characters in the Arnolfini mirror wears a similiar outfit, while his smaller companion, who is possibly van Eyck's servant, is clad in a red gown. The inscription above the mirror, *Johannes van Eyck fuit hic* – *Jan van Eyck has been here* or as some have argued *Jan van Eyck was this man*

– followed by the date *1434* confirms the presence of the artist himself embedded for posterity in this invented room . It is typical of his playful use of inscriptions on the frame or within the painting rather than a conventional signature. *The Virgin with Chancellor Rolin* (*c.* 1435, Louvre) is another example of his Hitchcockian insertion of himself into his work, not this time as a reflection but as a minuscule person in the background, far beyond the pillars that frame the main characters. For here are the same two little characters as in the Arnolfini mirror, this time with their backs turned to us as they contemplate the background view of lake, bridge, town and distant mountains. This is a very early example of landscape painting in its own right, and van Eyck has perhaps emphasised this by showing the creator justifiably admiring the scene.

The details of the mirror prove it was a superior type, having an exceptionally elaborate frame surrounded by ten lobes decorated with enamelled roundels. These contain the only overtly biblical subject matter in the whole painting, for they show ten scenes illustrating Christ's Passion and Resurrection: the Agony in the Garden, Arrest of Christ, Christ before Pilate, Flagellation, Christ carrying the Cross, Crucifixion, Descent from the Cross, Entombment, Harrowing of Hell and Resurrection. The presence of such familiar motifs in a living room was not at all unexpected in a pious age when some grand families had private chapels within their homes and many kept items of devotion in their living rooms. The Duchess of Burgundy's prized mirror was decorated with an image of the Holy Sepulchre.

A mirror could stand for good or evil. On the bad side, it was an attribute of Vanity, and sometimes even symbolised the power of Satan, who was believed to lurk within the glass to lure and deceive; the Devil was sometimes represented in art by the image of a monkey holding a mirror, and the moralistic Chevalier de la Tour Landry warned his daughters against looking in mirrors for fear of seeing the Devil's arse instead. Dürer illustrated this theme, while his contemporary Hans Baldung Grien depicted a young woman holding up a mirror to her face but seeing instead the reflection of a grinning skull. However, the virtuous figure of

Prudence might also carry a looking glass, and the Virgin herself was compared to an unblemished mirror. van Eyck included the words *speculum sine macula* (*mirror without a blemish*) on the frames of the van der Paele and Dresden *Madonnas*, and also inscribed them on the Annunciation panel on *The Ghent Altarpiece*. Given the other potential references to the Virgin, one role of the mirror in the Arnolfinis' room might be as yet another contribution to the Marian parallels.

By placing the mirror at the heart of his painting, van Eyck was displaying his exceptional technical skills, and perhaps differentiating himself from other local craftsmen and artists. The Bruges guild of painters also included mirror makers, both, in their different ways, concerned with reflecting reality. But they were not seen as privileged interpreters of the world, merely professional artisans; other members of the guild were sculptors, cloth painters, glaziers, saddlers and horse-collar makers. However, van Eyck's superior status as a member of the duke's household exempted him from membership and placed him on a higher plane.

10. *The Dealers and the Prince and the Critics*

In this nationalistic mood of post-Napoleonic redistribution, van Eyck's name came to increasing prominence in relation to *The Ghent Altarpiece*, his best-known work. The French had seized its central panels when they invaded the Netherlands in 1794, returning them in May 1816 from the Louvre to St Bavo's Cathedral in Ghent. The wing panels of Adam and Eve had previously been put into storage on the grounds of their shocking nudity, and the other side panels had been successfully concealed from the French in the town hall, though Denon had tried to get hold of them too. But in December 1816, before the whole work could be reassembled, the cathedral authorities sold the wings for 3,000 florins to an art dealer, Lambert-Jean Nieuwenhuys (father of the dealer Chrétien-Jean Nieuwenhuys, who in 1843 reported that James Hay had found his van Eyck in Brussels). It was proof of the growing interest in van Eyck and his contemporaries, stimulated by their display in the Louvre, that Nieuwenhuys had begun specialising in Flemish art because he realised there was a market for it. He sold the wings to the Berlin-based English businessman, Edward Solly, for 100,000 florins. And Solly sold them to the king of Prussia for 400,000 florins in 1821.

The art trade began to recover in the new, unfamiliar era of peace,

when the names of Wellington and Waterloo were synonymous with a confident pride in being British. In London, the dealer William Buchanan was keen to profit from the works he had so laboriously acquired in Spain, and tempted prospective buyers with a catalogue of 'some of the most valuable pictures which were in the royal palaces of Spain consigned to my care'. A mere 20,000 guineas would secure one lot that included Raphael, Leonardo, Correggio, Titian and Velázquez. He also offered Flemish and Dutch works, though nothing as early as the fifteenth century. In 1815, he handled the 200 Spanish, Italian and Flemish works that Lucien Bonaparte had removed from Spain in 1802. Buchanan justified his trade and encouraged likely customers by arguing that importing works of art enriched the host country, improved taste and educated artists.

So it seemed a promising time for the hard-up Hay to find a purchaser for his van Eyck, and he approached the greediest and most extravagant art collector and patron in the country, George, Prince Regent. In 1816, the Prince was aged fifty-four and still waiting to become king. Owing to his father's madness and blindness, he had been promoted from Prince of Wales to Prince Regent in 1811 and now basked in the glory of ruling a country that had defeated the French and saved Europe: the Prince even seemed to believe occasionally that he had personally fought in the Peninsular campaign and at the battle of Waterloo. His interests, however, had always been cultural rather than constitutional, involving lavish expenditure on buildings and their contents, where his mercurial, eclectic tastes ran riot. After Napoleon's final downfall, the Prince sought to present himself as the leader of Europe and with the new funds he had acquired after becoming Regent, wanted his palaces to rival those of continental rulers. He was now spending less time in his oriental fantasy pavilion in Brighton, and he disliked draughty, old-fashioned Windsor, where his parents mainly lived. His current favourite building project was the refurbishment of his official London residence, Carlton House in Pall Mall.

Once a simple villa erected in the bucolic wilderness of St James's Park, the property now blended classical, oriental and Gothic features, with Gold and Crimson Drawing Rooms, a Blue Velvet Room, a crimson

and gold Throne Room, a classical Circular Room, and a florid Gothic Conservatory. The burgeoning costs of the Prince's expansions and altera-tions to the building had already been raised during Parliament's 1795 investigation into his mounting debts, when it grudgingly granted him a further £60,000 to complete the project. Rehanging all his pictures to complement the new wall decorations would turn the building into a giant art gallery. The Prince was an avid, restless collector. He bought paintings copiously then sold them or gave them away. His contacts in the art world knew that keeping in the good books of this greedy patron was an important source of income and favour, and that the new hang in Carlton House was an excellent opportunity.

Among the Prince's circle of advisers was the restorer and dealer William Seguier (who had catalogued Joseph Bonaparte's artistic spoils for Wellington), and the artist Sir Thomas Lawrence, successor to Sir Joshua Reynolds as the king's 'Principal Painter'. Lawrence was a smooth and charming man who moved in grand circles and was in high favour with the Prince, although he had only relatively recently entered the royal good books. The Prince had previously employed John Hoppner, ignoring the flamboyant Lawrence because he had already portrayed the Prince's estranged wife Caroline of Brunswick (apparently becoming so intimate with her that he was summoned to give evidence in the Delicate Investigation of 1806 into her possible adultery; fortunately his name was cleared). After Hoppner's death the Prince commissioned Lawrence in the summer of 1814 to paint his portrait. Lawrence's interpretation of him as a slim young hero on the battlefield, wearing the immaculate uniform of a fieldmarshal (such a contrast to George Cruikshank's savage caricatures, but which Cruikshaik later parodied in his cruel triptych of 1816, 'Gent, No Gent, Re gent!!') so pleased the Prince that he commis-sioned Lawrence to paint all the allied leaders, including of course the Duke of Wellington, and knighted him in April 1815. These portraits, intended to hang together in the 'Waterloo' chamber at Windsor Castle, were exhibited in the 1815 summer show at the Royal Academy.

Opinions remain deeply divided as to whether George IV was one of

the greatest royal art patrons, or a selfish, tasteless voluptuary. Lawrence's view was characteristically charitable: his gossipy friend the artist and diarist Joseph Farington recorded that 'Sir Thomas Lawrence, who has now been a great deal with the Prince Regent, declared to me his conviction that he is one of the best natured men in the world: that he always has pleasure in doing things that are agreeable to others: and that with some weakness of vanity and the disadvantage of having people about him whose object it always is to accommodate themselves and every other thing to his feeling or humour, and thereby mislead him, yet his kind disposition prevents him from indulging in tyranny or caprice.' The Prince reciprocated by trusting Lawrence, for once revealing his better nature. Lawrence was society's favourite portrait painter. Advising on the royal collections or offering a painting on approval was precisely what he was expected to do.

On 10 October 1816, Benjamin Jutsham, the Inspector of Household Deliveries at Carlton House, made an entry in the Ledger of Receipts that he compiled daily: 'from Sir Thomas Lawrence, A Painting in a gilt frame – subject Two Portraits, a male and female joining hands – the Female dressed in green – the Male in black with a large Round Hat on & 33½ x 23¾". By John van Heyk – the person who first discovered the art of Painting in oil colours.' The reason why Hay was using Lawrence as intermediary must have been the military connection. The Duke of Wellington had been so impressed by Lawrence's portrait of him, and got on so well with the artist, that he commissioned more portraits of himself and of his generals for his own collection at Apsley House. He even showed off some of his loot from Vitoria: Farington recorded on 4 July 1816 that 'the Duke of Wellington had been with Sir T. Lawrence and brought with him a small portrait in oil of Bonaparte, the Picture that was found in Joseph Bonaparte's carriage at the Battle of Vitoria'. There was a real fascination with Bonaparte memorabilia that summer: Bullock's Museum in the exotic 'Egyptian Hall' in Piccadilly was exhibiting 'Bonaparte's carriage – with its coachman and two of his horses, built-in bed, wardrobe and writing desk, the golden washing basin, silver sandwich box and many other accessories of unimaginable luxury'.

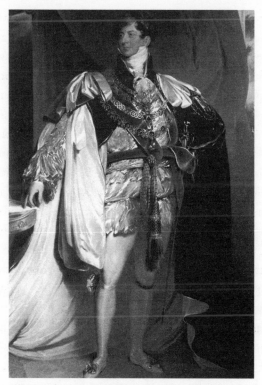

Thomas Lawrence, *The Prince Regent*

James Hay, who had survived Waterloo by a miracle and was on half pay with a picture to sell, may have learned from his military colleagues that Lawrence was in regular contact with Wellington in the summer of 1816, when he was also advising the Prince Regent over the new display at Carlton House. 'Sir T. Lawrence . . . told me he was with the Prince Regent this morning to give his opinion about arranging Pictures at Carlton House . . . he observed that the Prince is fond of Pictures,' announced Farington. Intimacy was growing. The Prince and Lawrence dined together frequently, and the artist provided guidance on which artists to commission, on the authenticity of certain works, and even on which paintings to buy. This was a well-recognised role: Farington, for example, advised John Constable, who was seeking

to help a friend who had two pictures for sale, to approach Lawrence to recommend a purchaser.

This was why Hay contacted him too. Lawrence himself was a discriminating collector of old master drawings, when his chaotic finances permitted, and he was sufficiently impressed by the soldier's van Eyck to offer it on a trial-or-return basis which would give the Prince ample time to make up his mind. After it reached Carlton House in October 1816, it was hung upstairs, according to an inventory compiled that December for valuation purposes, complicated by this being a time of social unrest when the costs of victory had inevitably caused inflation and unemployment. Farington of course took an interest: 'Sir T. Lawrence told me that the Prince Regent being uncertain what Mobs might do at this disturbed time had thought it prudent to have his pictures at Carlton House valued, and an insurance made upon them. A catalogue of them was making by Bryant who had been recommended by Christie, but his Royal Highness wished Sir T. Lawrence to superintend the whole of what was to be done. Sir Thomas thought that myself and Mr Ottley might unite with him in valuing the pictures but I declined it and thought Ottley and himself might do it properly.'

As a dealer and gallery owner the cataloguer Michael Bryant was well qualified for the task. His laconic entry for Hay's painting was: 'No. 168, Portrait of a man and his wife, John van Eyck. 2′8″ x 1′11″.' It was located in 'the Middle Attic next to the Prince's Bed-Room'. Attic here simply meant the upper storey, the floor where the Prince slept, and not the servants' quarters. The painting's proximity to the royal bedroom suggests that the Prince must have seen it many times, although, as Lawrence realised, upstairs was not an appropriate location for significant pictures: 'The Prince proposed to remove a collection of enamel pictures painted by Bone from a room which was at present furnished with them to His own Bedchamber a very large room, but where they would comparatively be but little seen. On this account, Sir T. Lawrence prevailed upon the Prince to allow them to remain where they now are.' Hanging the van Eyck next to the Prince's bedroom meant that it was not for public consumption but was very much on approval.

And it ultimately failed the test, because there was a footnote to Bryant's inventory in a different hand: 'This Picture was returned to Sir T. Lawrence April 25 1818.' The Prince Regent may have been hailed as a connoisseur and an arbiter of style, but he was not ready for the early Flemings. His taste in painting focused mainly on British art – the great eighteenth-century portraitists, modern storytellers like David Wilkie, animal scenes and sporting prints. The display in Carlton House did include a number of Dutch and Flemish domestic interiors by popular seventeenth-century genre artists, and there were of course works by Rembrandt and Rubens. But fifteenth-century art, whether Flemish or Italian, was alien to most eyes, except perhaps those of Lawrence himself. So he returned the van Eyck to James Hay in the spring of 1818. Hay was then still on half pay but joined a new regiment, the 4th Light Dragoons, in 1821, transferred to the 17th Dragoons, and then settled with the 2nd Queen's Regiment of Dragoons, better known as the 'Queen's Bays', where he became Commanding Officer in 1830. The Bays were then serving as a peacekeeping force in Ireland and in the north of England, where they helped quell the industrial riots of the 1820s. Hay did not take his painting to Ireland, however, but left it in London in the care of a fellow Scot, James Wardrop, a doctor and probably a family connection, for his patients included Hay's soldier cousin William. Wardrop collected art himself, so Hay may have hoped he might buy what the Prince Regent had rejected, especially since Wardrop was one of the Prince Regent's doctors, not only familiar with the collections hanging on the walls of Carlton House but one of the few who had access to the Prince's bedroom on the upper floor where the van Eyck had hung. Wardrop became the Prince's 'surgeon extraordinary' in 1818 and was promoted 'surgeon to His Majesty' in 1828, one of the team of medical men attending the obese, ailing monarch. Although a respected surgeon and pioneering ophthalmologist, with a royal client and other aristocratic patients, and a wit, gossip and socialite, Wardrop was a controversial figure who undermined the medical establishment by quarrelling with his fellow professionals, whom he attacked anonymously in the pages of the *Lancet* under the pen name Brutus. This made him so

unpopular that he was excluded from attending George IV during his final illness. Wardrop's other eccentricities included establishing a charitable hospital, and treating the poor for free in his London home in Charles II Street, off St James's Square.

Wardrop and those who visited him were no more impressed by the van Eyck than the Prince had been: 'Colonel James Hay gave me a picture to take care of during his absence from England. It was hung up in a bedroom where it remained for about thirteen years, during this period it was seen by many visitors, none of whom deemed it worthy of their notice.' This snide comment suggested that tastes were barely changing during the 1820s and 1830s. Yet although the Prince Regent and Wardrop failed to appreciate the subtlety of the seemingly unostentatious double portrait, a select group of connoisseurs and collectors was becoming interested in early Flemish art; although he did not know it, Hay's investment was maturing nicely.

The catalyst was German merchant Carl Aders, who had settled in London in 1811 to develop his import–export business but maintained strong contacts with the cultural life of his homeland. He collected many examples of early northern art, boldly preferring German and Netherlandish works to French or Italian ones: he held an open evening in his house once a week so that others could appreciate them too. His circle included the artists John Constable, John Linnell, Samuel Palmer, Henry Fuseli and William Blake, and literary figures like Charles and Mary Lamb, and the diarist Henry Crabb Robinson. They were all interested in the German Romantic tradition, which at that time claimed van Eyck and other Flemings as part of the Germanic heritage. One of the gems of Aders's collection was a seventeenth-century copy of *The Ghent Altarpiece*, which he bought in Paris in 1819. As the original was then divided between Ghent and Berlin, London was the only place to experience the overwhelming effect of the masterpiece. Being exposed to van Eyck's most majestic work, even in the form of a replica, stimulated Fuseli, Palmer and Blake, and inspired drawings by Linnell and a poem by Charles Lamb. Early Flemish art still only appealed to the elite, but the presence of examples in the Aders collection in London helped to widen horizons.

Among Aders's regular visitors was an influential, art-loving baronet, Sir George Beaumont, whom Farington called 'the Supreme Dictator on Works of Art'. Beaumont was one of the founders of the British Institution, a gallery established by a group of connoisseurs in 1805 to support British artists by exhibiting their work and those of their distinguished predecessors, in the form of masterpieces loaned by aristocratic owners. These included the Prince, who became the institution's patron. It was based at 52 Pall Mall, in the well-designed gallery built in the previous century by the entrepreneur Alderman Boydell. In the glorious summer after Waterloo, the institution put on the first ever public exhibition of old masters in England; this event was repeated every three or four years, showing Flemish, Dutch, Italian and French paintings in the hopes that they would inspire modern artists. Sir Thomas Lawrence indeed feared that the institution was impinging on the Royal Academy's remit and threatened to pull strings: 'He said they had departed from the original object of the Institute, which was to promote the sale of British Art, and were becoming *preceptors of artists* and thereby acting in direct rivalship or opposition to the Royal Academy as a Seminary . . . he intended to submit his opinion to the Prince Regent which he would do upon the ground of his owing everything to that establishment.'

Meanwhile, James Hay was with his regiment in Ireland, where he acquired a property at Kelburn, County Longford. Cavalry duties in peacetime were not so arduous as to prevent him from visiting London. Sir Thomas Lawrence died in 1830 (Seguier had to finish some of the uncompleted portraits intended for the Waterloo gallery at Windsor Castle) but Hay reconnected with the art world when he sat for the fashionable portrait painter William Salter. In 1835, Salter began preparatory studies for *The Waterloo Banquet*, a patriotic work to celebrate the Duke of Wellington's annual commemoration of the famous battle at the dinner he hosted for veterans in Apsley House. Hay attended this dinner regularly. As Waterloo receded in time, the banquet grew in stature and significance. Like the D-Day commemorations of our own century, there was a poignant awareness that 'time yearly makes ravages in the ranks of those veteran

warriors', as *The Times* put it in its report on the 1841 banquet. The event took on an established formula. Forcing their way through cheering crowds in the street, the old soldiers came to Apsley House at 6.30 p.m., where the band of the Grenadier Guards, Wellington's old regiment, welcomed them in the vestibule. They dined upstairs in the splendid Waterloo gallery, illuminated by a magnificent chandelier and gold candelabra presented by the Emperor of Russia, the table and sideboards adorned with trophies and triumphs, and the walls hung with Wellington's increasingly fine art collection, at its core Joseph Bonaparte's paintings from Vitoria.

Salter's epic portrait of the banquet showed eighty-four diners, among them Hay, barely perceptible at the far end of an extremely long dining table. The work (which hangs today in the entrance hall of Apsley House), effectively combines the sense of occasion with a pleasing informality created by the varied and relaxed poses of the many subjects. Salter completed the painting in 1836, and it evoked so much national pride that the public queued for tickets when it was later exhibited in a commercial gallery. The artist then cleverly developed new commissions from the same subject by producing individual, more formal oil portraits of many of those present at the banquet. (These are now all in the National Portrait Gallery.) His portrait of Hay shows a dapper, amiable-looking man with mutton-chop whiskers, wearing his scarlet cavalry jacket, and holding his sword and helmet.

It might have been while sitting for Salter in around 1840 that Hay decided to do something about his van Eyck again. Although Salter earned his living from portraiture, his aspirations (like so many others) lay in being hailed as a painter of history, creating dramatic and morally uplifting scenes from the past. He had been exhibiting ambitious biblical, classical and literary subjects at the British Institution since 1822, and of course knew that the institution put on occasional loan exhibitions of the old masters. This would be an excellent venue to publicise the little Flemish painting Hay had so far failed to sell. According to Dr Wardrop, 'During the thirteen years Colonel Hay was absent from London I never saw him again until he asked me if it could be convenient for me to send for his

picture, which he did accordingly. A few weeks afterward, I saw, to my surprise, in the British Gallery [Institution] Exhibition Colonel Hay's picture.' This was the institution's 'Ancient Masters' exhibition of the summer of 1841.

Here, Hay's van Eyck at last roused the interest of the art world. George Darley was the pioneering art critic of the *Athenaeum*, a lively weekly review founded in 1828. In a series of articles on the exhibition published in July 1841, he gave the first detailed account of a previously unknown yet definitive work by a master to whom there were far too many uncertain attributions in existence. 'It has never been our luck to see throughout England so many van Eycks as every other dilettante we meet with, who would seem to have put them up like partridge in coveys; we believe they are no more abundant here than golden eagles. The picture before us cannot be doubted; its brilliant colour flashes conviction upon anyone to whom the style of van Eyck is familiar.' With those words, he brought Hay's trophy painting into the public eye.

George Darley was an Irishman with a bad stammer who came to London in 1821 to establish a literary career. Through journalism, short stories and mathematical textbooks, he subsidised his rather less successful poems and plays. His intellectual circle included the comic poet Thomas Hood (who noted how Darley's ears wiggled like those of a rabbit when he was about to make a pronouncement) and Charles Lamb, an habitué of Aders's art collection evenings. In the early 1830s, after visiting the major continental art galleries, Darley extended his range from theatre to art criticism. He learned to appreciate the early art of Belgium and Germany, still so unfashionable in England; following a visit to the art gallery in Dresden, he approved how 'the antique painters such as Memling, van Eyck, Fra Beato and Francia have regained the station to which their exquisite feeling and spiritual finish and beauty entitle them'. It was the spiritual perfection of early art, whether northern or Italian, that most impressed him because of the contrast it made with what he saw as the gross materialism of modern art and taste, tainted by middle-class patrons and poorly trained artists. He became the *Athenaeum*'s regular arts

correspondent, and used its pages to denounce the current passion for seventeenth-century realism (he sneered at 'the hugger-mugger homeliness of a Dutch cabinet picture') and for portraiture ('the lowest department of the arts').

By 1840, he was London's most eminent art critic (his occasional frivolity, however, provoking the *Morning Chronicle* to announce, 'We do not . . . approve of the flippancy of Mr Darley's style of writing') and used his platform to rail against the absence of early art in Britain: 'There is not, we believe, a single specimen of Fra Angelico's painting in the British Empire, filled with "dead game" and Dutch pictures to its roofs.' He urged the young National Gallery to extend its range if such works came up in the sale rooms, attacking its 'inexcusable conduct' for failing to acquire the fragment of a Lippi fresco. He was certainly familiar with the replica of *The Ghent Altarpiece* in Aders's collection, for he mentioned how van Eyck's 'formal perpendicularity and severe parallelism of composition, however disagreeable when their altarpieces are seen in drawing rooms, fitted them with marvellous accord to their proper recesses in churches.' His various articles for the *Athenaeum* included a review of the French artist Léonor Mérimée's *On Oil Painting* and an article that stressed van Eyck's contribution to, rather than invention of, that medium. When he reviewed the British Institution exhibition of 1841, he was better qualified than most people, both stylistically and technically, to appreciate a genuine van Eyck.

Darley's exhibition review consisted of four articles published weekly in the summer of 1841, suitable coverage for a major show that contained works by Raphael, da Vinci, Rubens, Rembrandt, Teniers, two Cranachs (loaned by Prince Albert), Dürer, van Dyck, Correggio, Carracci, del Sarto and the more recent Reynolds, Hogarth, Gainsborough and Stothard. The extensive Dutch section included a Teniers and a Wouvermans loaned by the Duke of Wellington: this might have inspired Hay to become a lender. The first article stressed the overall quality of the show – 'what a pleasure to find in these times so unambitious of true excellence anything that we can honestly and heartily praise! . . . we have seldom seen an exhibition

that contained more of undeniable merit or attractiveness in one regard or another' – and he discussed the star exhibits, which included four alleged Raphaels. He came to the van Eyck in the second article, after a long preamble criticising the unthinking reverence given to great names and challenging the authenticity of the so-called da Vinci, whose Infant Christ and John the Baptist he dismissed as 'two gross grimacing boys' and attributed the work to Luini. Applying the same principles of 'connoisseurship' (the correct identification of an artist's hand) to *Portraits of a Gentleman and a Lady* by John van Eyck, he announced, 'This is also a great name and something more – a true one, and something better still, a great reality. . . . its clear keen style resembles that of the great Ghent Adoration.'

Then he skilfully analysed van Eyck's distinctive method of handling oils, which made the woman's flesh 'as sweet and pure as the first blush of a sunbright morn . . . [its] wondrous firmness and translucency . . . assisted perhaps by the antique method of keeping each colour simple and separate instead of fusing or breaking it into the colour next to it . . . [her robe] shines out as lucid and dazzling as liquefied emerald'. While recognising the work as technically brilliant in terms of colour and finish, Darley expressed certain reservations about the style and subject, warning against 'our amorous descants on primitive art, our love-laboured songs about the deep feeling, solemn beauty, simple grandeur and so forth of very ancient pictures despite their uncouthness, stiffness etc. These portraits, so the catalogue calls them, exhibit neither pathos, beauty nor grandeur though they are simple and solemn enough, he, a straight, lank, quakerish object, in a black broad-brimmed, high-crowned hat, stands full front before us, as if ready to moan; she, twisted three ways at once, bends sidelong towards him, with one hand on her stomacher like a lady who had "loved her lord" six months ere he became so; verily, this strange pair, hand-in-hand, resemble nothing better than Simon Pure about to atone for a faux-pas by making Sarah Prim an honest woman. However, the old-fashioned costume occasions much of this ludicrous effect; present fashions will perhaps render

portraits painted nowadays no less laughable to posterity.' Darley was aware that reviewers have a duty to entertain as well as to inform; and for a man who based his critical tenets on the idealising theories of Joshua Reynolds's *Discourses*, he was happy to mock those purist Gothic Revivalists like Pugin who refused to admire anything produced later than the Middle Ages.

The reviewer for the *Observer* begged to disagree, claiming that *Portraits of a Gentleman and a Lady* could never have been painted by van Eyck on the curiously inaccurate grounds that the clothes and the furniture 'are both of a much later date than the lifetime of the putative painter', working between 1410 and 1441. Nor was the style right: 'Though a good picture of its class, it wants that surpassing richness of positive colours, that astonishing clearness, and most extreme delicacy of finish which are stamped upon all the productions of his period.' This might have been a deliberate challenge to Darley's authority, arising from some ancient journalistic feud.

Blackwood's Edinburgh Magazine for September 1841 was far more impressed. Towards the end of a long article which unfavourably contrasted the over-stuffed Royal Academy Summer Exhibition ('there is not a picture of Turner's that is more than ridiculous') with the institution's fine works of the past, the writer regretted that the National Gallery had not bought Jan Steen's *The School*, 'a very fine picture which would give more pleasure to nine-tenths of the people who visit the National Gallery than would the finer products of the Italian schools'. At the institution:

> *there is one other picture, however, which we must not omit to mention — the van Eyck. Much has been said of late of van Eyck's supposed invention of painting in oil. This production therefore demanded great attention. It is wonderfully luminous, more so indeed than any picture in the room, and the finish is quite wonderful. Strange and stiff enough it is, and odd in form and design — but the painting, the texture, for which we look at it, is surpassingly beautiful. The metallic lamp and the clogs are specimens of most exquisite and elaborate work — the metal and the wood are perfect imitations.*

The reviewers' interest, combined with mounting criticism that the National Gallery lacked representative works of the northern schools, both earlier Flemish and later Dutch, meant that James Hay was able at last to sell his van Eyck to the nation. In the early summer of 1842, Dr Wardrop recalled, 'Mr Seguier, the picture restorer, called on me, mentioning I was a friend of Colonel Hay, who was then in Ireland, if I would communicate to him that he, Mr Seguier, had recommended the Trustees of the National Gallery to purchase the picture, and he was authorised to offer 600 guineas for it. This sum Colonel Hay accepted. The picture became of greater value annually, and now hangs in the National Gallery, much prized!!!'

The Chandelier

Hanging from the ceiling is an elaborate chandelier that seems to be made of highly polished brass. The chandelier is placed exactly above the mirror, so that they both form the central axis of the painting. van Eyck has included it as another painterly tour de force of gleaming light and intricate detail, though it seems overlarge and somehow out of proportion to the space available. It has six branches, and there is a socket at each tip to hold a candle, although only two candles are shown. One, on the man's side of the room, is lit, its bright flame further demonstrating van Eyck's ability to paint light – hardly needed on that bright summer's day. The other candle, in one of the sockets on the woman's side, is just a stub which has gone out as evidenced by a little trail of smoke. If the candles have a symbolic meaning, it remains unclear; some commentators believe the lit candle signifies the drafting of a dowry agreement (binding when it burns out), while others say the spent candle notifies a death. The mechanism that attaches the chandelier to the ceiling is not visible, and van Eyck has tackled the complexity of showing six equidistant branches by flattening the angle of those nearest to the viewer. Each branch is crescent-shaped, decorated below with architectural motifs like those carved on the chair back and above with stylised animal forms and a bracket terminating

in a fleurs-de-lys. All these flattened, faceted decorations help to refract the light further. The sturdy central unit ends at the bottom in a ring, clasped in an animal's mouth, which would help pull the chandelier up and down.

Altogether, it is far too ornate for a domestic setting, and was therefore an implausible symbol of high status in a living room. In the Middle Ages, lighting was the greatest luxury, originally the preserve of religious buildings: Antwerp Cathedral in the early fifteenth century possessed 400 chandeliers. It was not until the later fifteenth century that they began to be adopted for domestic use (though the palaces of Duke Philip the Good probably had their fair share) to create an elegant and expensive way of casting light from above rather than the oblique angles of separate candlesticks on table or windowsill. Being able to create such light extended the hours of the day; chandelier owners did not have to go to bed at dusk. The cost of candles also indicated privilege. Ordinary people made do with the rank tallow candles made from rendered beef or mutton fat, but rich people like merchants used pleasantly scented beeswax.

Like many other objects in the room, brass chandeliers were a local product, perhaps among the stock-in-trade of an Italian exporter from Bruges. A manufacturing centre since the thirteenth century, the town of Dinant on the Upper Meuse gave its name to 'dinanderies', superior brass wares – chandeliers and candlesticks, jugs and ewers, crosses and censers – made from the sturdy alloy of copper from Norway and Sweden, and tin from Bohemia (all imported though Bruges), cast or hammered into shape, and decorated by incising and chiselling.

Having such a chandelier in a domestic chamber was a mark of aspirational wealth, offset however, like the rest of the room's contents, by its association with images of the Virgin. In Rogier van der Weyden's *Annunciation* (*c.* 1434, Louvre), there is a brass chandelier of very similar shape to van Eyck's, although much smaller. It too has six branches, each ending in the outline of an animal's head. A clearly depicted pulley and chain show how it was raised and lowered from the ceiling. (Other parallels to the Arnolfini room in this painting are the red hung bed, the settle with red cushions, and oranges on the chimneypiece.) Dieric Bouts included chandeliers in his *Last*

Supper (1464–67, Louvain) and *Annunciation* (*c.* 1445, Prado); the latter suggests direct homage to van Eyck, or van der Weyden, because there is also a settle with red cushions and drapes, and an orange on the windowsill. This chandelier is again much smaller but otherwise strikingly similar to van Eyck's in the stout central pole and the fleur-de-lys ornamental terminals.

11. Star of the National Gallery

In 1842, the National Gallery was only eighteen years old, although there had been attempts to establish a national art collection since the late eighteenth century. Denon's Louvre, with its edifying historical displays, was a beacon of excellence. When its illegally obtained works first began to be dispersed in 1814, the Prince Regent demanded some 'for a museum or gallery here'. He might have meant for his own private collection, but the dealer William Buchanan gave him the benefit of the doubt: 'When the sovereign himself, a Prince of refined taste and extensive attainments, takes a lead in the establishment of institutions calculated to defuse a general knowledge . . . when Galleries of a public nature are forming in several of the principal cities of the Empire . . . [may] the reign of George IV rival the period of Lorenzo de Medici . . . the present epoch will ever be memorable in the history of this country by His Majesty having declared his pleasure that England shall possess a Public and National Gallery of the works of the great painters'.

Such a gallery would provide London with a painting collection as accessible and excellent as those in the other great cities of Europe. The Napoleonic wars provided a vital stimulus, when redrawn boundaries and the discovery of artworks previously hidden in palaces and monasteries

encouraged a nationalistic interest in styles and periods beyond the dominant Italian renaissance canon. Yet the aims of the founders of the National Gallery were by no means altruistic. Admission should be free in the hopes that art might improve society by keeping the working classes away from drink and radicalism (the French Revolution cast a long shadow). 'In the present times of political excitement, the exacerbation of angry and unsocial feelings might be much softened by the effects which the fine arts had ever produced on the minds of men,' according to Sir Robert Peel, who argued in 1833 for the expansion of the gallery; though the art-loving Tory politician did concede the justness of conferring 'advantages on those classes which had but little leisure to enjoy the most refined species of pleasure'. There were also commercial reasons. Exposing artists and designers to great art would improve manufacture, and thus boost British trade. Finally, a national collection that included fine foreign paintings would help preserve the status quo from dangerously modern artists.

In the summer of 1823, the art collection of the late John Julius Angerstein, a wealthy, Russian-born insurance broker, came on the market in the form of thirty-six masterpieces, among them works by Claude, Raphael, Rembrandt, Rubens, Cuyp, and the native Hogarth, Reynolds and Wilkie. This gave the government a perfect opportunity to intervene. One still influential voice was Sir George Beaumont, founder of the British Institution, and a man with a finger in every artistic pie. He now tried to bribe the government into reaching the right decision: '*Buy* Mr Angerstein's collection and I will *give* you mine.' This generous offer made available to the nation a further sixteen works – including landscapes, his particular interest, by Claude, Poussin and Canaletto – and it helped persuade Parliament to agree the necessary money. In March 1824, the Commons voted £60,000 for the purchase, preservation and exhibition of the Angerstein collection, and Prime Minister Lord Liverpool acquired the lease of Angerstein's house at 100 Pall Mall, where the pictures hung. This was the first home of the National Gallery.

The government established a Committee for the Superintendence of the National Gallery, drawn mainly from existing trustees of the British

Museum; the members included Beaumont, Sir Thomas Lawrence and Sir Robert Peel. On 30 March, they appointed the well-connected William Seguier (already responsible for George IV's collection, superintendent at the British Institution, and art adviser to Peel) as keeper on a salary of £200 per annum. The new gallery opened on 28 April 1824. Access was free, and it was available to the public four days a week, with a maximum of 200 people allowed in the building at any one time. At the end of the first week, Seguier described the visitors as very orderly and well behaved. Within the first six months, it attracted more than 24,000 visitors.

It was the keeper's job to negotiate purchases but the initial acquisitions policy was cautious, especially because of the appallingly cramped conditions at 100 Pall Mall where the weight of the growing collection threatened to crumble the walls, and the fire hazards were extreme. Initially, there was little interest in acquiring pre-renaissance art. The trustee Peel collected later Dutch artists (the sort of works Darley loathed) but did not like the early Italian masters, whom he called 'curiosities'. So when bankruptcy forced Carl Aders to put his predominantly early northern collection on the market in the 1830s, the National Gallery was not interested, and the works were sold off piecemeal at very low prices in two main sales in 1835 and 1839. After the first sale, Henry Crabb Robinson offered the replica of *The Ghent Altarpiece* to the Gallery for £250 but Seguier rejected it on the grounds of lack of funds. Lack of interest was more likely to be the case.

By 1842, however, after Hay's van Eyck had received critical acclaim at the British Institution, circumstances and attitudes began to change. Prince Albert had helped make Germanic art fashionable, and the National Gallery, which now owned around 180 paintings, had moved to more spacious, purpose-built premises. Designed by William Wilkins, the building was erected in the new public space that was being cleared north-west of Charing Cross, and would be named Trafalgar Square after the erection of Nelson's Column in November 1843. The gallery occupied the west wing but shared the accommodation rather uneasily with the Royal Academy, which was in the eastern wing. The classical facade

commemorated the late George IV, because the huge Corinthian columns of the portico came from the now demolished Carlton House.

George Darley attributed the gallery's hitherto unadventurous purchasing policy to the approach of keeper William Seguier, whose obituary he wrote for the *Athenaeum* in 1843. This was a surprisingly inappropriate tirade in which Darley took the opportunity to attack the current state of the arts in Britain and in particular 'the superintendence of national establishments'. Damning Seguier with faint praise as 'an amiable and respected man' who had used his natural common sense to move from being an unsuccessful artist to a competent picture restorer, he had regrettably turned into 'a wary connoisseur – a leading critic – and at length an oracle'. And Darley recounted how this 'uneducated man frequented the highest circles, where his natural good breeding received a polish that, despite the said drawbacks, carried him well through conversations not over-refined'. This was the fault of the 'essentially vulgar-minded' George IV for promoting him in the first place, and 'the despicable nature of the "aesthetics" then prevalent'. For Darley, Seguier represented a decline in modern standards which denied the need for any director of a collection to be 'educated, familiar with art, literature and criticism'. Another of Darley's demands was that collections should be well documented. Yet 'the catalogue Seguier drew up for the National Gallery would vindicate more than we have said against his limited attainments; it swarmed at first with errors, and is still over-run with them'.

Others shared this view. When Dr Wardrop recalled that it was the keeper who had recommended the purchase of Hay's van Eyck to the trustees, he got it the wrong way round. The keeper was subordinate to the trustees and, given the gallery's tight budget, only someone of greater influence and more discriminating taste would have initiated such a significant purchase. The moving spirit was almost certainly Charles Eastlake, one of the great and the good, and another former visitor to Aders's collection. Eastlake had trained as an artist and became a history painter in Rome for some years; however, after a visit to Flanders, he developed a passion for early Netherlandish art. After he returned to London in

1830, it was his networking rather than his painting skills that made him an influential member of the art establishment. In 1841, he was appointed Secretary of the Fine Arts Commission (president Prince Albert), responsible for selecting the decorative scheme of the new Palace of Westminster. His friend Sir Robert Peel, who instigated the commission, was also a trustee of the National Gallery. Eastlake realised that he could give the young institution the kind of breadth and chronological sweep of Denon's Louvre that had so impressed him, and many other English visitors. After Seguier's death, Peel appointed Eastlake as the new keeper of the gallery.

In the early summer of 1842, the trustees of the National Gallery officially sanctioned the acquisition of Colonel Hay's van Eyck, following some behind-the-scenes pressure. As the gallery had no funds of its own, all purchases had to be made through the Lords Commissioners of the Treasury, and it was therefore necessary to secure informal advance approval before making an official request for the money. According to the minutes of the gallery trustees' meeting of 2 May, attended by the Duke of Sutherland, the Marquis of Lansdowne, Lords Monteagle and Colbourne, and the collector Mr William Wells, it was 'resolved that the Trustees are of opinion that the extraordinary merit of the Picture by van Eyck, its perfect preservation, its extreme rarity and the moderate price at which it may be obtained, viz 600 guineas, moves them to recommend it without hesitation to my Lords as a valuable addition to the National Collection, and that a copy of this minute be forwarded to the Lords Commissioners of the Treasury in answer to their recommendation'. C. E. Trevelyan, the secretary to the Treasury Commissioners, confirmed his masters' approval, though at the same time he made it clear that the request for a further £10,300 for other paintings, including a Velázquez, would not be forthcoming 'under the present circumstances. But as my Lords have reason to believe that there are some particular circumstances connected with the picture by van Eyck which render it desirable that that picture should be acquired for the public, their Lordships would be willing to make provision for the purchase of it, on being informed of the manner in which it has been ascertained that the sum demanded for it is not beyond that

which the merits of the picture entitle the party to demand.' The sum of 600 guineas was at the lower end of the scale of prices paid by the Treasury over previous years. Correggio's *Holy Family* was worth £8,800, Rubens' *Judgement of Paris* £4,200, Murillo's *St John* £2,100. However, Bellini's *Doge Loredano* had also cost 600 guineas, and Rembrandt's *Jewish Rabbi* was a bargain at £409.10s.

The mills ground slowly. On 13 June 1842, Trevelyan informed the trustees, 'Having laid before the Lords Commissioners of Her Majesty's Treasury your Secretary's letter of 3 June conveying your recommendations of the purchase of a picture by van Eyck for 600 guineas, I have it in command to acquaint you that my Lords have directed an Estimate to be prepared for that sum and submitted to Parliament.' After this seal of approval Seguier collected the painting from Dr Wardrop. But six months later, James Hay had still not been paid, and had embarrassingly to write to the trustees requesting his long overdue 600 guineas. This letter, dated 6 December 1842, lumbered through the official channels, and was not discussed until the trustees' monthly meeting of February 1843, when it was 'resolved that a letter be written to the Treasury to inform them that the Picture by van Eyck, the purchase of which for £630 was approved by their Lordships is now in the possession of the Trustees and that it is their opinion that the purchase money should be paid to Major-General Hay and, further, that a communication be made to the Gallery to this effect'.

The purchase was not officially announced until the end of the year. George Darley, whose perceptive review had publicised the existence of the unknown masterpiece, was allowed to tell the good news in the *Athenaeum* of 3 December 1842 in a fulsome item of 'weekly gossip' which signalled the welcome impact of Eastlake on the trustees' decision making. 'We congratulate all who love the Fine Arts better than the superfine on a new acquisition made by the National Gallery – an authentic and admirable van Eyck; we congratulate the directing committee, moreover, on their new acquisition of spirit and judgement, evinced in the purchase of a work not at all distinguished for vulgar attractiveness. Till within

some short time, the opinion seems to have prevailed that the National Gallery should be stocked with pictures not otherwise than as a circulating library with books, that is with productions that would please the public taste whether they depraved or improved it.' He referred with horror to the excess of 'fourth-rate Bolognese masters' although the proper role of a gallery should be to 'enlighten and lead the public, not pander to it'. The van Eyck redeemed all this, and Darley ended with a neat piece of self-promotion: 'The new star remains as yet invisible at Trafalgar Square; when it shines forth in all its splendour, we shall make our own observations upon it. We have here but to add that it is the same van Eyck so commended by us when exhibited about two years ago among the "Ancient Masters".'

Darley was obviously in the gallery's good books, because he was granted a preview of the painting a week before it went on show to the public at the beginning of April 1843. His 'weekly gossip' column for 25 March announced that 'the celebrated picture by van Eyck purchased for the National Gallery will make its appearance there next week . . . by the kindness of the official authorities, we have had an opportunity for minuter inspection than we enjoyed before'. His close scrutiny confirmed that the date in the inscription was 1434 (not 1424), and therefore firmly dissociated the painting from the older van Eyck brother, Hubert, thought to have died in Italy in 1426. Although Darley misread *'fuit'* as *'fecit'* in the inscription, his sharp eyes recognised the tiny Passion scenes around the mirror, and the 'Lilliputian' figures it reflected entering the room (though he claimed to spot three, not two). As in his original review, he emphasised the nature of the medium: 'It has a smooth, lucid, crystalline impasto, somewhat like enamel, as though it would break "with a glassy fracture" in the geological phrase, and possesses all the concomitant qualities, good and bad, of its style — firmness but hardness of line, purity of tone but no morbidity, exquisite but super-subtle imagination: John van Eyck's marvellous power in simple colours evinces itself by the art he has of making yellow tell as gold — this is true alchemy!' The realism was such that many details 'seem to be daguerreotyped rather than painted,

such is their extreme fineness and precision'. The critic had now changed his mind about the lady's 'embonpoint', which was not the result of pregnancy but 'the effect of her bizarre costume' and the conventions of fifteenth-century art. He regarded the 600 guineas paid for 'our van Eyck' as a small price, considering its rarity, and ended with pride: 'NB. It is in almost immaculate condition.'

The *Art Union* ('a monthly Journal of Fine Arts') also hailed the new acquisition; the January edition noted the purchase, although pointing out the disgraceful delay in payment, which prevented it from being hung until Hay had reached his money. The April edition announced that display was imminent, and May contained an enthusiastic review: 'This is the most estimable picture lately added to the Gallery, inasmuch as works of such quality coeval with the earliest practice of oil-painting are so rarely attainable.' It was altogether 'a marvel in the art of painting' whose even 'minor beauties equal the work of those who have formed their styles on the best work of the best schools' while the chamber and its contents 'are made out with particular fidelity and care. We counsel all those who know John of Bruges only through the wretched forgeries circulated in his name to examine this work and say if he, in this single picture, does not surpass many whose names are lauded to the stars.'

There was also excellent coverage in the *Illustrated London News*, a weekly founded only a year earlier as the world's first illustrated newspaper. On 15 April 1843, it published a long article which gave a great sense of the painting's charisma and instant appeal. 'A picture has been added to the National Gallery which affords as much amusement to the public as it administers instruction to the colour grinders, painters and connoisseurs who, since the day of its exhibition, have crowded the rooms to admire its singularity or discuss its merits. To every one it is a mystery. Its subject is unknown, its composition and preservation of its colours a lost art.' An intriguing comment implied that James Hay had used an intermediary in his negotiations with the gallery: 'It was bought from an obscure Belgian dealer who knew nothing of its history and sold to the Gallery for six hundred guineas.' In some ways this makes better sense than Wardrop's

version, that Seguier approached Hay directly. The 'obscure' Belgian was in reality Chrétien-Jean Nieuwenhuys, one of Britain's leading art dealers, who was selling other works to the gallery at this time (another of his clients was Robert Peel) and would buy the Coxcie copy of *The Ghent Altarpiece* in 1850. Nieuwenhuys was the sole source for the implausible account of Hay coming across the painting in Brussels: if he was involved in cutting a deal with the National Gallery, he would naturally have needed to establish a respectable provenance for the work.

The article speculated on what was being seen as the painting's most intriguing feature, the identity of the man and woman. Despite the neutral title *Portraits of a Gentleman and a Lady*, 'it has enjoyed at the fancy of beholders a multitude of names, and some of them not very flattering to the good taste or moral purity of the parties designated'. The writer quoted that 'able reviewer', Darley, on Simon Prim belatedly making an honest woman of Sarah Pure, but 'others again are almost sure the portraits represent a mother elect consulting her medical attendant, or even honest Giovanni the painter and his wife'. However it was more likely, said the article, that the painting had a religious context, and might therefore be the wing of a devotional triptych whose central panel represented the Virgin and Child. It was typical of the fifteenth century – 'hard in its outline, stiff, restrained . . . simple full and discriminative in its colouring but disfigured by mean conceits and the petty details and quaint devices of household furniture and massive costumes'. Technical excellence redeemed it: 'A marvellous finish and a more marvellous brilliancy of colour, which the accidents of 400 years have not been able to diminish, reign through the entire composition and seem to declare with an energy which no dealer's evidence can second that this is emphatically *the* van Eyck, to the exclusion of thousands which assume the name.' An added attraction in the magazine was the first-ever reproduction of the painting; the article boasted that 'no engraving save our own has ever been made'. The illustration was actually rather heavy-handed, and it repeated Darley's inaccurate reading of the inscription on the wall, with *fecit* rather than *fuit*.

A better engraving was published in the same year, in the 1843 edition
of *Felix Summerly's Handbook for the National Gallery*. Felix Summerly was the
pseudonym of the versatile Henry Cole, civil servant and ardent campaigner
for art and design reform. In 1841 he began to produce an affordable
series of guidebooks to collections and historic buildings in a gallant
attempt to make art accessible to the working man. His 1843 guide to
the National Gallery listed all the paintings, numbered according to the
order of their acquisition and the last being Number 186, *Interior of a Room
with Figures* by John van Eyck. This was 'a perfect specimen of the colours
of this old German painter. It is inscribed *Johannes van Eyck fecit hic 1405*
[sic]. Exhibited at the British Institution in 1841 and was then the property
of Colonel Hay. The Government purchased it for 600 guineas.' In his
list of the artists represented in the gallery, Cole described van Eyck as
'one of the earliest painters in oil, the use of which he is said, but erro-
neously, to have invented as a vehicle. There are evidences of oil painting
existing in our own country a hundred years before his time. His pictures
are remarkable for extreme care and finish.'

This 1843 edition of the handbook was the first to be illustrated with
woodcuts 'to give the general character and feeling of the originals'. Many
of the entries were therefore accompanied by tiny wood engravings, no
larger than around 5 x 9 centimetres, produced by the three artist sons
of John Linnell (himself once a regular visitor to the Aders collection).
The engraving of the van Eyck provided an inevitably simplified version
of the painting, with simple vertical and horizontal lines to represent the
folds of clothing, back wall and floorboards, but it managed to capture
the downward tilt of the woman's head more effectively than the much
larger example in the *Illustrated London News*.

Cole's combative preface to the volume defended his own popular series
of handbooks, 'being the first published below a shilling', and attacked
'a succession of piratical imitations of them'. The chief perpetrator, Cole
alleged, was Joseph Hume, the radical MP for Montrose, who had long
argued for free access to sites, monuments and galleries on the grounds
of their improving nature; Cole now accused him of issuing a badly

plagiarised version of the handbook in the previous year. He recorded that the gallery had attracted 540,315 visitors in 1842, and pointed out that this represented excellent value for money: 'For the gratification, not to say improvement, of half a million of persons, the annual cost of the Gallery (exclusive of the purchase of pictures) does not exceed £1,000, or about a halfpenny each person admitted.' However, he demanded better accommodation for the nation's collection than its five cramped rooms of 'diminutive size', in which the pictures were hung without labels and with no regard to schools or dates. He agreed with his distinguished colleague Charles Eastlake that the gallery still seriously lacked early works. This was a topical point that Anna Jameson also made in her 1842 *Guide to the National Gallery*; she conceded the problematic nature of pre-renaissance paintings but argued that art should elevate standards rather than appeal to the lowest common denominators of popular taste, an issue that Darley had also raised.

Under Eastlake's regime, and inspired by the enthusiastic reception of the van Eyck (the gallery's earliest painting), the Flemish and German holdings were expanded. Eastlake did not have an easy ride in the early years: there was criticism of his emphasis on the north, especially after his purchase of a dubious 'Holbein', and this was followed by the great varnishing controversy. It had been customary for restorers like Seguier to apply a layer of varnish, made from resin and linseed oil, to protect paintings (then displayed without glass) from the filthy air of central London; it was also thought to give them a warmer tint, though this ominously darkened with age. The van Eyck was coated in this way before being put on display. But Eastlake, who had a fine technical understanding, and was then researching his *Materials for a History of Oil Painting*, cancelled this practice and established a cleaning programme (undertaken by the late Seguier's brother). The bright new colours shocked connoisseurs accustomed to the grubby old patinas, and was ammunition in a campaign John Ruskin waged in the pages of *The Times* that forced Eastlake to resign as keeper in 1847.

Three years later, however, he became a trustee and was called to give

evidence to the Select Committee on the Management of the National Gallery in 1852–53; the committee report vindicated his cleaning programme: 'Of the other objectionable properties of the Gallery varnish, its tendency to change colour and to attract dirt, there seems now to be no question in any quarter.' More significantly, it established an annual purchase grant of £10,000 so there was no more going cap in hand to the Treasury, and recommended that there should be a new post of director. Eastlake was appointed to this position in 1855, and soon expanded the German and Flemish collections, including two more van Eycks, *Man with the Red Turban* and *Timotheos*, expenditure which he no longer needed to justify. In 1859, the gallery attracted almost a million visitors.

The Dog

In contrast to the visual inventory of goods and possessions, the little dog who stands between the couple in the very foreground of the picture appears to be the most spontaneous item in the carefully constructed display. Unlike the sideways gaze of the man and the woman, the dog's lustrous eyes, like miniature versions of the mirror, engage directly with the viewer, and seem to follow you around the room. The wiry russet coat, alert ears, short black nose, broad chest and wide-legged stance mark him out as a member of the breed called the Brussels griffon; the features are still carefully prescribed by the Kennel Club today. Descendant of a long line of Flanders terriers bred to catch rats, this little dog was another distinctively local product. (The breed only reached England from Belgium in the nineteenth century.) The bright eyes, gleaming coat and plumy tail suggest, almost more than any other aspect of the work, that there was an actual model for this essence of alert dogginess, a living creature longing for someone to throw a stick or, better still, for a rat to emerge from the wainscoting.

Dogs certainly featured in the art of the day. Faithful unto death, they accompanied their owners on tomb effigies, with knight and lady resting their feet on their loyal companions for eternity. Noblemen were painted

with hunting hounds, their wives with lapdogs. In the sumptuous *Bedford Book of Hours*, begun around 1423 to celebrate the marriage of the Duke of Bedford to the Duke of Burgundy's sister, the duchess is shown kneeling in homage to her name-saint, St Anne, who holds the infant Mary on her lap. Yet despite the solemnity of the moment, the manuscript painter has included two little dogs frolicking on the trailing hem of the duchess's gown; one looks just like a Brussels griffon, with the same sturdy posture, reddish coat, pricked ears and erect tail as the Arnolfini dog. If this was the lapdog of choice in Burgundian court circles, a merchant's wife might aspire to own one as well.

Yet van Eyck was also using the dog as a device to connect the modern and the biblical world, making the past present and bringing holy characters to life by associating them with familiar objects and images. This was a feature of his style, an inventive extension of what his contemporaries were doing. Among the scenes that he contributed to in the richly illustrated manuscript known as the Turin–Milan Hours was the birth of John the Baptist, which he set in a busily furnished chamber with a red-curtained bed. In the foreground were a dog and a cat.

12. Pre-Raphaelite Idol and Connoisseurs' Quest

For the middle- and working-class visitors who thronged the National Gallery in the 1840s and '50s, the domestic theme of the van Eyck and its exquisite detail appealed far more than the grandiose subject matter and dramatic techniques of Italianate canvases once owned by aristocrats. A secular portrait was also more pleasing to the Protestant ethos than van Eyck's religious works like *The Ghent Altarpiece* or his sumptuous Madonnas with their dangerously Roman Catholic connotations. The exquisite precision of his painting drew comparisons with the very new medium of photography: Darley had already compared the work, then in its dignified ebony frame, to a daguerreotype. Other spectators appreciated its modernity as a moral painting on the ever fascinating topic of the 'fallen woman' – for some, the swollen belly beneath the green gown was indubitable proof of sexual misconduct. For all these reasons, the new acquisition was in tune with the times.

Despite its excellent content, many people perceived the National Gallery itself as unfit for purpose. A *Visitors' Guide* to London, compiled in 1843, criticised the 'paltry building . . . occupying unquestionably the finest site in the metropolis [which] from the contempt it is universally

held, has been stigmatized with the damning designation of a *national disgrace.* The art critic John Ruskin agreed, referring to 'that preposterous portico . . . those melancholy and miserable rooms'. Like so many works in the collection, the van Eyck was badly hung, 'placed unfortunately under glass, and in a salon but ill-lighted', according to a disappointed French visitor in 1855.

This did not dull the public's appreciation, nor that of the aspiring young painters who studied at the Royal Academy Schools next door. Until 1869, the building in Trafalgar Square continued to be shared by the National Gallery and the Royal Academy. The public had access to the gallery four days a week, but on Fridays and Saturdays it was reserved for the academy. Although the divided accommodation was inadequate, the easy availability of the national collection was an essential part of the academy's art training: the direct study and copying of old masters was considered a vital stage in an artist's education. Students spent six years at the academy. For the first three years, they studied the antique by drawing from casts of classical sculptures, then they were permitted to join the life class, and only after that to study painting – of which the main teaching collection was the two hundred or so works in the adjoining National Gallery.

Despite poor viewing conditions, the van Eyck became an icon for a group of young academy students and their circle, whose works showed its influence in many different ways. The youngest was John Everett Millais, a former child prodigy who had joined the Royal Academy Schools when he was only eleven. His friend and fellow student was William Holman Hunt, whom Millais had met in the British Museum and encouraged to apply to the academy. Hunt was enthralled by the combination of realism and religious symbolism in Flemish painting which he saw as effortlessly achieving the truthful morality that he and Millais sought to restore to art. In 1848, the two young artists got to know the charismatic Dante Gabriel Rossetti, poet and painter, who had admired their innovative work when he saw it in the Royal Academy exhibition that year, and together they founded a secret society, the Pre-Raphaelite Brotherhood. Signing

their works with the tantalising initials PRB was an act of fun and rebellion against the Italian renaissance bias of official art training. The brotherhood argued that the 'primitive' artists of the fifteenth century, like van Eyck and his contemporaries, were infinitely finer than the over-blown sixteenth-century masters Raphael and Michelangelo, the role models of the Royal Academy.

In the summer of 1849, unusually flush because they had each sold a painting, Rossetti and Hunt visited France and Belgium to see original works by the artists they admired. In the Louvre, which they found to be of a far higher quality than the National Gallery, they were impressed by 'a tremendous van Eyck' (*The Virgin with Chancellor Rolin*), and in Bruges they saw more of his work (*Madonna with Canon van der Paele*, and *Portrait of the Artist's Wife*) and discovered Memling. In Ghent, they went to St Bavo's Cathedral to inspect the altarpiece, which Rossetti would later recall he had seen several times with the greatest delight. This influenced the dramatic Annunciation which he painted on his return and entitled *Ecce Ancilla Domini*, the words that van Eyck had inscribed beside the altarpiece's Virgin Annunciate. According to Ruskin, Rossetti also intended to paint something 'like that van Eyck in the National Gallery with the man and woman and mirror' but typically failed to do so; the great critic believed that the painting was a 'judicious addition' to a collection in which he found much to criticise.

In addition to the biblical and romantic medieval subjects of his early career, Rossetti struggled for some years on a modern morality painting, *Found*, on the ever popular topic of the fallen woman. Holman Hunt tackled the same theme more rapidly and effectively under the immediate inspiration of the National Gallery's van Eyck, a work he had known and admired since its acquisition. In *The Awakening Conscience*, exhibited in the Royal Academy summer exhibition of 1854, Hunt depicted a couple in a well-furnished room with a mirror on the back wall. The contents symbolised their relationship, and the contemporary status symbols of piano, carpet, chair and ornaments were all as minutely detailed as the bed, chest and settle in the Flemish painting. But Hunt

daringly turned the scene into the exact opposite of van Eyck's depiction of a stable marriage, for the two characters were a kept woman and the lover who has ruined her. Instead of the faithful dog, a cruel cat toys with a bird just as the man has toyed with the woman; instead of the orderly pattens and slippers, a soiled glove is tossed on the ground, just as he will toss her aside. Hunt had absorbed van Eyck's symbolism as much as his realism. The main difference is in the scale of Hunt's mirror, which is rectangular and takes up much of the rear wall. It reflects the window opposite and the woman's back: the message is one of hope, that she may be able to walk into the light and away from her seducer.

If the van Eyck represented the recollection of a happy marriage for its first, widowed owners Marguerite of Austria and Marie of Hungary, it also appears to have suggested stability and calm to Hunt, then deeply troubled over his own relationships with women. Indeed, aspiring to virtue, he had decided to 'educate', Pygmalion-style, the pretty but common young woman, Annie Miller, who had modelled for the woman in his painting. *The Awakening Conscience* was not the painter's only act of homage to van Eyck. He introduced a round mirror on a back wall into the sentimental *The Lost Child* (1861), and the languid *Dolce Far Niente* (1866); in the latter the reflection includes the statue of a married couple. In his baroque late work *The Lady of Shalott*, there is a dominating mirror on the wall, in this case essential to the plot, since the Lady was only allowed to view the outside world through its reflection in the glass. When she breaches the rule in order to look directly on Sir Lancelot, she is doomed to die. Hunt's swirling, dramatic depiction of her moment of decision included another borrowing from van Eyck, a pair of pattens on the floor beside her.

Ford Madox Brown was a mentor and friend to the Pre-Raphaelite Brotherhood. Having begun his art training in Bruges, he was well aware of the powerful Flemish tradition, and was another regular visitor to the National Gallery, a good place for a penniless artist to pass a few hours. A round mirror was the focal point of his painting *Take Your Son, Sir!*, a

disturbing work which he began in 1851 but never finished; the main character is a woman whose head is framed like a halo by the round mirror on the wall behind her. Without the title, the image is puzzling; she is holding out a baby to a man who only exists through his reflection in the mirror, looking at us and therefore at her, a visual device as tantalising in terms of depth and perspective as the figures shown entering the room in van Eyck's mirror. This painting was another meditation on relationships. The title implies that the subject was a fallen woman, a ruined creature confronting the father of her illegitimate child, yet the model was Brown's lawful wife Emma.

A second work suggests van Eyck's influence more obliquely. Brown set *The Last of England* (1855) in a circular wooden frame resembling the form of the mirror, while the subtly distorted perspective of the painting gives the impression that the whole scene is being reflected in a convex lens. The central characters are a couple, the man on the left, the woman on the right, and they are holding hands; this motif is reinforced a second time by the woman's other hand, which clasps that of the baby otherwise concealed in the folds of her cloak. The painting is an image of marriage as much as of emigration.

By the mid-1850s, the original Pre-Raphaelites were going their own ways, but Rossetti acquired two new disciples, William Morris and Edward Burne-Jones, Oxford undergraduates who had decided to devote their lives to art. Morris had always been passionate about the Middle Ages. In the summer of 1854, he toured northern France and Belgium with his sister in order to see the great cathedrals and the famous Flemings van Eyck, Memling and van der Weyden, who more than fulfilled his expectations. He visited the Netherlands again two years later, and adopted van Eyck's motto, '*Als Ich Kanne*', *As I can*; this was the first half of an old Flemish saying, which concluded *but not as I would*. The phrase also punned on *Eyck/Ich — as Eyck can —* as painted on the frame of the possible self-portrait *Man with the Red Turban*, on display in the National Gallery since 1857. Morris included these words, translated as 'If I can', in his first piece of embroidery.

He also adopted elements of the double portrait into his own painting *La Belle Iseult*. This was his attempt to portray his love and bride-to-be, Jane Burden, the 'stunner' from Oxford whom he met in the summer of 1857, when she modelled for the team of friends Rossetti recruited to paint murals in the Oxford Union debating chamber. In order to present the exotic-looking Jane as the temptress Isolde, Morris included the familiar imagery of the van Eyck – a draped bed with looped-up curtains, a little dog, slippers and oranges, features which proved how he had absorbed the details, and particularly the textures of the Flemish chamber. Even Isolde/Jane's posture echoed that of the woman in the green gown.

Morris married Jane in the spring of 1859, and on their six-week honeymoon they visited Paris, the Rhine and Bruges, 'one of the towns which always gave Morris pleasure' according to his colleague Philip Webb. And he later described it as 'a really beautiful place, so clean and quiet too'. Naming one of his wallpaper patterns 'Bruges' was perhaps in memory of happier times as well as homage to van Eyck.

Edward Burne-Jones also loved the double portrait. Reminiscing in 1897, a year after Morris's death, he lamented, 'I've always longed in my life to do a picture like a van Eyck, and I've *never done it* and never shall. As a young man, I've stood before that picture of the man and his wife and made up my mind to do something as deep and rich in colour and as beautifully finished in painting, and I've gone away and never done it, and now the time's gone by.' This nostalgic mood inspired him to inspect the painting again, and two weeks later, killing time before a tedious committee meeting of the Royal Watercolour Society:

I went into the National Gallery and refreshed myself with a look at the pictures . . . I looked at the van Eyck and saw how clearly the likes of it is not to be done by me. I should think it is the finest picture in the world. But he had many advantages. For one thing, he had all his objects in front of him to paint from. A nice clean neat floor of fair boards, well scoured, pretty little dogs and everything. Nothing to bother about but making good portraits – dresses and all

else of exactly the right colour and shade of colour. But the tone of it is simply marvellous, and the beautiful colour each little object has, and the skill of it all. He permits himself extreme darkness though. It's all very well to say that it's a purple dress — very dark brown is more the colour of it. And the blacks, no words can describe the blackness of it. But the like of it's not for me to do — can't be — not to be thought of.

Despite this self-deprecation, Burne-Jones had been adopting elements from the painting into his own work from an early stage in his career. He never trained at the Royal Academy Schools, but found free access to the National Gallery crucial to the self-education of a struggling young painter. His first major work, *Sidonia* (1860), adopted van Eyck's palette of 'extreme darkness' offset with whites. He persuaded his father, a frame maker, to recreate the mirror on the portrait (even though it had to go back to the workshop because the ends wouldn't meet properly) which he depicted in *Fair Rosamund and Queen Eleanor* (1862). Much later in life, he was enchanted by Katie Lewis, the little daughter of his business adviser, and in his 1886 portrait of her, he incorporated the motifs of a curtained, draped settle with cushions, oranges and a terrier. He paid a final tribute to the Flemish master in a diatribe against those incomprehensible modern painters the Impressionists, reserving particular scorn for Manet's *Olympe*, 'a woman sitting up in bed with a black ribbon round her neck . . . by the side of these fellows, Whistler's a kind of van Eyck'.

After he became director of the National Gallery, one of Charles Eastlake's innovations was to provide the paintings with labels. The text only gave the most basic facts — name of the artist and title of the work — but this was preferable to forcing interested visitors to buy the one-shilling handbook or the more expensive catalogue, which undermined the principle of free entry. The first titles given to the van Eyck had been blandly descriptive because the subject was unknown. In the Carlton House inventory of 1816, it was *Portrait of a Man and his Wife*, for the British Institution exhibition *Portraits of a Gentleman and a Lady*, for Henry Cole's

handbook *Interior of a Room with Figures*. In the National Gallery catalogue of 1847, compiled by Eastlake and his keeper Ralph Wornum, it became *Portraits of a Flemish Gentleman and a Lady*. Hailing it as 'the oldest picture in the collection', their entry correctly recorded *fuit* in the inscription. A cautious footnote added that van Mander, in his 1603 *Lives of the Painters*, had described the picture as showing a man and his wife, and therefore the scene might show a bridegroom introducing his bride to her new home; also taken from van Mander was the information that Marie of Hungary had bought the painting from a Bruges barber for 100 guilders.

In the same year, however, Eastlake came up with an alternative suggestion, which he published in *Materials for a History of Oil Painting* (1847). As the recent decipherment of *fuit* (*was*) rather than *fecit* (*made*) turned the reading of *Johannes van Eyck fuit hic* into *van Eyck was this man*, and not *van Eyck made this*, he suggested the couple in the room might be van Eyck and his wife. 'The question is submitted to those who have given much attention to the history of John van Eyck,' concluded Eastlake.

For a while, this became the official line, promulgated by several critics including the eminent German scholar Gustav Waagen when he discussed the painting in *Treasures of Art in Great Britain* (1854). As a former director of Berlin's Gemäldegalerie, home to the wings of *The Ghent Altarpiece*, Waagen was one of the first to appreciate the distinction between early Flemish and early German art. His book was translated into English by an old friend, the formidable Lady Eastlake. He confidently described the work as *Full-length portrait of Jan van Eyck and his wife, standing in a room with rich accessories*, and noted its exceptional quality. 'This valuable picture . . . is not only executed with the greatest truth and life in every portion, even to the reflection of the figures and the room in a circular mirror . . . The picture also presents a fine general effect and a deep and rich chiaroscuro, which is the more remarkable considering the period.' Then he repeated Eastlake's van Mander reference. The 1860 edition of the National Gallery catalogue cautiously confirmed the interpretation, referring to the painting as

Portraits of a Flemish Gentleman and a Lady; probably the Painter and his Wife. But it was already out of date.

In 1857, a cosmopolitan journalist, Joseph Archer Crowe, and an Italian political exile, Giovanni Battista Cavalcaselle, came up with a radical new identification of the couple. The names of Crowe and Cavalcaselle are still cited today, and their titles are numerous. They came together as two strong-willed young men with a mutual passion for paintings, and their friendship turned into an important collaboration which made early art more accessible and popular by setting artists and their works in the wider historical context. Their pioneering survey of Flemish painters spelled out for the first time the connection between Jan van Eyck and an Italian merchant in Bruges named Arnolfini.

Joseph Crowe was born in London in 1825 but spent his childhood in Paris where his father was foreign correspondent for the *Morning Chronicle*, the leading Whig daily newspaper. Crowe junior wanted to become an artist, and joined the studio of Paul Delaroche, the historical painter; his training included copying works in the Louvre, where he decided that he liked the Dutch school best. After the family moved back to London in 1843, Crowe joined his father's old paper as a crime reporter and theatre reviewer, but maintained his art studies by copying paintings in the National Gallery; here he was able to study the gallery's new star, the van Eyck, in intimate detail. In 1846, he joined the *Daily News*, a radical new newspaper founded by Charles Dickens. His father suggested that he might keep up his artistic interests by writing a life of van Dyck, but, as Crowe recorded in his *Reminiscences*, 'I, for my part, had looked with admiration at the works of John van Eyck, and thought I discovered in them a subject of study which had not hitherto been occupied . . . I soon came to the conclusion that a biography of van Eyck would be possible if I could make a minute examination of pictures in Belgium and Germany. I also observed that it was not so much a biography that was wanted as a history of early Flemish painting, which might be compassed by taking together van Eyck, his precursors, contemporaries and followers. Little did I then know what a wide field of inquiry I had opened for myself.'

Crowe knew French and Latin, but now gave himself a crash course in Italian, German and Flemish. He visited Bruges, Ghent and various continental galleries, and set to work.

On a second research trip in 1847, he met en route to Berlin a young Italian painter, Giovanni Cavalcaselle, who was researching 'the lost treasures of his country', the Italian paintings dispersed through the galleries of Europe. Meeting again in the Berlin Gemäldegalerie:

I confided to him that I was going to do the same thing with the Flemings. We entered. He turned to the left in the gallery, I to the right. Presently I saw him running in my way. Breathlessly he called on me to follow him, give up my stupid quest of the Flemings, and come and look at a wonderful masterpiece on the other side. But I had already found the panels of van Eyck's Agnus Dei [The Ghent Altarpiece] *and was lost in admiration of them — so much so that I stopped my friend and tried to persuade him that he was prejudiced; and to my surprise and great pleasure, I gradually saw a smile of enjoyment playing about his features . . . he burst out at last with the confession that he had never seen the like by a Flemish master.*

Crowe struggled to reconcile his ambitious project with his day job as a journalist. In 1848, he became foreign affairs reporter for the *Daily News* and in 1849 was sent to Paris, where he again met Cavalcaselle, dishevelled by 'unkempt locks and a bristly beard', now a political exile because he supported Garibaldi and Mazzini's campaign to liberate Italy. Threatened with imprisonment and even a death sentence if he remained in France, he begged Crowe to help him seek political refuge in England, where he struggled to find work as a draughtsman. Crowe lost his job in 1850, and the two young men shared lodgings, often short of money and food. But 'we found that we could be useful to each other in art and art–literature . . . we hunted in couples, we went constantly to the British Museum, where we now found the studies of Count de Laborde on letters, arts and industry, under the dukes of Burgundy, and I was fortunate enough to make important literary discoveries'.

The academician Comte Léon de Laborde's exemplary analyses and publication of the fifteenth- and sixteenth-century archives of Lille, Brussels and Dijon, which appeared in 1850, revealed a wealth of detail about daily life at the Burgundian court, essential reading for anyone attempting to study van Eyck and the other Flemish painters in relation to the society and patrons who commissioned them. The meticulous ducal treasury accounts mentioned the name of van Eyck, the duke's painter and *varlet de chambre*, a number of times. But Crowe's journalistic instincts were stirred by another recurring name, that of Jehan Arnoulphin (sometimes Ernoulphin), a merchant from Lucca who lived in Bruges and was selling luxury textiles to the duke in the 1420s – goods such as 'imperial gold cloth from Lucca on a vermilion ground' or 'an imperial cloth from Lucca on a green ground' or 'six pieces of tapestry', a lavish gift for the Pope. Crowe was struck by the similarity between 'Arnoulphin' and the 'Ernoul le Fin' or 'Arnoult fin' who was recorded as the subject of the van Eyck painting that Diego de Guevara presented to Marguerite of Austria, according to inventories of her collections. An archivist, André le Glay, had already published these in 1839. So had Laborde.* The industrious Crowe was familiar with both publications.

Putting two and two together, Crowe asserted that 'Arnoulphin lived in Bruges, and John van Eyck painted both his and his wife's likeness: the picture in the National Gallery coincides with the [inventory's] description' and is the reason why the painting is still known today as the Arnolfini portrait.

Yet Crowe, an amateur art historian working in initially unfamiliar territory, was afraid of appearing to contradict the received wisdom of the experts Sir Charles Eastlake and Gustav Waagen. So he kept his options open in a text packed with contradictions by adding that 'it has been

* As a good Frenchman, Laborde tried to be fair to Marguerite of Austria: 'For twenty-five years she worked for the good of the house of Austria to do all the harm that she could towards us, and she pursued this work with all the passion of a woman's heart. However this was not a crime, and we should respect her patriotism.' (1850, 89)

supposed however and with some appearance of probability, that the figures in the National Gallery are the portraits of John van Eyck and his wife; and the likeness between the female face and the portrait of the painter's wife at Bruges bears out this supposition', and agreed with Eastlake that 'the signature of the painter *Johannes de Eyck* tends to confirm the opinion that the male figure is a portrait of Jan himself'. Yet he confusingly referred to the painting as *A Newly Married Couple*. He repeated the van Mander legend that Marie of Hungary had found it, though this totally contradicted his earlier suggestion that the painting was previously owned by Marguerite. He also rejected the recent interpretation of Laborde, who had personally inspected the work in the National Gallery, even managing to have the glass removed so that he could check the inscription. Laborde called it *La Légitimation* and claimed it was a historical document witnessing a marriage taking place in 1434 because of the woman's advanced pregnancy.

Crowe's description of the painting showed how he had learned to appreciate the development and subtlety of van Eyck's distinctive style:

> *Harder outlines and clearer general forms distinguish this from the painter's previous works, yet in no single instance has John van Eyck expressed with more perfection, by the aid of colour, the sense of depth and atmosphere. He nowhere blended colours more perfectly, nor produced more transparent shadows . . . the finish of the parts is marvellous and the preservation of the picture perfect, and there are few things more wonderful than the chandelier which hangs above the pair.*

At the end of the book, almost as an afterthought, he returned to the significance of Marguerite's inventory, but again seemed reluctant to drive the point home, although it named Ernoul or Arnoult. This unsatisfactory circular argument resulted from the delays in production and publication, the stops and starts resulting from Crowe's more pressing commitments as a freelance journalist, combined with later editorial changes and the complex nature of his collaboration with Cavalcaselle. As Crowe defined it:

We gradually brought together such an additional amount of materials as made the rewriting of my earlier chapters on Flemish art necessary . . . To see and judge of panels and canvases and confirm or contest my opinions respecting them was Cavalcaselle's main share in the history of the Flemish painters. He helped me at the British Museum in copying extracts and was full of zeal for this sort of work. He had also an amazing insight into the periods of a master's career, the subject sometimes of acrimonious debate between us. But the time always came when he or I yielded, and then, the question being decided, I adopted it and set it in its proper order in the narrative which, like all others bearing our joint names, was entirely written by myself.

This was too dismissive. Cavalcaselle, whom Eastlake used to consult on Italian art, was one of the experts summoned to give evidence in the 1852–53 Select Committee on the Management of the National Gallery.

Crowe finished writing the manuscript in the summer of 1853, almost lost it in a temporarily missing portmanteau at Boulogne, then offered it to 'the all powerful art publisher John Murray' in October, just before he was sent abroad as war correspondent for the *Illustrated London News*, where he was 'embedded' with the troops in the Crimea and became an eyewitness to the Charge of the Light Brigade.

In June 1854, he received disappointing news: 'Mr John Murray had refused to print my *Flemish Painters* because he held that the work required revision.' Undaunted, Crowe set to work again after returning to England in the following year. 'After all, my real interest and pleasure lay in my book which, having pulled to pieces, I now proceeded to reconstruct. I cannot say how often certain passages were cancelled and rewritten . . . but it was full of new and interesting matter.' This helps to account for his contradictions over the gallery's van Eyck. John Murray approved the revised version but the illustrations were delayed and the book did not appear until the end of December 1856, ten years after the start of the project. Crowe later mused that 'Mr Murray assured me of his conviction that, interesting as the matter dealt with must needs be to a class, the number of readers would never be sufficiently large to yield a return. Looking into the pages of the book and considering things dispassionately

after the lapse of thirty-six years, I feel surprised that Mr Murray ever published the work at all.'

The publisher's confidence was rewarded. *The Early Flemish Painters* became a great success because it filled a gap in the market: it set out the historical background for the still unfamiliar concept of the Northern renaissance, it suggested that Flemish artists were innovative rather than primitive, and provided confident attributions for many contested works. It helped to promote a minor van Eyck craze. One manifestation was Charles Reade's novel *The Cloister and the Hearth* (1861), which included the character of Margaret van Eyck, who passed on the secret of her brother's magical oil techniques to the hero, scribe and illuminator Gerard. And in 1867 William Burges, architect, designer of exotic furniture and friend of the Pre-Raphaelites, recreated the Arnolfini mirror as part of a dressing table, while a workshop in South Kensington turned out commercial copies of the mirror for van Eyck fans. The book was translated into French, German and Italian, and went into a further two editions. Murray subsequently commissioned from Crowe and Cavalcaselle three major surveys of Italian art, plus studies of Raphael and Titian, all of which Crowe somehow managed to combine with a later career as diplomat and spy.

By the time he produced the first revised edition of *Flemish Painters* in 1872, Crowe was entirely confident about the Arnolfini identification: van Eyck's 'most important pictures were undertaken on private commission, chief of which is the panel in the National Gallery representing Arnolfini, a draper of Bruges, and Jeanne de Chenany, his wife'. Arnolfini was 'a personage known on the testimony of contemporary records to have been a cloth-merchant living in Bruges'. Putting a name to Arnolfini's wife for the first time proved that Crowe had assimilated the very latest research on the painting, undertaken by an even more obsessive van Eyck scholar, William Henry James Weale.

Weale was the son of a librarian and book collector. In 1849, at the age of seventeen, he became a Roman Catholic under the inspiration of the convert, architect and designer A. W. N. Pugin and decided to explore

the medieval art and architecture that Pugin's polemic works identified with spiritual purity. He moved from London to Bruges in 1855 to advance his studies of early Flemish art, 'far too long obscured and undermined by lies and calumnies', as he expressed it in typically robust manner. Another reason for leaving England was to escape the public disgrace of a three-month imprisonment for flogging a pupil at the Islington Catholic poor-school where he was the master, a controversial sentence which reflected the anti-Catholic mood of the day. In Bruges, the local community regarded him as 'a rather troublesome and meddlesome young foreigner' because of his protests against their attempts to modernise and 'improve' the town.

In 1861 Weale published *Notes sur Jan van Eyck*, a sarcastic, point-by-point refutation of the views of the Abbé Carton, distinguished member of the Belgian Academy, who had written on the van Eyck brothers in 1847. Carton's crimes included misreading the date and signature of the National Gallery's painting and citing van Mander as an authoritative source. Weale also savaged Laborde on the grounds of inaccuracy, and dismissed the National Gallery's catalogue entry. But he did agree with Crowe's identification of the man as Arnolfini of Bruges, and provided details of the life and career of Giovanni di Arrigo Arnolfini, whom he believed to be the man in the painting. Drawing on local documents, he proved that this merchant from Lucca was active in Bruges from the 1420s, married Jeanne de Chenany (a misprint for the actual family name, Chenami), became a member of the Duke of Burgundy's council, and died in 1472. His wife survived him and was still living in 1490. As for the inscription's *fuit hic*, Weale took this as a reference to the presence of van Eyck as one of the tiny figures in the mirror entering the room to join his friends the Arnolfinis. He also provided the important new information that the painting was among those Marie of Hungary took to Spain in 1556, as listed in the posthumous inventory of her possessions, published as recently as 1856 after it was discovered in the Spanish National Archives at Simancas.

The National Gallery totally accepted his findings. The 1862 edition of the catalogue called the work *Portrait of Jean Arnolfini and Jeanne Chenany* and

acknowledged that 'the researches of Mr Weale have proved beyond all ques-
tion who the personages represented in this picture were'. No longer did
Crowe need to worry about contradicting the gallery and so he happily
confirmed Arnolfini's identity in his revised edition of *The Flemish Painters.*

Weale remained immersed in Flemish studies. He made an enormous
contribution to the cultural and antiquarian life of Bruges, but after his
prickly personality lost him the post of town archivist, he returned to
London in 1878. He later served for seven years as keeper of the National
Art Library in the South Kensington Museum, but was sacked in 1897
for being too active and typically outspoken to his employers. This was
the opportunity to start writing up his life's work, forty years of research
into the van Eycks. Despite a terrible setback – at the last moment he
lost his copious bibliography in an omnibus – he published his major
study, *Hubert and Jan van Eyck: their life and work* in 1908. Describing the
Arnolfini portrait, he accepts the then received wisdom that it is a study
of 'a newly married couple'. He concludes, 'The colouring of this
marvellous interior is full of vigour and blended with the utmost care.
The fresh tints are admirable and in their rendering show a remarkable
transparency of shadow. The picture, in short, is an exquisite gem in
the finest state of preservation save in one place, across the mirror.' The
tome as a whole, however, was so indigestible that his publisher John
Lane of the Bodley Head commissioned a more accessible edition, and
appointed a collaborator, Maurice Brockwell, to help him.

Brockwell was a knowledgeable colleague, 'an indefatigable researcher
and pungent writer and lecturer' according to his obituary in *The Times*,
who dazzled audiences by speaking entirely without notes. The National
Gallery employed him to rewrite many of its catalogues, then he worked
in Florence as librarian and assistant to the renaissance scholar Bernard
Berenson. He was also a regular contributor to the *Athenaeum.* Almost
forty years younger than the bearded, shambling, short-sighted Weale, the
dapper Brockwell was 'a tall erect man of fine presence and handsome
features', with a private passion for horse racing. As he was as opinionated
and extreme in his views as Weale, the imposed collaboration created

intolerable strains (especially as Brockwell's review of the book for the *Athenaeum* had described it as 'long and whole-hearted, even if uninspired and unexacting'). Yet in the end it produced a more viable book, and Brockwell always referred to Weale with respect. They identified just twenty-four surviving works by the van Eycks, the restraint of this figure enhanced by an appendix which listed the 400 pictures variously ascribed to the brothers in the years between 1662 and 1912: 'A century ago practically all early pictures of the Netherlandish, German, French and even Spanish, Portuguese and English schools' were assigned to van Eyck, Dirk Bouts or Memling. For the moment, Brockwell accepted the official line that the portrait showed the Arnolfinis. But he would change his mind.

The Arnolfini portrait remained a major attraction. When the galleries were rehung in 1876, it was described as one of 'the gems of the collection'. It was illustrated, among 'forty-two choice reproductions', in one of the *Pall Mall Gazette*'s 'Extras', or special supplements, in February 1890, 'Half-Holidays' at the National Gallery. The aim was to provide a popular and well-produced guide, at a cost of only sixpence, so that industrious visitors might master the entire collection in the course of twelve afternoons: the Flemish school was recommended for the sixth visit. This evidently fulfilled a genuine need, since according to one newspaper 'the National Gallery guide-books have been a disgrace both to the Gallery trustees and to the Nation'.

Stung by such comments, in 1899 the gallery produced a new and fully illustrated edition of the catalogue, with a preface by the director, Sir Edward Poynter. In it he described the van Eyck as 'one of the most precious possessions in the collection and, in respect of its marvellous finish, combined with the most astounding truth of imitation and effect, perhaps the most remarkable picture in the world'. The catalogue earned a mention in the *Manchester Guardian*'s 'books of the week' review in January 1900; criticising the inevitable small-scale reproduction of many paintings, the reviewer praised the full-page illustrations, an 'honour here accorded only to a few of the greatest treasures – such as van Eyck's Jean Arnolfini and his wife', and repeated Poynter's praises. Someone who agreed was

the great financier and discriminating collector Baron Ferdinand de Rothschild MP, of Waddesdon Manor. His obituary in *The Times* recorded his opinion that the Arnolfini was the 'one picture in the National Gallery for which I would pay literally any price and commit any folly'.

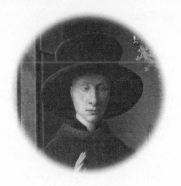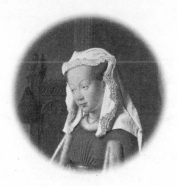

Techniques

The first stage in the production of a painting was the contract between artist and client. This might specify the timescale, the quality of the materials to be used, the extent of the master's own involvement (rather than that of his assistants), and when the payments were to be made (normally in three instalments). van Eyck's workshop was part of his house, in St Gilles Nieuw Straat. The room where he painted was probably north-facing and on an upper floor in order to obtain the best natural light. At any one time it would contain a number of works in progress: as each layer of oil paint took a long time to dry (more slowly in the winter than the summer months), and as van Eyck used many layers, he needed to have several projects underway at the same time. He employed a number of assistants whose duties ranged from cleaning and tidying to preparing paints and perhaps working, under his supervision, on the backgrounds of larger panels as part of their training. In the late fifteenth-century painter's workshop observed by Jean Lemaire de Belges, librarian to Marguerite of Austria (second owner of the Arnolfini portrait), there were straw mats on the floor to control the dust, a number of wooden easels, and planks leaning against the walls to support the paintings in progress.

The subjects of van Eyck's portraits would have been unlikely to visit

the workshop for a sitting. He would have gone to them in order to make a preliminary drawing, as he did for his portrait of Cardinal Albergati (1438, Vienna), whose drawing has miraculously survived (Dresden). For this, van Eyck used silverpoint (a narrow strip of silver inserted in a metal or wooden holder, like lead in a pencil) on paper rubbed with white chalk to prepare the surface. And he made precise notes on the colour tones required, standard practice if a busy sitter did not expect to be present for the painting stage; there was no point wasting time and materials on preliminary painting when the written word could effectively prompt a well-trained visual memory. To the right of the Albergati drawing are van Eyck's aides-mémoires, reading rather like a poem:

> *The nose dark sanguine*
> *Like the cheekbone down the cheeks*
> *The lips very whitish purple*
> *The stubbly beard rather greyish*
> *The chin reddish*

He probably started with just such a preliminary, colour-annotated drawing of the Arnolfinis, grand people who could hardly be expected to show their faces to him for too long.

Next was the making of the wooden board (or the selection of a previously prepared one) on which to paint the portrait. The board of the double portrait was made of oak, the wood Netherlandish painters favoured; the Italians preferred poplar, Germans limewood. The Hanseatic traders imported painters' oak from Poland and other Baltic countries with slow-maturing trees. The wood had to be so thoroughly dried out and seasoned that it could not be used for at least ten years after felling. Narrow-grained timber was best because it was less likely to shrink. The board consisted of three panels joined together by tiny mortice-and-tenon joints. The original frame does not survive, but van Eyck often used wood from the same plank for the painting board and for the frame. Then he or his assistants planed the board, rubbed it down and covered it with

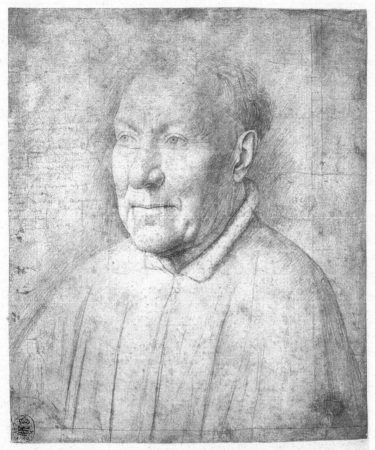

Jan van Eyck, *Portrait of Cardinal Albergati, c. 1435*

layers of warmed animal glue, then a ground of glue and chalk which hardened when it dried. Smoothed down, this concealed any trace of the wood grain, and became the basic surface of the painting.

On this prepared layer, van Eyck made an underdrawing of the whole scene, laying out the image in advance in order to structure the composition and decide where to put the light and dark areas. Although the subsequent layers of paint and varnish obviously concealed what was underneath, in the 1950s twentieth-century advances in the scientific analysis

of paintings first made it possible to see through these layers and recreate the whole sequence of work. The underdrawing of the Arnolfini portrait was revealed by infrared photography, a technique which initially had its limitations because it could not penetrate certain pigments, particularly blue and green. From the 1960s, the more advanced and sensitive technique of infrared reflectograms was developed; these miraculously render most pigments transparent and reveal the entire underdrawing, recorded as a series of digital images.

The Arnolfini reflectograms reveal how much van Eyck modified his original underdrawing or chose to ignore it altogether as work progressed and he followed his creative instincts. Looking over his shoulder, we know he made very detailed underdrawings, using cross-hatched lines to indicate the darker areas and to give a three-dimensional sense. Using a brush and liquid (others might employ dark chalk or metalpoint), he outlined the layout and contents of the room, using parallel strokes and hatching to suggest depth. Yet there are surprising omissions: the chandelier, the pattens and sandals, the oranges, the amber beads, the chair by the bed, and the dog were absent from the drawing. The dog must have been inserted at a very late stage indeed, because it does not even feature in the mirror's otherwise accurately reflected view of the room.

There were significant changes between the underdrawing and the final painted version in the form of changes in scale and size. The mirror was originally larger, with eight lobes round the frame rather than ten. The brush was bigger, the rug longer, the window and shutters had different proportions, the base of the chest was another shape. The greatest modifications, however, were to the man and the woman. Evidently dissatisfied with his preliminary drawing of Arnolfini's striking features, van Eyck moved the eyes, nose and mouth further down. They still seem too large in relation to the size of his face, and to his extremely narrow shoulders, which were also lowered for the painted version. He made the straw hat more impressive by extending its brim and crown, he lowered the hem of the tabard and changed the position of the feet, bringing them closer together to achieve a more elegant stance. He twisted the palm of the

man's raised right hand further from the viewer, and made the left hand fold more tightly around that of the woman. Her face was originally smaller and tilted. van Eyck decided to place her eyes higher up her face (although her forehead still remains implausibly deep) and made them look more towards the man. The hand which, not very convincingly, holds up the heavy fabric of her gown over her stomach, originally did not grasp the material at all but pointed downwards. What this all shows is a confident and flexible artist not adhering rigidly to his original design but viewing it with fresh eyes and modifying as necessary. It was not a case of altering mistakes but adapting to a fresh imaginative vision.

When he was satisfied with the drawing as a basis, van Eyck began to paint. Despite later legends, he was not the inventor of oil painting. In his *Lives*, Vasari announced that van Eyck had found the secret recipe, which he eventually revealed to Antonello da Messina, who passed it on to Veneziano, whom Castagno murdered for the secret formula. But this was really Vasari's way of lauding Antonello's contribution to the development of Italian art. Medieval craftsmen would certainly have guarded their methods, but the real flaw in the story was the fact that Antonello was only a boy when van Eyck died. Paints made from a mixture of linseed oil and ground pigment had been known since at least the thirteenth century, with their use expanded in the fifteenth century, thanks to a range of new recipes which enabled the paint to set more firmly. van Eyck's particular contribution to the medium was to realise that some pigments became virtually transparent in oil, and that by applying a series of very thin layers, working from opaque to translucent, he could achieve an exceptionally luminous and permanent finish. Another advantage of working in oil was the long time it took to set, with the result that an artist could continue manipulating it until he achieved just the desired effect. This was done not only with brushes: van Eyck's fingertips have left their imprint on the green gown.

Artists prepared their own paints in the workshop, the kind of task van Eyck's assistants would have helped with. On a slab of stone or marble

they pounded and mixed the pigments with linseed oil, then stored the finished products in jars covered with pigs' bladders to keep them moist. Pigments normally came from minerals, and some were more precious than others. A respected artist like van Eyck would have been expected to use the very best quality available (the contract probably insisted upon it), and the markets of Bruges were a cornucopia. Paint sampling has shown that the blue of the woman's sleeves was ultramarine made from lapis lazuli, a semi-precious stone from Afghanistan (often mentioned in contracts to avoid inferior substitutes made from azurite or blue glass). The green of her gown was made from ground copper, the reds of the textiles from a mix of silver and sulphur. Like kermes itself, this was more expensive and effective than an ochre-based pigment. Even van Eyck's brushes were costly, with tips of sable or miniver inserted into quills attached to a wooden handle.

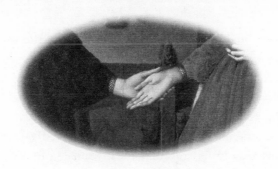

13. Wars and Disputes

The painting's continuing popularity in the twentieth century was enhanced by its reproduction as an etching by the German artist Bernard Schumacher in 1901, part of a flood of new publications by print sellers hoping to cash in on a potentially lucrative market of popular artworks. *The Times* attacked their greed and the uneven quality of their works, but gave qualified approval to Schumacher's plate: 'ambitious, and we will not say that he has succeeded with "John Arnolfini" . . . but his work is careful and delicate, and we are grateful to him for having aimed so high.' The portrait featured again in a twenty-five-piece part-work issued by the *Manchester Guardian* in 1903 consisting of separate sheets of photogravures: 'Great Masters' would 'enable the public to collect in their homes a real Art Gallery of Gems carefully selected' from public and private collections for a total cost of only £5. van Eyck was represented by the Arnolfini portrait. At the same time, workshops began churning out commercial spin-offs such as heavy 90-pound 'Gothic Art' replica chandeliers (now fetching up to £5,000 on ebay).

In 1914 the start of the Great War disrupted the stability and permanence of the National Gallery collection, available to all, in the very heart of London. The Germans were using increasingly sophisticated Zeppelin

airships for bombing raids over enemy territory; so the gallery trustees decided that it would be wise to remove the cream of the collection from the building. The Arnolfini portrait was naturally among the sixty key works initially taken off display (more were added later). Although the Air Raids Protection Committee had already arranged to allocate the most precious contents of the capital's museums and galleries to appropriate locations, mainly underground, the National Gallery chose to ignore this and negotiated directly with the London Underground Electric Railway Company to store the painting in the tunnels of the Aldwych branch line.

However, the trustees decided to keep much of the gallery open to the public, exhibiting a representative selection of works of the various schools following safety measures such as shutting off parts of the building, and lining the walls of the main staircase with asbestos. In the absence of the stars of the collection, many of the remaining paintings were truly enjoyed for the first time. An article in the *Observer* entitled 'The vanished pictures – a walk through the denuded galleries' described how 'the magnetic attraction of the world famous masterpieces is bound to interfere with the study and just appreciation of the works of those masters of the second rank, who are now left in almost undisputed possession of the walls'. Although the gallery was not damaged, the removal proved wise. While the Kaiser had kindly announced that London would not be bombed west of the Tower of London, in the autumn of 1915 his Zeppelins dropped their bombs on Charing Cross, Piccadilly and Holborn. Once the Armistice was signed, the pictures were swiftly returned, including the Arnolfini, which the *Observer* acclaimed in 1921 as 'one of the most subtle and impressive' portraits in the world.

In April 1924, the National Gallery celebrated the centenary of its foundation with a great banquet. Among the other commemorations of the collection's wonderful range and variety an informal survey of 'notable people' and 'persons of taste' was carried out to determine the nation's favourite painting. The gallery invited eighteen luminaries to nominate the pictures that gave them the most pleasure, and in the final score

(calculated on the number of mentions) the Arnolfini portrait came joint second, together with Uccello's *Battle of San Romano* and Velázquez's *Philip IV.* (The winner was Michelangelo's *Entombment.*) Among those listing the van Eyck among their favourites was William Rothenstein, director of the Royal College of Art, Sir Robert Witt, chairman of the National Art Collections Fund, and Millicent Garrett Fawcett, doughty campaigner for women's rights.

In the hands of professional art historians, however, appreciation of the work became far more complicated because untangling its meaning, rather than just enjoying it, evolved as the main aim and led to many misunderstandings. The process began in 1934, when the March edition of the *Burlington Magazine* included an article called 'Jan van Eyck's Arnolfini Portrait'. The author, Erwin Panofsky, was an eminent German scholar, educated in Berlin, but forced to flee from his position as the first professor of art history at Hamburg University when the Nazis banned Jews from holding academic positions. Panofsky escaped to New York in 1934 and moved to Princeton the following year. A specialist in the northern renaissance, including Dürer, he was concerned with the wider issues of methodology and the application of literary and documentary sources to provide a fuller understanding of an artwork in the context of its society.

He wrote the Arnolfini article in order to refute a recent claim by the French art critic Professor Louis Dimier reviving the old argument that the couple in the painting were van Eyck and his wife, and not the Arnolfinis. Citing Weale and Brockwell on the van Eycks, Panofsky demolished Dimier's case, then went on to provide the first detailed analysis of the work's meaning. This was a totally new reading which provided a symbolic function for every material object shown, an attempt to reconcile van Eyck's apparent realism with the medieval Christian mindset, a concept he subsequently applied to other Flemish paintings.

He argued that the double portrait commemorated a marriage ceremony at which van Eyck was an official witness, as proved by the legalistic hand of the unusual inscription on the wall, and his presence

in the mirror. This gave the painting the status of a legal document, a pictorial marriage certificate. The marriage ceremony, however, was clandestine – that is to say, private, or by common law – because it did not take place in a church and was not solemnised by a priest. To reinforce this point, Panofsky claimed that the objects in the room were all 'disguised' symbols referring to the rituals of marriage in a deliberately opaque way, which would not have been necessary had the event taken place in the orthodox manner. He claimed that the man's raised hand was a formalised gesture that was part of the marriage ceremony, symbolising speech in pledging an oath of fidelity, that the lit candle was an integral part of the official process, and that all the contents of the room were typical of a nuptial chamber, its focal point being the marriage bed. He concluded that medieval spectators saw the whole of the visible world as a symbol, and that Flemish painters therefore incorporated this expectation into their work.

Dimier fought back in a letter published in the September edition of the *Burlington Magazine,* defending his claim by insisting that the inscription's *hic – this man –* referred to van Eyck as the subject of the painting and not to *here.* 'This I regard to be so certain that if the person represented in the picture were ever proved to be Arnolfini, I should not hesitate to assert that the inscription is false and a later addition.'

Panofsky responded in the December issue, rubbing in Dimier's acceptance of van Mander's inaccurate statement that the couple were being literally joined together by the personification of Faith, though a third party was obviously not present. He concluded acidly, 'M. Dimier's letter gives a wrong impression, not only of my methods (which would be comparatively unimportant) but also on the issue as such.'

For the next fifty years Panofsky's interpretation of the scene as revealing a marriage ceremony with the aid of 'disguised' symbols remained virtually unchallenged and embedded in later studies. His thesis even became the foundation for his concept of iconology for understanding works of art in relation to their specific cultural background, which became his best-known, though subsequently challenged, legacy as an art historian. Perhaps

the weakest point in his argument is that although clandestine marriages did take place in the fifteenth century, they were regarded as sinful and would hardly have been commemorated or commissioned from an artist as celebrated as van Eyck by the prosperous gentleman portrayed.

One fierce critic of Panofsky was Maurice Brockwell, James Weale's former collaborator on the 1912 epic study of the van Eycks. Forty years later Brockwell published *The Pseudo-Arnolfini Portrait: a case of mistaken identity.* This unfurled his novel theory that van Eyck had painted *two* double portraits. The one in the National Gallery depicted Jan van Eyck and his wife Margaret, while the other, owned by Marguerite of Austria and taken to Spain by Marie of Hungary, showed the Arnolfinis but, according to Brockwell, it got burned in a Madrid palace fire. His cantankerous and confusing text denounced Panofsky's seminal article as 'the highly coloured and misleading effusion of an American Professor . . . a lengthy and untenable fiction'. He also turned on his former colleague Weale, whom he accused of leading the world astray by misinterpreting the picture referred to in the Spanish archives. The one in the National Gallery had never left the Netherlands, which was why it was still in Brussels to be discovered by the convalescent Hay. Reviews were mixed. The *Observer* said, 'It is a nice exercise for the amateur to determine whether or not the evidence provided does in fact discredit the official provenance.' The *Manchester Guardian* warned, however, 'It is salutary to be reminded how few facts we really possess, but the scepticism with which the author successfully infects us when he discusses the theories of others lingers uncomfortably on when he puts forward his own.'

The Arnolfini portrait left the National Gallery for a second time in 1939. The threat this time was not only from German bombs but also from Nazi art collectors anxious to repatriate Germanic works of art. Hitler, Goering and Himmler snapped up the treasures of occupied Europe, ticking off their wish lists as they invaded country after country. The northern paintings in the National Gallery were all highly eligible, and anything by van Eyck became a prime target for the monumental art gallery Hitler planned to found in his birthplace, Linz. His targets

included German, Flemish and Netherlandish paintings of the fifteenth to seventeenth centuries; his minions had already seized the van Eycks' altarpiece in Ghent cathedral, and stored some of its panels in a salt mine in Austria.

The director of the National Gallery responsible for saving the priceless paintings from destruction or plunder by the Nazis was Kenneth Clark, appointed in 1934 when he was only thirty. Combining arrogance with popular flair (his nickname was Kenneth Napoleon Clark), he and his assistant keeper, the ascetic Martin Davies, were at loggerheads. Their personalities could not have been more different; Davies was a meticulous administrator, an old-school civil servant who was distinctly sniffy about publicity while the flamboyant Clark loved it. No wonder he was later appointed controller of home publicity (aka propaganda) at the Ministry of Information. Both were, however, at one in their determination to make radical changes in the way the collections were presented. Davies, who joined the gallery in 1930 and rose to become director in 1968, aimed to rewrite the existing catalogues in a much more scholarly way. He started with Early Netherlandish paintings, went on to the French and British schools of painting and, by 1946, had published the catalogues, successfully setting new standards of quality. Others followed, including his acclaimed catalogue *The Earlier Italian Schools* which came out in 1951. As early as 1938, Clark selected elements from the Arnolfini portrait to include in his *One Hundred Details from Pictures in the National Gallery* 'chosen chiefly for their beauty' which he presented in the form of contrasted examples of northern and southern art (updated in 2008). Other portions of the portrait were shown in his 1941 sequel *More Details*.

When war with Germany seemed imminent, Clark and the gallery's scientific adviser Francis Rawlins decided to follow their own plans to protect the collections, and to disregard the national evacuation strategy formulated as early as 1933 by the Museums and Galleries Air Raid Precautions Committee. In the gallery, they built an armoured corridor, installed new lifts to effect rapid evacuation of pictures from the upper

floors, and provided new loading bays at the back. In September 1938, there was a full-scale rehearsal when many of the paintings were taken down and transported by train to various locations in north Wales: the scientist Rawlins was a railway buff who knew all the routes and time-tables intimately. After Munich, the paintings were fetched back, but removed for real in August 1939, when the contents of the entire gallery were evacuated by train in just twelve days. This was just in time to protect them from the good intentions of the US government, who proposed in October 1939 that the entire collection should be shipped to America. Churchill famously commanded Clark, 'Bury them in the bowels of the earth, but not a picture shall leave this island.'

The paintings were initially distributed between a range of safe loca-tions, including the Gloucestershire stately home of trustee Arthur Lee, the National Library of Wales at Aberystwyth, the University of Wales at Bangor, and Penrhyn Castle. The latter, however, was problematic, for Martin Davies complained that 'the owner is celebrating the war by being fairly constantly drunk', and evidently he was the greatest threat to the paintings. Another fear was the potential impact of troops being billeted there after Dunkirk. And the alarming geographical expansion of Luftwaffe bombing raids meant that even the Welsh locations were no longer safe. Yet another worry were the locals themselves, 'very Welsh, highly nation-alistic, not to be trusted, and more than likely to form a Fifth Column in the event of invasion'.

In 1941, Churchill's 'bowels of the earth' came true when the paintings were moved to the top-secret location of the vast caverns of the Manod slate quarry at Blaenau Ffestiniog high up in Snowdonia. Here they were safe; in all, nine bombs fell within the National Gallery building with one gallery and the rooms below being totally destroyed. Stored in six purpose-built, air-controlled brick huts and further protected by some 200 feet of rock above, the paintings were all under the careful eye of Martin Davies who took this golden opportunity to avoid his enemy Clark, prepare a new catalogue (the gallery's library was stored in the slate mine too) and supervise the cleaning and conservation of many works.

This included the Arnolfini portrait, which was restored to 'its full brilliance' again.

From early 1942, following a bright suggestion from the young journalist Charles Wheeler, the trustees began a 'Picture of the Month' scheme whereby a painting was brought down from Snowdonia to Trafalgar Square and put on show for four weeks to cheer up war-weary Londoners. This imaginative initiative was hugely popular and the arrival of each masterpiece was a news event that attracted large numbers; nearly 37,000 people saw Velázquez's *Rokeby Venus* and 34,000 Botticelli's *Venus and Mars*. By the end of the war thirty-seven pictures had been exhibited. The choice was heavily influenced by letters from the public who, according to Clark, wanted uplifting religious images and not 'Dutch painting or realistic painting of any kind'. Another factor was condition; Davies thought that the double portrait of an elderly couple by Jan Gossaert, for example, was 'irreplaceable' and should not make the risky journey by rail from Bangor to Euston and then by road to central London. Elaborate precautions were taken to protect the national treasures; they were packed carefully into railway containers with strict instructions that no wet bundles were to be placed on them, and heavily guarded throughout transit. A hardened shelter was built inside Clark's armoured corridor to safeguard them overnight, and a train was kept on hand to whisk them back to the quarry in the event of a sudden crisis. Despite these measures, in 1944 the trustees eventually decided, mainly because of the unpredictable V-rocket attacks, that it would be prudent only to exhibit good works and not the very greatest ones in the collection.

The Arnolfini was never Picture of the Month. Possibly Davies, who had the last word on whether a particular masterpiece might be damaged by travel, thought the panels too delicate, although in its lifetime the portrait had survived much more hazardous journeys than being bumped about in an LMS guard's van. A more likely explanation is Clark's preference for exhibiting large pictures: 'We have found that small pictures, when exhibited alone in this way, look rather lost,' he wrote. While the letters between Clark and Davies debate the proper care of the masterpieces ('I

am not eager to drive these pictures around in my Ford,' Davies says in one) they also show an extraordinary concern for administrative details. Would the Treasury pay for an extra typist at Manod, the leave for women for domestic purposes, a magnifying glass that may have been stolen – nothing was too small to be aired. In one letter Clark devotes nearly a page to the burning issue of whether an employee called Shorey could claim for the wear and tear of his bicycle. 'I have never heard of anyone considering seriously the extra wear to a bicycle entailed by the occasional short trip,' he tells Davies. Sixty-five years later the portrait did make a guest appearance in reverse, a reproduction hanging on the wall of a Manod café in the BBC's 2009 one-off comedy drama *Framed*, which was inspired by the relocation to the Welsh slate mine. The final scene shows that the dry-as-dust National Gallery curator Quentin Lester (curiously similar to Davies, played by Trevor Eve) has finally fallen for the charms of the pretty young local teacher Angharad. They stand together before the van Eyck as Quentin lectures his enthralled audience about its merits; then the camera pans back to reveal a pregnant Angharad, mimicking the canvas.

In May 1945 the Arnolfini was among the first fifty paintings to be hung in the two galleries that were hastily reopened after the war. 'The speed of their return from their safe hold in the Welsh mountains should give a lead to other Government departments,' said the *Manchester Guardian*. 'Some of the works including the van Eyck portrait piece can be studied for a little without their glass – a high privilege.' For its Saturday opening on 19 May the gallery, made much more popular by Clark's policy of providing tasty sandwiches, drinkable coffee and Mozart concerts at lunchtime, was packed full with people of all classes including many enthusiastic young female workers. 'One had almost to queue up for a glimpse of van Eyck who seemed to outdistance even Rembrandt and Velasquez in popularity,' reported the *Observer*. 'Flemish and Dutch were the general favourites. In these years of dust and rubble and drabness any clean bright colour has a tremendous appeal, and how rich are the red and apple-green in van Eyck's portrait of the Arnolfinis, like an orchard's russet kingdom for these two sombre souls!' Cheers greeted King George

and Queen Mary, and the two princesses Elizabeth and Margaret, when they attended the opening ceremony; the public mood of rejoicing was aptly summed up by the *Manchester Guardian* which hailed the return as 'surely the completest symbol of victory in Europe'. It thought, however, that some of the paintings, while looking more brilliant than before the war, seemed oddly smaller than remembered, particularly 'the two exquisite interiors' by Vermeer and van Eyck. 'Great art does not fade from the memory in five and a half years,' it concluded, 'yet its impact, after so long an absence, is as potent and surprising as ever.'

In 1950, the Arnolfini portrait was moved to the lavishly refurbished Duveen gallery. There it remained one of the highlights of the collection. It featured in the *Twenty-Four Masterpieces* publication that epitomised the gallery in 1958 and was the subject of one of the National Gallery's 'Painting in Focus' exhibitions, from October 1977 to January 1978. This stimulated media debate about its meaning after the exhibition pamphlet suggested it represented not the actual moment of marriage but the state of marriage conceived of as existing over a length of time. During this period it was among the top ten of the best-selling postcards at the gallery, the Leonardo cartoon *Virgin and Child with St Anne and St John* topping the list. It was the centrepiece of the gallery's rather uneven 1998 show *Mirror Image*, created by Jonathan Miller, which looked at the way creative people have used mirrors and reflecting surfaces, and it continued to be popular with artists everywhere. As the year 2000 approached, the *Observer* conducted a poll among leading British artists asking the question, 'Which works of art could you not do without in the new Millennium?' Tracey Emin replied it would be the Arnolfini.

When the gallery pioneered putting old masters onto computer screens in 1999, it devoted an interactive CD-ROM to the portrait. As Waldemar Januszczak observed in the *Sunday Times*, this was the perfect picture for an interactive display. 'Not only is it packed with encyclopedia-friendly details to click on – the mirror, the dog, the chandelier, the shoes, all occupying their own, eminently clickable section of picture space – but it also boasts a polished photographic finish that appears entirely free of

those recurring computer-screen irritations: brushstrokes.' He found clicking around his new toy was 'as much good fun as a good game of Trivial Pursuits', but the best thing was 'it leaves you with an irresistible urge to rush to the Gallery to see the real painting again'. Encouraged by its foray into high technology, the gallery began allowing full access to its collections over the internet and was one of the first to do so. From the start, in March 2003, when more than 192,000 people accessed the site to view the collections and buy tickets, one of most popular images to be visited has consistently been the Arnolfini.

In 2007, following Clark's precedent of bringing culture to the masses, the picture was 'set free' with forty-four others (all high-quality digital reproductions) to tour the streets of central London. For three months, the faithful copy was displayed between a Japanese restaurant and a small block housing film companies at 109 Wardour Street in Soho, attracting appreciative crowds. A year later it was one of the highlights of the National Gallery's critically acclaimed winter exhibition *Renaissance Faces: van Eyck to Titian*. On this occasion the catalogue offered the intriguing advice that viewers should imagine the figures undressed.

It stayed in the Duveen gallery until the new Sainsbury Wing opened in 1991. This was a purpose-built home for the medieval and renaissance collections, providing a linking sequence of rooms and galleries that created vistas to show the works to best advantage and generate the sort of comparisons and juxtapositions that Clark had pioneered in his *Details* books. Not everyone applauded the new home. In 2001 the art critic Brian Sewell, criticising the failure to move the portrait during the revised hanging that accompanied the refurbishment of the wing that year, complained that 'ever since the Sainsbury Wing was opened this has hung in the windowless and misshapen room at its stunted south-east corner, in light so dim that it is virtually impossible to see the painting's wonderful colour or discern its immaculately precise detail . . . It deserves better than this broom cupboard.' Yet many viewers find the intimate feel of the chamber is well suited to the small size of the painting, and aids enjoyment. They are also usually impressed by the fact that van Eyck is the

only northern name in the artists' roll of honour inscribed on the outside of the building, flanked by the Italian masters Masaccio and Piero della Francesca. Today, there is always a small crowd transfixed before this familiar yet always fascinating image.

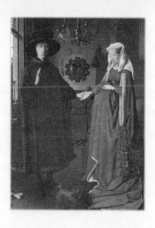

Hidden Puzzles?

Many commentators underestimate or misunderstand the innate skills, professionalism and expertise of medieval craftsmen. The technical aspects of van Eyck's double portrait continue to baffle those who study it, because they are reluctant to concede that such talents may be unmeasurable and autonomous. There is no evidence, for example, in the underdrawing of any ruled lines or perspective diagrams: on the contrary, the modifications between drawing to painting prove van Eyck was open and flexible. Yet contemporary art historians and mathematicians claim to identify a number of different perspectival schemes structuring the painting, ranging from the kind of one-point perspective advocated by Alberti in *Della Pittura* (1435) to a two-point, or elliptical perspective, and even a range of multiple points. But it is dangerous to start counting the orthogonals and imposing a grid of lines, especially as this tends to be done on smaller-scale reproductions rather than the original. Art historian James Elkins has wisely warned against turning such pictures into puzzles, pointing out that the left window produces nine major orthogonals, and the ceiling thirty-two, whereas in fact 'we need not assume that he [van Eyck] had any system in mind. Yet he accomplished by eye,

and with consistency between paintings, a compromise between medieval and renaissance sensitivities.'

Did he employ mechanical devices? In his book *Secret Knowledge* (2001), David Hockney, himself a practising artist and not a theorist, controversially claimed that from around 1430, Netherlandish painters, including van Eyck, pioneered the use of optical devices such as lenses and mirrors – the camera lucida, camera obscura and concave mirror, which can make an upside-down image for the artist to copy – in order to project the subject onto a flat surface and thus achieve a greater degree of accuracy than was possible with the human eye alone. Hockney claims that van Eyck's invention of the 'modern' face would have been impossible without the assistance of such optics. Yet the many changes made to the man's face as the work progressed disprove this hypothesis. The mirror theory is not new. In 1929, British art historian R. H. Wilenski concluded his book *Dutch Painting* with a chapter called 'Vermeer's Mirror' which argued that mechanical devices were employed and suggested that Vermeer used more than one mirror to work out his compositions; this he inherited as part of the historic Netherlandish tradition established by van Eyck and his contemporaries.

Whatever his techniques, van Eyck's fame meant that the portrait was already developing a reputation of its own by the later fifteenth century; the original, or copies of it, inspired other painters, who adopted both the pose of the two figures, sometimes using them as models for other historical characters in a room, and also many of the room's contents – the convex mirror and its reflections, the interior with a bed on the right, fruit on a windowsill, the ostentatious chandelier, and the beads hanging from the wall.

Van Eyck's reputation also swiftly won him a place in the canons of Italian humanist writing. A near contemporary, Bartolomeo Fazio, historian at the court of Alfonso V, King of Aragon, Sicily and Naples, included him in a book on eminent men (*De Viris Illustribus*, 1456). This had a chapter on great painters which listed two Flemings (van Eyck and van der Weyden) and two Italians (da Fabriano and Pisanello). Fazio stressed

the renaissance criterion that 'no painter is accounted excellent who has not distinguished himself in representing the properties of his subjects as they exist in reality', and on these grounds van Eyck was 'judged the leading painter of our time'. After emphasising the artist's exemplary background and skills – 'he was not unlettered, particularly in geometry' – and his long training, Fazio described the works he had seen for himself. One was a triptych King Alfonso obtained from Battista Lomelli, a Bruges-based merchant from Genoa, notable for the excellent perspective, the stunning light effects of a sunbeam, and the likenesses of the donor portraits. Then there was another painting that Cardinal Ottaviano of Florence had bought from the Duke of Urbino, which seemed to have some elements in common with the double portrait: including a mirror, an ornate light, some 'minute figures' and a little dog. The painting did not, however, show a respectable couple in their reception room, but a naked woman emerging from her bath, with the mirror cunningly positioned to reveal her backside – so that there was nudity from two angles. This suggests it belonged to van Eyck's 'alternative' range for discriminating patrons, while purportedly showing the naked Bathsheba spied upon by King David. (The actual work does not survive, but it seems to be recorded on a tiny scale in a painting depicting the crammed gallery of Antwerp art collector Cornelis van der Geest in 1615.) Other fifteenth-century Italians recorded his skills. The Florentine architect Filarete referred in his treatise *De Architectura*, written in the early 1460s, to the artist's invention of oil painting. Later Giovanni Santi, father of Raphael, in his versified life of the Duke of Urbino (1482), included a section on modern painters which praised his mastery of colour. Even in his own lifetime van Eyck had achieved celebrity status both for himself and for his sitters.

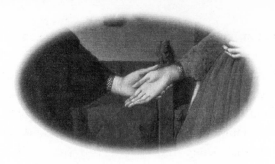

14. Interpretations and Transformations: The Arnolfinis Today

Scholars have made many conflicting claims about the meaning of the picture and the names of its subjects. Yet the features which puzzle modern viewers posed no problems for the painting's spectators in fifteenth-century Bruges. These days, we expect da Vinci code enigmas, a trail of deliberate clues planted by the artist in a cultural treasure hunt: spot the symbol, join up the dots and the secrets will emerge. But there are no conspiracies: if we cannot understand the picture, it is because we live in the wrong period and can no longer read the information it presents.

It is proof of the work's eternal appeal that it still stands on its own and speaks to modern viewers, just as it attracted earlier owners. But do the various interpretations enhance our appreciation? Or do they detract from the pleasure of the work's poise and restraint, its colours and shapes? Being aware of the speculations about this couple and what they are doing there adds layers of complexity which can distract rather than enlighten. The label in the National Gallery in 2011 calls it simply *The Arnolfini Portrait.* Confusion over the identity of the man and the woman has increased as more documents have emerged. The first association with the

name Arnolfini, made in the 1516 inventory, was revived by Crowe and Cavalcaselle in their 1857 claim that the painting was linked with the Italian merchant of Bruges, and that the couple were Giovanni Arnolfini and his bride Giovanna Cenami. This identification was not seriously challenged until the late twentieth century. But new archival research has suggested that Giovanni did not marry Giovanna until 1447, six years *after* van Eyck's death.

So the next likely candidate became a cousin, Giovanni di Nicolao Arnolfini, who married Costanza Trenta in 1426. The Trentas were another Bruges-based family, and Costanza's aunt was married to Lorenzo de Medici. But Costanza had died by 1433, the year before the date on the painting.

Did the portrait show Nicolao Arnolfini with his second wife, or was it a memorial to the late Costanza, who might have died in childbirth? This memorial reading gives new meaning to the various objects in the room: in the chandelier, one candle is lit and one has guttered out, the rich carpet was the correct accessory for the birth chamber, as of course was the bed – which was also an accessory of death. The little figure carved on the chair, which can be seen over the woman's left shoulder, is St Margaret, the patron saint of childbirth. So perhaps the portrait was a statement of enduring love, and the wife should be seen as an apparition, or a vision. The presence of the mirror may add weight to this theory. Through their very rarity, mirrors were also more sinister objects of awe for their capacity to reveal the hidden, and even bring the dead to life. The thirteenth-century French allegorical poem *The Romance of the Rose* stated that mirrors 'make phantoms appear to those who look within. They even make them quite alive, outside the mirror . . .', a thesis which originated in classical learning: the Roman encyclopedist Pliny claimed that mirrors reflected the shadows of the dead.

Others have continued to argue that it is a betrothal scene, at a ceremony which was just as significant legally as was the rite of marriage: betrothal was a civil ritual involving a ring and the presence of witnesses. Although marriage was solemnised and depicted in art by the joining of the couple's

right hands, here the woman's right hand rests in the man's left hand. Nor could it be a proper marriage without the presence of a priest.

But before assuming the work does record a betrothal or a marriage, it is necessary to appreciate the customs that would be followed by Italian families living in Flanders. Would they retain their own national practices, or would they follow the rites of their host country? Are the closest artistic and literary parallels Italian or Flemish?

The marriage theory had been powerfully argued by Panofsky in 1934, who saw the painting not only as a representation but almost a visual contract in itself, bearing witness to marriage, but recent scholars have challenged the concept of disguised symbols and thus undermined Panofsky's entire argument. In his reviews and lectures, the distinguished art historian Otto Pächt pointed to the naturalism as opposed to elaborate 'symbolism' of Netherlandish art. Disagreeing with Panofsky's theory that the scene commemorated the contracting of a private, non-church wedding, Pächt argued that the full-length pose was entirely appropriate for a traditional bethrothal or marriage portrait and this was made more specific by being located in a nuptial chamber, a specific place at a specific time. Pächt noted that the subjects are not getting on with their lives but are forced to pose, 'lost in an inner world of their own'. He found in the painting a sense of dualism, the medieval apprehension of the split between mind and body, and a suggestion of the creation of human inner life through contemplation – casting further doubt on Panofsky's ingenious interpretation that the portrait was a pictorial marriage certificate.

Alternatively, some commentators have argued that the painting was not meant to show any sort of ceremony but was simply the portrait of a married couple. Only then might the woman be pregnant, which of course she could not honourably have been at the time of betrothal or marriage. Thus in 1902 an article in the *Fortnightly Review* declared:

The Arnolfini and his wife realises in the presentment, hand in hand, of the quaintly costumed Italian merchant and his not specially well-favoured young wife, a moment of unusual solemnity, or mystic union between the couple. Can it be doubted, by

those who have carefully and sympathetically considered the picture, that it is intended to commemorate the condition of the wife, so clearly indicated not less by her form and attitude than by the expression of the husband, in whom a moment of the holiest emotion, though it is made manifest neither by word nor gesture, transfigures to a solemn beauty a countenance of almost grotesque ugliness.

Wider artistic comparisons, however, suggest that the gown billowing over her stomach was a fashion statement matched in contemporary works; it was also a particular mannerism of van Eyck, who gave a similar posture to his virginal St Catherine. But the theory still has its adherents, the most recent being Pierre-Michel Bertrand. He argues strongly that not only is the woman heavily pregnant, but also that she is actually the painter's wife Margaret van Eyck: the real subject of the picture is the painter's son who is about to be born. He points out that the dismissal of the pregnancy interpretation on the grounds that the Arnolfinis had no recorded children becomes invalid if the woman is Margaret. And, in a detailed analysis of the portrait in support of his argument, he finds symbols of procreation everywhere: beds are shown in all birth scenes, pregnant women offer candles to the Virgin Mary, they eat oranges and cherries to prevent sickness, and a dog often appears in Nativity scenes signifying an unborn child.

A recent, feminist-influenced interpretation made by Linda Seidel is that the painting does demonstrate a legal moment – not however the betrothal or marriage ceremony, but the moment when the husband is officially giving his wife the right to act for him and run his business in his absence, as was the case for some powerful fifteenth-century women in a French–Burgundian context.

A host of other theories have been put forward: the portrait is a charm against infertility, an alchemical symbol of the elemental union of fire and water, a morality tale on the theme of chastity, a pictorial prayer for a child; the woman is really a ghost, van Eyck's muse, a mother consulting her doctor, a woman having her palm read; it is all an elaborate joke on the part of the artist to show off his skills. Like the soothsayer's crystal ball, people see in it what they want to see.

The portrait continues to intrigue modern artists and designers, serving as a source of inspiration for new media as well as old. The briefest search of Google images reveals cartoons, posters, T-shirts, fridge magnets, cufflinks shaped like the convex mirror, mugs, copies, reproduction on everything from calendars to wedding announcements, weird adaptations on YouTube and some startling new versions. Pop artist Richard Hamilton turned it into a screen-print poster in the 1970s. Others have realised that its luminous clarity is particularly suitable for creating staged photographic works; the Australian art photographer Anne Zahalka's version *Marriage of Convenience* (1987) adds modern items like a radio but retains the haunting quality of the original. *Epiphany* (1992), one of the early works of the sculptor Gavin Turk, in homage to van Eyck, features his name scrawled in permanent marker on a convex mirror. More recently, the Irish portrait painter Oisin Roche, who like van Eyck uses subtle devices, included himself in the background of his pastel portrait of a young woman called Fatou, by being reflected in the fisheye mirror. This has echoes of William Orpen's *The Mirror* (1900, Tate Gallery) where he shows himself in a mirror with easel and modern candelabra above the head of a young woman sitting in a room. In 2006, New York artist Alyson Shotz made a work featuring a group of twelve fisheye mirrors, which reflect each other into infinity, and called it *Arnolfini 360 Degrees x 12*.

Chinese, South Korean and Latin American artists have reinvented it in their own distinctive styles, including the Mexican painter Frida Kahlo who commemorated her marriage to fellow artist Diego Rivera by reworking the Arnolfini into a double portrait of them both. David Hockney drew inspiration from the Arnolfini for his *Mr and Mrs Clark and Percy* in the Tate Gallery. Painted between 1970 and 1971 as one of a series of large double portraits, it depicts the fashion designer Ossie Clark and the fabric designer Celia Birtwell in their Notting Hill bedroom shortly after their wedding. The positions of the two figures are reversed, making the standing Celia dominant while Ossie is seated with Percy, one of their cats, on his knee. Another beguiling modern

take is Benjamin Sullivan's portrait of his partner, Virginia, in their shared home, which was shown at the 2009 BP Portrait Award in the National Portrait Gallery. In the same year, the Hungarian ceramic artist Sandor Dobany created a contemporary reinterpretation in a porcelain piece called *The Visitors* which put himself in the painting as a fifteenth-century ceramic artist whom the Arnolfinis are visiting in his studio. So iconic has the work become that no written explanations are ever required.

Habitat advertisement, 2006

For advertising, it is a useful tool, although it has not been used as much as one might have expected. In 2006, the home furnishings store

Habitat launched its autumn range with a campaign that featured three jokey executions updating a piece of classic portraiture; Velázquez's *Rokeby Venus* was changed into a contemporary mother-and-daughter scene, Holbein's *The Ambassadors* became a gay biker couple and the Arnolfini duo became a young modern couple wearing dressing gowns (purple for him, green for her) eating their morning toast surrounded by Habitat furniture. The images were used for print ads that brightened the pages of fashion magazines and newspapers. They also appeared on sales postcards which showed the original on one side, and the new version on the other, a clever device that prompted potential purchasers to flip over to compare, viewing product details as they did so. The portrait's luminosity and photographic clarity makes it ideal for digital billboards which use computer-painted vinyl bulletins, the first big change in printed technology since the advent of colour lithography in the nineteenth century. Such billboards can be changed rapidly, allowing precise targeting of audiences, and also draw in the eye in a way that static outdoor formats cannot; apparently twice as many people look at these out-of-home televisions than at traditional posters. The National Gallery, eager as always to embrace the latest technology, has used the rows of digital billboards along the sides of escalators in the London Underground to promote itself by alternatively flashing up the Arnolfini portrait with details of its opening times and location.

It is a gift for cartoonists. Dave Brown's *The Arnolfini Divorce* put George W. Bush and a skeleton in a bombed room, with Tony Blair as the dog. Bush is saying, 'OK . . . you get to keep the house . . . I keep the alimony . . . and the dog can go take himself walkies!' Martin Rowson has also used it for political satire: a 1996 drawing showed Bill Clinton and Blair, then opposition leader, with a dollar-decorated pig as the dog and a bank of mikes instead of the chandelier. Ronald Reagan and Margaret Thatcher are shown reflected in the mirror. The caption reads, 'After Jan van Eyck.' Next to the cartoon is an account of Blair's highly successful visit to Washington; it is headlined, 'Blair is the bride of Bill.' Peter Brookes, poking fun at

the delicate manoeuvres in 1983 to ally the Social Democratic and Liberal parties, has David Owen saying to a heavily pregnant David Steel, 'Frankly, I think we should wait awhile.' A *Times* cartoon on the BBC *Today* programme competition to find the greatest painting in Britain featured John Humphrys and James Naughtie as the figures, with an old-fashioned radio replacing the mirror. The newspaper caustically commented that the competition 'is ripe for mockery, and so we have obliged. Which of John Humphrys and James Naughtie was responsible for agreeing to the idea that paintings would make good radio?'

Newspapers have also cannibalised it. When Neil and Christine Hamilton, in yet another publicity stunt, posed nude for *GQ* magazine to mimic Lucas Cranach the Elder's classic picture of Adam and Eve in the Garden of Eden, the *Mirror* was inspired to give similar treatment to other celebrities. The Arnolfini portrait duly featured in this photomontage series of famous faces on famous paintings, displaying Liz Hurley and Hugh Grant under the headline 'WILL HUGH BE MINE'. Another photomontage, by the *Mail on Sunday*, headlined 'A Brush with Fame', used the same idea to turn soap stars into old masters; this time *Coronation Street*'s Claire and Ashley Peacock (Julia Haworth and Steven Arnold) were in the frame. The familiar image is always appearing in spoofs elsewhere. Typical is the item 'Art, Sacred and Profane' in Reading University's 1964 rag magazine *Rattler* which has a bubble caption from the man's mouth saying, 'You can tell the Press that we're just good friends', a gag that has been used many times before and since. Another spoof featured Kermit the Frog, host of *The Muppet Show*, the 1970s television variety show of deranged puppets, and his diva superstar Miss Piggy, as 'The Marriage of Froggo Amphibini and Giopiggi Porculini' in Miss Piggy's *Art Masterpiece Calendar*.

United Nations stamps, 1991

Despite the critics' doubts, the portrait has become a symbol of marriage. When the United Nations printed a series of stamps on the theme of human rights, it was chosen as the image to illustrate matrimony. The citation accompanying the commemorative set issued on 20 November 1991 read in part, 'Men and women of full age, without any limitations due to race, nationality or religion, have the right to marry and to found a family. They are entitled to equal rights as to marriage, during marriage, and at its dissolution.' It has also come to symbolise bethrothal, as in the exhibition *Ron and Roger* by the photographer Richard Ansett which was shown in the Turbine Hall of Tate Modern in 2002. This was a study of the first gay couples to join the Greater London Authority's London Partnership Register, which recognised relationships of same-sex couples, and was intended to celebrate the progress made by this new scheme. It featured the home lives of couples who had signed the register, in poses that were inspired by the Arnolfini.

Illustrators love it. Susan Herbert turned the couple into cats for the

cover of her witty feline versions of famous masterpieces, *The Cats Gallery of Western Art* (2002). Children's Laureate Anthony Browne has a similarly surreal adaptation in his book for young children, *Willy's Pictures* (2000), which shows the couple reflected in a small television that has replaced the mirror. The portrait was the subject of one of the imaginative 'meet the artist' performances conceived and performed by artist James Heard for nine- to eleven-year-old schoolchildren in their Easter holidays. van Eyck breaks off from painting the Arnolfini portrait to discuss his methods and the unfinished work with his young audience.

On television, it featured among the range of striking images in the credit titles of *Desperate Housewives*, and appeared as an example of censored art in the film *V for Vendetta* (2005), a thriller set in London in the near future. A South Korean horror film, *Into the Mirror* (2004), offered the National Gallery's postcard of the portrait as a clue in a mystery over strange murders possibly done by a vengeful ghost operating through the endless mirrors of a Seoul department store. It was the subject of an engaging 1980 BBC television play by satirist John Wells, starring himself and Alison Steadman as Mr and Mrs Arnolfini, which showed the portrait coming to life in a picture restorer's basement. The daft but charming conceit, in an experiment that gets out of hand, was that the painting wanted to prove that the couple were not posing for a painted portrait but for the world's finest example of coloured photography. Every few years the portrait pops up in a television documentary, for example in 1966, 1982 and 2002, under such titles as *Renaissance Secrets*, usually trailed as promising 'new historical and scientific evidence'. Radio documentaries include the BBC World Service series *Artists in a Nutshell* in 1993 and, four years later, Piers Plowright's thoughtful feature for BBC Radio 3, *What Are They Looking At?* In 2010, BBC radio broadcast Jonathan Pinnock's prize-winning short story about a husband and wife tightrope-walking team touring America. It was entitled, presumably in homage, *The Amazing Arnolfini and His Wife*.

The Arnolfini portrait is discussed on blogs worldwide, by undergraduates, art enthusiasts and amateur experts in chandeliers, perspective and

fashion. Typical of the many references is a blog that described a particular look as 'Persian Rug + Arnolfini Wedding Portrait'. Yves Saint Laurent once designed a rather strange 'Marriage of Arnolfini' long, babydoll dress for American actress Kirsten Dunst, star of the *Spider-Man* films, to wear at a New York fashion gala. In 1998, students from a Wimbledon art school brought the couple to life when they recreated the costumes from masterpieces at the National Gallery in an exacting exercise involving precise sewing and dyeing of fabrics to get the exact look. Models then paraded the costumes (each student had to do a male and female costume) past their muses, allowing the famous paintings to be seen in the third dimension.

There have been several computer reconstructions of the room. A 2001 video installation by Norah Ligorano and Marshall Reese, called *van Eyck's Mirror*, features a man wearing the red 'turban' in what may be van Eyck's 1433 self-portrait looking at himself in the Arnolfini mirror. British artist Mark Leckey won the 2008 Turner Prize with a witty body of work that included a film in which Jeff Koons's *Bunny*, a polished steel sculpture of a rabbit, appears to reflect Leckey's studio in its convex surface. For their 2005 piece, *The Peach and the Pair*, the Stepback dance company projected the work onto a video screen for some amusing sequences whereby the dancers' faces were superimposed on the portrait, one as a swaggering bridegroom, the other as a naive bride.

The portrait has also been the theme of several recent novels. The poet Ciaran Carson's hallucinatory *Shamrock Tea* (2001) takes the painting as the focal point for a dazzlingly complex set of stories within stories involving Wittgenstein, Conan Doyle, Oscar Wilde and medieval Flanders: the intense scrutiny of colours and the questioning of reality are common to the book and to the painting. Jack Thomas's *Arnolfini: Reflections in a Mirror* (2004) describes the experiences of an amateur art historian who, in the middle of giving a lecture about the portrait, finds himself transported to van Eyck's studio in Bruges to become a witness at the wedding. Pauline McLynn's novel *The Time is Now* (2010) consists of interlinking stories over a century about the inhabitants of a Soho townhouse; one,

set in the 1940s, features David, a former security guard at the National Gallery who seeks relief from the war in the Arnolfini portrait which he stole before it could be removed to Manod. Some minor characters in Dorothy Dunnett's complex series of historical novels of the early renaissance are also based on the couple; *Niccolo Rising* (1987), first of the 'House of Niccolo' series, begins in 1460 in Bruges and features a silk merchant called Giovanni Arnolfini. The masterpiece has even given the Arnolfini gallery on Bristol's harbourside its title. Since its foundation in 1961 this internationally renowned contemporary arts centre has consistently presented work in the visual and other arts which is genuinely innovative, and has thus lived up to its illustrious name – a name that has achieved, and deserved, truly global fame.

Perhaps the last word should go to the Arnolfinis. In 1994, the portrait inspired the poet Paul Durcan to write a quirky dramatic monologue called 'The Arnolfini Marriage'. It starts with the enigmatic couple telling us:

> *We are the Arnolfinis.*
> *Do not think you can invade*
> *Our privacy because you may not.*
>
> *We are standing to our portrait,*
> *The most erotic portrait ever made*
> *Because we have faith in the artist*
>
> *To do justice to the plurality*
> *Fertility, domesticity, barefootedness*
> *Of a man and a woman saying 'we':*
>
> *To do justice to our bed*
> *As being our most necessary furniture;*
> *To do justice to our life as a reflection.*

Postscript

C
arola was putting the finishing touches to this book only hours
before suffering a fatal brain haemorrhage, almost certainly linked
to her advanced cancer. Writing *Girl in a Green Gown* had supported
her in her final illness, and was a great comfort.

Using Carola's methodical and meticulous research notes, handwritten
comments on the manuscript and excellent bibliography, I hope I have
accurately incorporated all the amendments she would have wished to
make and answered outstanding queries. Any omissions, errors or ambi-
guities are mine. Some queries needed just a little detective work. Was
the 'M of A' scrawled on an information sheet about New York's Elizabeth
A. Sackler Center for Feminist Art a shorthand for Marriage of Arnolfini,
i.e. the portrait itself, or a reference to one of its early owners, Marguerite
of Austria? It was the latter. Others were more complicated. The 'Late
payments?' reference in a passage on van Eyck's employment as court
painter to Duke Philip the Good was eventually resolved by looking at
Flemish archival documents attached as appendices to various nineteenth-
century tomes. My knowledge of Dutch proved handy here, while a
background in advertising and journalism was useful in amplifying the
outline on how the portrait was used in the mass media of the

twentieth- and twenty-first centuries. My only contribution not based on Carola's original research concerned the question of why the Arnolfini was never Picture of the Month during the Second World War. The reason, from a reading of the wartime correspondence between the director, Sir Kenneth Clark, and Martin Davies, his assistant keeper looking after the Snowdonia safe house, appeared to be that Clark thought only the larger pictures should be displayed because they would have more impact on the public.

Carola's last notes, under the heading 'Conclusion', simply asked two questions:

> *Is the portrait medieval or modern?*
> *Why do we still so like the portrait?*

From her conversations with me and our daughter Colette it is clear she would have answered 'both' to the first question. The Arnolfini certainly appealed to medieval viewers, who would have had no difficulty in understanding the symbolism which baffles us. Yet this first-known double portrait in a domestic setting also fascinates modern viewers because it is a work of genius – a classic capable of being reinterpreted in every generation. In reply to the second question, she would have explained that its precision, clarity and luminosity (so technically brilliant that some have claimed van Eyck must have employed mechanical devices or even dabbled in the black arts) make it particularly appealing to us today, surrounded as we are by images everywhere. As others have observed, its smooth photographic finish and self-contained details like the mirror, chandelier and dog make it ideally suited for interactive display, digital advertising, and other high-definition applications. And in the third-dimensional holographic media of the future this adaptable portrait, glowing with unearthly light, will surely continue to hold its own.

Carola would, too, have reiterated her stance on interpretation. That old saying about the portrait, 'a thousand art historians have put forward a thousand theories', may well be true but, as she says in this book, an

obsession with what it means can be a blind alley, a profitless diversion that detracts from enjoyment of the painting as a work of art. Unless lost documents (unaccountably missed by hordes of researchers over the years) turn up in those Flemish archives, we will never know for sure whether the couple in the portrait is indeed Giovanni di Nicolao Arnolfini, rich Italian merchant of Bruges, and his putative second wife (or possibly his late wife Costanza) or what the context really is. The carefully worded caption in the National Gallery, wisely following the Occam's Razor principle that entities should not be multiplied beyond necessity, states, 'The picture is often interpreted as a depiction of a marriage ceremony. It is in fact a particularly elaborate portrait of Arnolfini and his wife.' The simplest explanation is not invariably correct, but it so often is. Carola, believing that this was an image primarily designed to show off social status, wealth and importance, whatever else it may contain in the way of hidden symbolism, would not have dissented from the set description.

Finally, for fun, Carola would have urged anyone who really wished to understand the true complexity of this work to try their hand at the fiendishly difficult 1,000-piece jigsaw puzzle, which our son Toby gave to her as a Christmas present in 2008; two years later it remained uncompleted despite copious help from our old friend Steve Russell, an artist with a quick eye for matching colour. Details such as the chandelier, mirror and patterned carpet, which all have distinctive markings, are reasonably easy to conquer. Even the green dress, looking dauntingly uniform at first, is achievable once you have realised the folds and plaits are painted to a formula. The real challenge is in the areas of shadow created by intricate systems of hatched brushwork, the man's sable coat and the bare wooden boards of the floor and ceiling. So subtle and imperceptible are the gradations of colour and hue here that it can easily take up to one hour to click in a single piece; the gaps that are yet to be filled remain as a fitting testimony to a magical mastery of oil paint.

On the many occasions since Carola's death that I have stood before

the Arnolfini, there have always been others on the spot, silent and entranced as they study this most mysterious of masterpieces – alien yet somehow very modern – which continues to cast its spell as it has done for centuries.

Gary Hicks
Carola's husband
July 2011

Notes

1: Court Painter to the Duke of Burgundy

7 'had a handsome figure': Vaughan, 127.

7 'almost till dawn': ibid., 128.

8 'decorated the room': ibid., 138–9.

9 'a circular representation of the world': Belozerskaya, 184.

9 'and several other lords': Vaughan, 180.

10 'that the keeper': Letts (1957), 28.

2: Bruges, Venice of the West

13 'the multitude': Letts (2007), 195.

14 everything which': ibid., 200.

14 'looks as if half': ibid., 201.

15 'the inhabitants are': ibid., 199.

16 'it is the custom': Letts (1957), 41.

Followers of Fashion

23 *heuque*: H. L. Monnas, 'Silks in van Eyck's Paintings', *Hali* (December 1991), 110.

26 Bruges was the hub of the fur trade: R. Delort, *Le Commerce des Fourrures en Occident à la Fin du Moyen Age* (1978), 280.

29 *bracci*: M. Scott, *Medieval Dress and Fashion* (2007), 125.

30 'bag-sleeves': ibid., 131.

31 'I saw the jagges': R. Easting (ed.), *The Vision of William of Stranton: St Patrick's Purgatory* (1991), 87.

31 'I have no gown': N. Davies (ed.), *Paston Letters and Papers of the Fifteenth Century*, Part I, Early English Text Society, ss 26 (2004), 216.

33 *houppelande*: M. Scott, *Medieval Dress and Fashion* (2007), 125.

3: Courtier, Ambassador, Spy: Don Diego de Guevara

39 '*écuyers tranchants*': Report on recently discovered manuscripts listing the household ordinances of Philip the Fair in 1496, *The Compte-rendu des séances de la Commission Royale d'Histoire*', II (1846), 678–718.

44 'he gave the greatest sigh': M. Gachard, *Collection des Voyages des Souverains de Pays-Bas* (1874–1882), vol. I, 543.

The Beads and the Brush

51 By 1420, the Bruges guild: Rice, 55, Gessler 48.

52 'Amber is a juice': Guicciardini, 36.

4: *La Grande Mère de l'Europe*: Marguerite of Austria

55 'a large picture': Le Glay, II, 479.

59 'this princess had': Tremayne, 92.

64 'a person of about thirty-five': Hale, 89.

64 'fine panel paintings': ibid., 92–93.

64 'the finest painting in Chistendom': ibid., 96.

64 'Lady Marguerite': A. Dürer (ed. J. Goris and G. Marlier), *Diary of his journey to the Netherlands, 1520–21* (1971), 95.

The Furniture

67 'These old rules': P. Eames, 'Furniture in England, France and the Netherlands from the Twelfth to the Fifteenth Century', *Furniture History*, XIII (1977), 271.

5: The Amazon Queen: Marie of Hungary

77 'if that you should': Tremayne, 245.

78 'she is a virago': Piret, 110.

82 *'Mad queen, remember Folembray!'*: J. de Iongh, *Mary of Hungary* (1959), 259.

82 'Let there be also packed': A. Pinchart, *'Tableaux et sculptures de Marie de Hongrie'*, *Revue Universelle des Arts*, III (1856), 141.

The Fabrics

87 'the bed that was not for sleeping': P. Eames, 'Furniture in England, France and the Netherlands from the Twelfth to the Fifteenth Century', *Furniture History* (1977), 270.

89 *scarlatto*: J. H. Munro, 'The Medieval Scarlet and the Economics of Sartorial Splendour', *Cloth and Clothing in Medieval Europe*, ed. N. B. Harte and K. G. Ponting (1983), 66.

6: Art Lover: Philip II

95 'it is astonishing': K. Van Mander, *Lives of the Illustrious Netherlandish and German Painters*, 4 vols, ed. H. Miedema (1994–97), 53.

95 'many portraits, each one': ibid., 69.

7: Spanish Palaces: From Philip to Napoleon

102 'several fierce, obtrusive daubings': W. Beckford (ed. G. Chapman), *The Travel-Diaries of William Beckford of Fonthill*, II (1928), 223–4.

102 'Greek slaves in Constantinople': Luxenberg, 8.

102 'I know that there are': ibid., 110.

103 'paintings of the most famous': ibid., 111.

103 'the centre of gossip': D. Hilt, *The Troubled Trinity: Godoy and the Spanish Monarchs* (1987), 23.

104 'so many and so alike': Luxenberg, 111.

105 'the pictures in the sacristy': Lady Elizabeth Holland (ed. Earl of Ilchester), *The Spanish Journal* (1910), 78.

105 'by favour we were': ibid., 81.

105 'a few excellent pictures': ibid., 109.

105 'The house is small': ibid., 120–21.

8: The Uninvited King of Spain: Joseph Bonaparte

111 'They are nothing': D. Seward, *Napoleon's Family* (1986), 1.

113 'with a view to acquiring': Buchanan, 203.

113 'many fine things': ibid., 209.

113 'I wrote to advise you': Bonaparte; J. Bonaparte, (ed. A. du Casse) *Mémoires et Correspondence Politique et Militaire du Roi Joseph* (1854–55), ii, 55.

114 'This measure': ibid., 34.

114 'three years in a humid location': Luxenberg, 213.

115 'the splendid gallery': Leith-Hay (1834), 90.

115 'taking with him': Miot de Melito (ed. General Fleischmann, trans. C. Hoey and J. Lillit), *Memoirs of Compte Miot de Melito* (1881), 588.

116 'all the blunders': Seward, 143.

117 'neither a gentlemanlike': Leith-Hay (1834), 159.

117 'persons of rank': ibid., 179.

117 'at night, Vitoria': ibid., 183.

118 'The nature of the ground': Hay (1901), 114.

118 'beyond the city': A. H. Atteridge, *Napoleon's Brothers* (1909), 321 (citing Napier).

118 'both the road': de Melito, 605.

119 'The fortunes amassed': ibid., 608.

119 'Such a scene': Leith-Hay, 203.

120 'The moment that': *Caledonian Mercury*, 8 July 1813.

120 'The baggage of King Joseph': Kauffmann, 6.

120 'soldiers were stripping': G. Bell, *Rough Notes of an Old Soldier*, I (1867), 93.

121 'attired themselves': B. H. Liddell Hart (ed.), *The Letters of Private Wheeler 1809–28* (1951), 119.

121 'It was not generally': Bell, 93.

121 'When I left': Liddell Hart, 119.

9: Hero of Waterloo: Colonel James Hay

128 'the neighbourhood of': W. Tomkinson, *The Diary of a Cavalry Officer in the Peninsular and Waterloo Campaigns 1809–1815* (1894, republished 1999), 273.

129 'On moving to support them': Tomkinson, 301.

129 'Colonel Hay fell': H. T. Siborne, *Waterloo Letters: a selection from original and hitherto unpublished letters* (1891), 121.

130 'At the extreme end': Hay (1901), 202–4.

130 'almost every private house': ibid., 209.

131 'During his long convalescence': C.-J. Nieuwenhuys, *Description de la Galerie des tableaux de S. M. le Roi des Pays-Bas* (1843), 6.

132 'How many masterpieces': Luxenberg, 107.

132 'the claim of the Allies': Gould, 133–51.

132 'I sent them to England': Kauffmann, 6.

133 'His Majesty': ibid., 6.

The Mirror

134 'Almost nothing is more': M. Baxandall, *Giotto and the Orators* (1971), 101–2.

135 'The most notable mirrors': *The Times*, 21 July 1956.

10: The Dealers and the Prince and the Critics

140 'some of the most valuable': Buchanan, 238.

142 'Sir Thomas Lawrence': Farington, 5110, 21 November 1817.

142 'from Sir Thomas Lawrence': O. Millar, 'Jan van Eyck's Arnolfini Group: an addition to its history', *Burlington Magazine*, vol. XCV (1953), 97–98.

143 'Sir T. Lawrence . . . told me he was with': Farington, 4871, 12 July 1816.

144 'Sir T. Lawrence told me that the Prince Regent': ibid., 4946, 20 December 1816.

144 'No. 168, Portrait of a man': Millar, 97.

144 'The Prince proposed': Farington, 4971, 12 July 1816.

146 'Colonel James Hay': D. Robertson, *Sir Charles Eastlake and the Victorian Art World* (1978), 294; Davies, 127–8.

147 'He said they had departed': Farington, 4920, 10 November 1816.

148 'During the thirteen years': Davies, 27.

149 'It has never been our luck': *Athenaeum*, 3 July 1841.

149 'the antique painters': Abbott, 212.

150 'the hugger-mugger': ibid., 110.

150 'We do not . . . approve': *Morning Chronicle*, 6 June 1840.

150 'there is not': Abbott, 164.

150 'formal perpendicularity': ibid., 187.

151 'as sweet and pure': *Athenaeum*, 3 July 1841.

152 'are both of a much later date': *Observer*, 8 August 1841.

152 'there is one other picture': *Blackwood's Edinburgh Magazine*, CCCXI, 349–51.

153 'Mr Seguier, the picture restorer': autobiographical notes transcribed by Wardop's daughter. NG archive, AP file.

11: Star of the National Gallery

157 'for a museum or gallery here': Gould, 121.

157 'When the sovereign': Buchanan, i, 26.

158 'In the present times': C. Whitehead, *The Public Art Museum in Nineteenth-Century Britain: the Development of the National Gallery* (2005), 5.

158 '*Buy* Mr Angerstein's collection': H. Cole, *Felix Summerly's Handbook for the National Gallery* (1843), vii.

160 'the catalogue Seguier drew up': Abbott, 165–7.

161 'under the present circumstances': Correspondence in the National Gallery archive, NG5/501/1. Letter from Trevelyan to Trustees, 2 May 1842.

162 'resolved that a letter': NG 5/50/1842; NG 5/51/1842; Trustees' Minutes, 6 February 1843.

163 'It has a smooth': *Athenaeum*, 25 March 1843.

164 'This is the most estimable': *Art Union*, May 1843.

164 'A picture has been added': *Illustrated London News*, 15 April 1843.

166 'a perfect specimen': *Felix Summerly's Handbook for the National Gallery*, 48.

166 'one of the earliest painters': ibid., 63.

168 'Of the other objectionable': NG 1947, 4, Select Committee Report.

12: Pre-Raphaelite Idol and Connoisseurs' Quest

171 'paltry building': E. Moggs, *New Picture of London and Visitors' Guide*, 1843.

172 'that preposterous portico': *The Times*, 7 January 1847.

172 'placed unfortunately': *Athenaeum Français* 24 (16 June 1855), 507–9; trans. *Art-Journal*, 1 September 1855, 251.

176 'I've always longed': M. Lago (ed.), *Burne-Jones Talking* (1982), 132.

176 'I went into the National Gallery': ibid., 136.

177 'a woman sitting up': ibid., 123.

178 'The question': C. Eastlake, *Materials for a History of Oil Painting* (1847), 185.

178 'This valuable picture': C. Waagen (trans. Lady Eastlake), *Treasures of Art in Great Britain*, I (1854), 348.

179 'I, for my part': Crowe (1895), 56.

180 'I confided': ibid., 65.

180 'unkempt locks': ibid., 87.

181 'imperial gold cloth': L. de Laborde, *Les Ducs de Bourgogne: études sur les lettres, les arts, et l'industrie pendant le XV siècle*, 2 vols (1849), 196, 208, 210.

181 'Arnoulphin lived': Crowe and Cavalcaselle (1857), 65.

181 'it has been supposed': ibid., 66.

182 *La Légitimation*: L. de Laborde, *La Renaissance des Arts à la Cour de France*, vol II (1855), 601–3.

182 'Harder outlines': Crowe and Cavalcaselle (1857), 85–86.

183 'We gradually brought together': Crowe (1895), 100–104.

183 'Mr John Murray had refused': ibid., 132.

183 'After all, my real interest': ibid., 182.

184 'most important pictures': Crowe and Cavalcaselle (1872), 99–100.

185 'a rather troublesome': Brockwell (1952), 91.

186 'the researches of Mr Weale': Brockwell (1952), 68.

186 'The colouring of this': Weale (1908), 70.

187 'A century ago': Weale and Brockwell, xiv, preface.

187 'the National Gallery guide-books': *Pall Mall Gazette*, 15 February 1890.

187 'one of the most': E. J. Poynter (ed.), *The National Gallery* (1899), 158.

187 'honour here recorded': *Manchester Guardian*, 11 January 1900.

188 'one picture': *The Times*, 19 December 1898.

Techniques

190 'The nose dark': Cited in A. L. Dierick, 'Jan van Eyck's handwriting', in Foister et al. (2000), 79.

13: Wars and Disputes

195 'ambitious, and we will not': *The Times*, 26 February 1901.

196 'The vanished pictures': *Observer*, 7 March 1915.

196 'one of the most': *Observer*, 16 January 1921.

196 'notable people': *Manchester Guardian*, 1 April 1924.

198 'This I regard': L. Dimier, letter in *Burlington Magazine*, vol. LXV (1934), 135.

198 'M. Dimier's letter': *Burlington Magazine*, vol. LXV (1934), 296.

199 'the highly coloured': Brockwell (1952), 10.

199 'It is a nice exercise': *Observer*, 1 February 1953.

199 'It is salutary': *Manchester Guardian*, 23 January 1953.

201 'very Welsh': N. J. McCamley, *Saving Britain's Art Treasures* (2003), 89.

202 'We have found': Correspondence in the National Gallery archive, NG 16/591–7, Clark to Davies, 4 March 1943.

203 'The speed of their return': *Manchester Guardian*, 18 May 1945.

203 'One had almost to queue': *Observer*, 20 May 1945.

204 'surely the completest': *Manchester Guardian*, 26 May 1945.

204 'Which works of art': *Observer*, 26 December 1999.

205 'ever since the Sainsbury Wing': *Evening Standard*, 17 August 2001.

Hidden Puzzles?

207 'we need not assume': J. Elkins, 'On the Arnolfini Portrait and the Lucca Madonna: Did Jan van Eyck have a Perspectival System?', *Art Bulletin*, 73 (1991), 56.

209 'no painter is accounted': M. Baxandall, *Giotto and the Orators* (1971), 101–2.

14: Interpretations and Transformations: The Arnolfinis Today
211 'make phantoms': Guillaume de Lorris and Jean de Meun (trans. Charles Dahlberg), *The Romance of the Rose* (1983), 18044–18287.
212 'The Arnolfini and his wife': C. Phillips, *Fortnightly Review*, October 1902.
215 Habitat advertisement: I am most grateful to the History of Advertising Trust, Norwich, for finding this example.
216 Dave Brown cartoon: *Independent*, 28 October 2006.
216 Martin Rowson cartoon: *Guardian*, 13 April 1996.
216 Peter Brookes cartoon: *The Times*, 12 September 1983.
217 *Times* BBC cartoon: *The Times*, 17 August 2005.
217 'WILL HUGH BE MINE': *Mirror*, 6 December 2001.
217 'A Brush with Fame': *Mail on Sunday*, 30 April 2006.
221 'We are the Arnolfinis': P. Durcan, *Give Me Your Hand*, 1994.

Bibliography

Abbott: C. C. Abbott, *The Life and Letters of George Darley, Poet and Critic* (1928).

Ainsworth: M. W. Ainsworth, *Petrus Christus in Renaissance Bruges: an interdisciplinary approach* (1995).

Allende-Salazar: J. Allende-Salazar, 'Don Felipe de Guevara', *Archivo Español de Arte e Arqueologia*, I (1925), 189–92.

Alpers: S. Alpers, *The Art of Describing Dutch Art in the Seventeenth Century* (1983).

Armstrong: C. A. J. Armstrong, *England, France and Burgundy in the Fifteenth Century* (1983).

Baildon: W. P. Baildon, 'The Trousseau of Princess Philippa', *Archeologia*, 67 (1916), 163–88.

Baldass: H. Baldass, *Jan van Eyck* (1951).

Baldwin: R. Baldwin, 'Marriage as a Sacramental Reflection of the Passion: the mirror in Jan van Eyck's Arnolfini Wedding', *Oud Holland*, 98 (1984), 57–75.

Beaulieu: M. Beaulieu and J. Baylé, *Le Costume en Bourgogne* (1956).

Belozerskaya: M. Belozerskaya, *Rethinking the Renaissance: Burgundian Arts across Europe* (2002).

Bermejo Martinez: E. Bermejo Martinez, *La pintura de los primitivos flamencos en España* (1980).

Bertrand: P.-M. Bertrand, *Le portrait de van Eyck: l'énigme du tableau de Londres* (2006).

Bialostocki: J. Bialostocki, *The Message of Images* (1988).

Billinge: R. Billinge and L. Campbell, 'The infra-red reflectograms of Jan van Eyck's Portrait of Giovanni (?) Arnolfini and his Wife Giovanna Cenami (?)', *National Gallery Technical Bulletin*, Vol. 16, January (1995), 47–60.

Billinge: R. Billinge, *Examining Jan van Eyck's underdrawings* in Foister et al. (2000), 85–96.

Bonaparte: N. Bonaparte, *The Confidential Correspondence of Napoleon Bonaparte with his Brother Joseph, Sometime King of Spain* (1855).

Bosman: S. Bosman, *The National Gallery in Wartime* (2008).

Brockwell: M. W. Brockwell, *The Pseudo-Arnolfini Portrait: a Case of Mistaken Identity* (1952).

Buchanan: W. Buchanan, *Memoirs of Painting, with a chronological history of the importation of pictures by the great masters into England since the French Revolution* (1824).

Cameron Highlanders: *Historical Records of the Queen's Own Cameron Highlanders*, I (1909).

Cardon: D. Cardon, 'Medieval Kermes and Kermes-dyeing', *Dyes in History and Archaeology*, 7 (1988), 5–9.

Carroll: M. D. Carroll, '"In the Name of God and Profit": Jan van Eyck's Arnolfini Portrait', *Representations*, 44 (1993), 96–132.

Cartellieri: O. Cartellieri, *The Court of Burgundy: studies in the history of civilisation* (1929).

Carter: A. Carter, 'Reflections in Armour in the Canon van der Paele Madonna', *Art Bulletin*, 36 (1954), 60–62.

Cauchies: J. M. Cauchies, 'Les Etrangers dans l'entourage politique de Philippe Le Beau', *Revue du Nord*, 84 (2002), 413–28.

— *Philippe le Beau, le dernier duc de Bourgogne* (2003).

Chatelain: J. Chatelain, *Dominique Vivant Denon et le Louvre de Napoleon* (1973).

Checa: F. Checa, *Felipe II, Maecenas de las Artes* (1992).

Chenciner: R. Chenciner, *Madder Red: a history of luxury and trade* (2000).

Conlin: J. Conlin, *The Nation's Mantelpiece: a history of the National Gallery* (2006).

Corkran: A. Corkran, *The National Gallery* (1908).

Crowe: J. A. Crowe, *Reminiscences of Thirty-five Years of my Life* (1895).

Crowe and Cavalcaselle: J. A. Crowe and G. Cavalcaselle, *The Early Flemish Painters: notices of their lives and works* (1857/1872).

Crowfoot: E. Crowfoot, F. Pritchard and K. Staniland, 'Textiles and Clothing c. 1150–c. 1450', *Medieval Finds from Excavations in London*, 4 (2001).

Cunliffe: J. Cunliffe, *Griffon Bruxellois* (2001).

Cunnington: C. W. Cunnington and P. Cunnington, *Handbook of English Medieval Costume* (1952).

Davies: M. Davies, *Les Primitifs Flamands:* Vol. I, *Corpus of the Paintings of the Southern Netherlands in the Fifteenth Century* (1954).

Defourneax: M. Defourneax, *La vie quotidienne au temps de Jeanne d'Arc* (1952).

Dhanens: E. Dhanens, *Hubert and Jan van Eyck* (1981).

Doyle: D. Doyle, 'Mary of Hungary: Patronage and Politics', *Sixteenth-Century Journal*, 31 (2000), 349–60.

Dufresne: L. R. Dufresne, 'A woman of excellent character', *Dress*, 17 (1990), 104–17.

Dunkerton: G. Dunkerton, S. Foister, D. Gordon and N. Penny, *Giotto to Dürer: Early Renaissance Painting in the National Gallery* (1991).

Eastlake: C. Eastlake, *Materials for a History of Oil Painting* (1847).

Eichberger: D. Eichberger, 'Margaret of Austria's portrait collection: female patronage in the light of dynastic ambitions and artistic quality', *Renaissance Studies*, 10.2 (1996), 258–73.

Eichberger (ed.): D. Eichberger (ed.), *Women of Distinction: Margaret of York, Margaret of Austria* (2005).

Eichberger and Beaven: D. Eichberger and L. Beaven, 'Family Members and Political Allies', *Art Bulletin*, 77 (1995), 225–48.

Erdmann: K. Erdmann, *700 Years of Oriental Carpets* (1970).

Evans: J. Evans, *A History of Jewellery 1100–1870* (1953).

Farington: J. Farington (ed. K. Cave), *The Diary of Joseph Farington*, XIV, January 1816–December 1817 (1984).

Feller: R. Feller (ed.), *Artists' Pigments* (1980).

Fligny: L. Fligny, *Le Mobilier en Picardie, 1200–1700* (1990).

Foister and Nash: S. Foister and S. Nash, *Robert Campin: New Directions in Scholarship* (1996).

Foister et al.: S. Foister, S. Jones and D. Cool, *Investigating Jan van Eyck* (2000).

Friedlander: M. Friedlander, *From van Eyck to Bruegel* (1981).

Gelfland: L. Gelfland, 'Regency, Power and Dynastic Visual Memory: Margaret of Austria as Patron and Propagandist', *The Texture of Society: Medieval Women in the Southern Low Countries*, ed. E. Kittell and M. Suydam (2004), 203–25.

Gessler: J. Gessler (ed.), *Le Livre des Mestiers de Bruges* (1931).

Glover: M. Glover, *Legacy of Glory – the Bonaparte Kingdom of Spain 1808–1813* (1972).

Glover (ed.): M. Glover (ed.), *A Gentleman Volunteer: the Letters of George Hemmell* (1979).

Goldring: D. Goldring, *Regency Portrait Painter* (1951).

Gosman: M. Gosman, A. Macdonald and A. Vanderjagt, *Princes and Princely Culture 1450–1650* (2003).

Gottlieb: M. Gottlieb, 'The Painter's Secret: Invention and Rivalry from Vasari to Balzac', *Art Bulletin*, 84 (Sept 2002), 469–90.

Gould: C. Gould, *Trophy of Conquest*, 1965.

H. Graham: H. Graham, *History of the Sixteenth, the Queen's, Light Dragoons (Lancers) 1759– 1912* (1912).

J. Graham: J. Graham, *Inventing van Eyck: The Remaking of an Artist for the Modern Age* (2007).

Greenfield: A. B. Greenfield, *A Perfect Red: empire, espionage and the quest for the colour of desire* (2006).

Grew: F. O. Grew and M. de Neergaard, *Shoes and Pattens: Medieval Finds from Excavations in London* (2001).

Guicciardini: L. Guicciardini, *The Description of the Low Countreys* (1593). Reproduced in the English Experience series (1976).

Hale: J. R. Hale (ed.), *The Travel Journal of Antonio de Beatis: Germany, Switzerland, the Low Countries, France and Italy 1517–18* (1979).

Hanham: A. Hanham, *The Celys and their world: an English merchant family of the fifteenth century* (1985).

Harbison: C. Harbison, *Jan van Eyck: The Play of Realism* (1991).

Harvey: J. Harvey, *Men in Black* (1995).

Hay: W. Hay, *Reminiscences 1808–1815 under Wellington* (1901).

Hills: P. Hills, *Venetian Colour Marble: Mosaic, Painting and Glass 1250–1550* (1999).

Hindman: S. Hindman, *Text and Image in Fifteenth-century Illustrated Dutch Bibles* (1977).

Hughes: R. Hughes and L. G. Faggin, *The Complete Paintings of the van Eycks* (1970).

Huizinga: J. Huizinga, *The Waning of the Middle Ages* (1924/1955).

Iongh: J. de Iongh, *Margaret of Austria, Regent of the Netherlands* (1954).

Kauffmann: C. M. Kauffmann, *Catalogue of Paintings in the Wellington Museum* (1982).

King: D. King and D. Sylvester, *The Eastern Carpet in the Western World from the 15th to the 17th Century* (1983).

Koster: M. Koster, 'The Arnolfini Portrait: a simple solution', *Apollo*, 158 (September 2003), 3–14.

Laborde: L. de Laborde (ed.), 'Inventaire des Tableaux, Livres, Joyaux et Meubles de Marguerite d'Autriche', *Revue Archéologique*, 7 (1850), 36–57, 80–89.

Laszio: P. Laszio, *Citrus: a history* (2007).

Lazzareschi: E. Lazzareschi (ed.), *Libro della communità dei mercanti lucchesi in Bruges* (1947).

Lee: D. Lee, *Nature's Palette: The Science of Plant Colour* (2007).

Le Glay: A. Le Glay, *Correspondance de l'Empereur Maximilien I et Marguerite d'Autriche 1507–1519* (1839).

Leith-Hay: A. Leith-Hay, *A Narrative of the Peninsular War*, 2 vols (1834).

Letts: M. Letts (trans. and ed.), *The Travels of Leo of Rozmital* (1957).

— *Pero Tafur: Travels and Adventures 1435–1439* (2007).

Libert: Louise-Marie Libert, *Dames de Pouvoir* (2005).

Lightbown: R. Lightbown, *Medieval European Jewellery* (1992).

Lusy: A. de Lusy (ed. A. Louant), *Le journal d'un bourgeois de Mons, 1505–1536* (1969).

Luxenberg: A. Luxenberg, *The Galerie Espagnole and the Museo Nacional 1835–1853* (2008).

Maillet: A. Maillet, *The Claude Glass* (2004).

McClellan: A. McClellan, *Inventing the Louvre* (1994).

Melchior-Bonnet: S. Melchior-Bonnet, *The Mirror: a history* (2001).

Merrifield: M. Merrifield, *Medieval and Renaissance Treatises on the Arts of Painting* (1849).

Miguel: M. Miguel, *Charles-Quint: son abdication, son séjour et sa mort au monastère de Yuste* (1857).

Miller: J. Miller, *On Reflection* (1998).

Monnas: H. L. Monnas, 'Silk textiles in the paintings of Jan van Eyck', in Foister et al (2000), 147–61.

Murray: J. M. Murray, *Bruges: Cradle of Capitalism 1280–1390* (2005).

Nash: J. Nash, *Veiled Images: Titian's mythological paintings for Philip II* (1985).

National Gallery: *An Exhibition of Cleaned Pictures* (1947).

Nicholas: D. Nicholas, *Medieval Flanders* (1992).

Nightingale: P. Nightingale, *A Medieval Mercantile Community* (1995).

Pächt: O. Pächt (trans. D. Britt), *van Eyck and the Founders of Early Netherlandish Painting* (1994).

Panofsky: E. Panofsky, 'Jan van Eyck's Arnolfini Portrait', *Burlington Magazine*, Vol. LXIV (1934), 117–127.

Paravicini: W. Paravicini (ed. R. G. Asch and A. M. Birke), 'The Court of the Dukes of Burgundy, a Model for Europe?', in *Princes, Patronage and the Nobility: the Court at the Beginning of the Modern Age, c. 1450–1650* (1991).

Paviot: J. Paviot, 'The Arnolfini double portrait', *Revue Belge*, LXVI (1997), 19–33.

Pearson: A. Pearson, *Envisioning Gender in Burgundian Devotional Art 1350–1530* (2005), chapter 5, 'Disrupting Gender at the Court of Margaret of Austria', 162–92.

Peman: C. Peman, *Juan van Eyck y España* (1969).

Piponnier: F. Piponnier and P. Mane, *Dress in the Middle Ages* (1997).

Piret: E. Piret, *Marie de Hongrie* (2005).

Pisan: C. de Pisan, *The Treasure of the City of Ladies* (1985).

Redondo: A. Redondo, *Antonio de Guevara et l'Espagne de son temps* (1976).

Reuterswärd: P. Reuterswärd, *The Visible and Invisible in Art* (1991), 'The Dog in the Humanist's study', 206.

Reynolds: J. Reynolds (ed. H. Mount), *Journey to Flanders and Holland* (1996).

Ribeiro: A. Ribeiro, *Dress and Morality* (1986).

Rice: P. Rice, *Amber: the golden gem of the ages* (1980).

Ridderbos: B. Ridderbos, A. van Buren and H. van Veen, *Early Netherlandish Paintings: Rediscovery, Reception and Research* (2005).

Roover: R. de Roover, 'The Iroquois and their neighbours', *Annales de la societé d'emulation, Bruges*, 86 (1949), 23–89.

— *Money, Banking, and Credit in Mediaeval Bruges* (1948).

— *The Bruges Money Market around 1400* (1968).

Rosenau: A. Rosenau, 'English Influences on van Eyck', *Apollo*, 36 (1942), 125–8.

Ruddock: A. A. Ruddock, *Italian Merchants and Shipping in Southampton 1270–1600* (1951).

Sandler: L. F. Sandler, 'The Handclasp in the Arnolfini Portrait: a manuscript precedent', *Art Bulletin*, 66.3 (September 1984), 488–91.

Schabaker: P. H. Schabaker, '*De Matrimonio ad Morganaticam Contracto*: Jan van Eyck's "Arnolfini Portrait" reconsidered', *Art Quarterly*, 35 (1972), 375–98.

Schwarz: H. Schwarz, 'The Mirror of the Artist and the Mirror of the Devout', *Studies in the History of Art: dedicated to William E. Suida on his Eightieth Birthday* (1959), 90–105.

— 'The Mirror in Art', *Art Quarterly*, XV (1952), 97–118.

Scott: M. Scott, *The Visual History of Costume: the 14th and 15th centuries* (1986).

— 'Dress in van Eyck's paintings', in Foister et al., *Investigating Jan van Eyck* (2000), 131–41.

— *Medieval Dress and Fashion* (2007).

Secord: W. Secord, *Dog Painting: the European Breeds* (2000).

Seidel: L. Seidel, *Jan van Eyck's Arnolfini Portrait: Stories of an Icon* (1993).

Singleton: E. Singleton, *Dutch and Flemish Furniture* (1907).

Snyder: J. Snyder, 'Jan van Eyck and Adam's Apple', *Art Bulletin*, 58 (1976), 511–15.

Steppe: J. K. Steppe, 'Het overbrengen van het hart van Filips de Schone van Burgos naar de Nederlanden in 1506–07', *Biekorf-westvlaams archief*, 3 (1982), 209–18.

Sutton: D. Sutton, 'Crowe and Cavalcaselle', *Apollo*, 122 (August 1985), 111–17.

Tavenor-Perry: J. Tavenor-Perry, *Dinanderie: a history and description of medieval art work in copper, brass and bronze* (1910).

Tolkowsky: S. Tolkowsky, *Hesperides: a history of the culture and use of citrus fruits* (1938).

Tremayne: E. E. Tremayne, *The First Governess of the Netherlands: Margaret of Austria* (1908).

Trevor-Roper: H. Trevor-Roper, *Princes and Artists: Patronage and Ideology at Four Habsburg Courts 1517–1663* (1976).

Van der Wee: H. van der Wee, 'Structural changes and specialisation in the industry of the Southern Netherlands 1100–1600', *EHR*, 28 (1975), 203–21.

Van Houtts: J. A. van Houtts, 'The Rise and Decline of the Market of Bruges', *EHR*, 19 (1966), 129–47.

Vaughan: R. Vaughan, *Philip the Good: The Apogee of Burgundy* (1970).

Veale: E. Veale, *The English Fur Trade in the Later Middle Ages* (1966).

Warner: M. Warner, 'The Pre-Raphaelites and the National Gallery', *The Pre-Raphaelites in Context* (1992), 1–12.

Weale: W. H. Weale, *Hubert and Jan van Eyck: their life and work* (1908).

Weale and Brockwell: W. H. Weale and M. Brockwell, *The van Eycks and Their Art* (1912).

Weiss: R. Weiss, 'Jan van Eyck and the Italians', *Italian Studies*, 11 (1956), 1–15, 12 (1957), 7– 21.

Wellington: A. W. Wellington, *Dispatches of Field Marshal the Duke of Wellington during his various campaigns*, compiled by Colonel Gorwood (various edns).

Wilenski: R. Wilenski, *Dutch Painting* (1929/1945).

Wilkins: E. Wilkins, *The Rose-Garden Game: the symbolic background to European prayer-beads* (1969).

Wilson: J. C. Wilson, *Marketing Paintings in Late Medieval Flanders and Brabant* (1990).

Ydema: O. Ydema, *Carpets and their Datings in Netherlandish Paintings 1540–1700* (1991).

Index

Index

Index